THE OTHER OBSERVERS

WOMEN PHOTOGRAPHERS IN BRITAIN
1900 TO THE PRESENT

VAL WILLIAMS

Published by VIRAGO PRESS Limited 1986
42–43 Gloucester Crescent, Camden Town, London NW1 7PD
under the title *Women Photographers: The Other Observers 1900 to the Present*

Reprinted 1991, 1994

Published with financial assistance from the Arts Council

*A CIP catalogue record for this book
is available from the British Library*

Typeset by Goodfellow and Egan Ltd, Cambridge
Printed by Butler and Tanner, Frome, Somerset

■ ACKNOWLEDGEMENTS

Many people have helped me with ideas and information about
the development of women's photography in Britain. To all of
those listed here I express my gratitude:

Marjorie Abbatt; Susan Ash; Quentin Bell; Kathy Biggar;
Noreen Branson; Louisa Buck; Tessa Codrington; Clare Colvin
(Tate Gallery Archive); Anne Forshaw; Colin Ford (National
Museum of Photography); Paul Fort; Nancy Hatch; Bert Hardy;
Amanda Hopkinson; Tom Hopkinson; Barbara van Ingen;
Jennifer Jones; Edith Kaye; Barbara Ker-Seymer; Monika Kinley;
Monica Flaherty Frassetto; Eve Leckley (British Institute of
Florence); Ursula Powys-Lybbe; Margaret and John Monck;
Terry Morden (National Museum of Photography); Helen
Muspratt; Maggie Murray; John Somerset Murray; Colin Osman;
Richard Pankhurst; Jane Parkin (Virago Press); Terence Pepper
(National Portrait Gallery); Ruthie Petrie (Virago Press); Brenda
Prince; Shirley Read; Pam Roberts (Royal Photographic Society);
Fyfe Robertson; Nicolette Roeske; Jo Spence; Wolfgang
Suschitzky;Mike Seabourne(Museum of London);Betty Swaebe.

My thanks also to the librarians and staff of the following
institutions and organisations: the *British Journal of Photography*;
the Camera Club; the Charleston Trust; *Creative Camera*; the
Communist Party of Great Britain; the Museum of Modern Art,
Oxford; the National Portrait Gallery; the National Museum of
Photography; the Imperial War Museum; the National Museum
of Labour History; the Museum of London; the Fawcett Library,
City of London Polytechnic; the Tate Gallery Archive; the
Science Museum; the Royal Photographic Society; the Royal
Archives, Windsor Castle, and the International Institute for
Social History, Amsterdam. The photograph of Ursula Powys-
Lybbe by Susan Ash reproduced by courtesy of Channel Four.
Very special thanks to Jill Cabrillana, Florrie Evans, Pat
Parsons and Consuelo Sanchez, who, in their different ways,
gave me the time and space to write this book.

■ CONTENTS

■ PREFACE 1991

In the five years since the first publication of *The Other Observers*, interest in women's photography has grown enormously. Spectrum, the first festival of women's photography was held in Britain in 1988, encompassing work which ranged from the aristocratic nineteenth-century tableaux of Clementina Hawarden to the pioneering self-portraiture of Jo Spence. New curatorial moves brought exhibitions ranging from *Shifting Focus*, a revelatory examination of contemporary women's photography (shown at London's Serpentine Gallery in 1989) to an incisive retrospective of the fantastical colour satires of 1930s' Madame Yevonde at the National Portrait Gallery in 1990.

Books as different as Helen Chadwick's *Enfleshings* (1989) and *Forbidden Land*, (1990), Fay Godwin's furious defence of the British countryside, have brought critical acclaim, proving that women have moved from the margins of the cultural debate to its centre. Women such as Karen Knorr, Maud Sulter, Hannah Collins, Sue Packer, Anna Fox and Jenny Matthews have, in their different ways, ensured that women's photography continues as a vital and challenging tradition.

The story of women's photography expands in the telling. Since writing this book, I have read about, written to, and met, many of the women I first encountered only as the unknown authors of some remarkable photographs. Some, like *Picture Post*'s Grace Robertson, have found enthusiastic audiences for their past work, and for fresh initiatives. Others, like Margaret Monck and Helen Muspratt have intrigued a contemporary public with fuller accounts of their lives and careers.

Since 1986, I have discovered much which is new and exciting – the London studio of Bauhaus photographers Ellen Auerbach and Grete Stern; photographs made in the '40s and '50s by Elizabeth Chat and Inge Morath for the radical London photo agency, Report; the powerful severity of Ida Kar's portraits of post-war Soho.

History continuously informs the way we perceive our lives. In the mid-'80s, the threat of nuclearism, the rise of a new politics, appeared to announce apocalypse. Feminist photography of mid-decade mirrored that state of alarm. The concluding chapter of *The Other Observers* examined how feminism had directed women's practice. Such practice has itself now become a part of history, a fragment in the chronicle of our times. Constantly progressing, changing and directing, women's photography remains a mirror of our present and our past.

Val Williams,
London 1991

■ INTRODUCTION

A story can be told in a hundred different ways; plots can be altered, characters changed to suit the teller's point of view. Writing this history and detailing the lives and careers of some of the many women who worked in photography in Britain from 1900 to the present day dispelled many of my own preconceptions about photography and its received history.

Until I began work on the research both for this book and for the exhibition sponsored by the National Museum of Photography, which in many ways it reflects, I had not fully recognised the existence and importance of a women's photography. Some women had of course always been prominent within photographic history – Dorothy Wilding's studio portraits have long been acknowledged as important, and Edith Tudor Hart's reforming documentary work during the 1930s had similarly been recognised as a significant part of leftist iconography – but they have been viewed only as photographers participating in a history which involved both men and women, and not as workers within some precise women's tradition.

The aims of this history are twofold: first, to resituate, within a women's tradition, women whose work is widely known and secondly to rediscover the work of women photographers whose photography has fallen into obscurity. When discussing the photographic work of well-known women like the painter/photographer Vanessa Bell, I have attempted to remove Bell's snapshot photography from the mordant niche of social history to which it has been consigned, and to see it as the skilled and subtle family propaganda which it certainly was. I have also discussed some of the ways in which women have used the snapshot to convey illusions of domesticity. Many questions about women's snapshot photography remain to be answered – why do women picture their families in the way they do? For whom are these photographs intended? What place do they have within image-making systems? Similarly, I have tried to draw the work of the portraitist Madame Yevonde away from notions of eccentricity and excess, and to review it as the satirical feminist picturing which it was.

When discussing lesser-known women, I have traced their careers in as much detail as is possible in the brief space allowed by a book of

this kind, and I hope that by doing this I have given them back some of their history. The careers of some of these women are remarkable – Ursula Powys-Lybbe, after contributing montages of High Society women to the *Tatler* in the 1930s, set up as a touring portraitist in Australia after the war, taking her enormous Dodge car to the heart of the outback to photograph farming families and their houses. Margaret Monck, possessed of an intense curiosity about the lives of working people, travelled around the East End of London making a documentary of the men, women and children whom she encountered. The Austrian *émigrée* Gerti Deutsch became a reporter of everyday life for the mass-circulation, quintessentially British picture magazine *Picture Post*.

Many of the women whose photographs I have discussed in this book are dead or untraceable, and so the precise motivations for their moves into photography can only be deduced from a knowledge of the cultural forces which existed at the time. For example, the reasons why a worker like Elsie Collins began to introduce modernism into her photographs of food and domestic interests at her Sydenham studio can be assembled only from a recognition of prevailing currents. From those women who are still alive and willing to discuss their careers, however, I have learned much of value about why women became photographers and the motivations that led them into particular areas of practice. To hear from the radical portraitist Helen Muspratt that her initial photographic interest came from a childhood visit to the studio photographer Constance Ellis in Guildford, and to learn of the excitement which she experienced when she began to share ideas with members of the Swanage arts grouping in the 1920s, makes the retelling of women's photographic history precise and comprehensible. Talking about her experiences as a photojournalist in the 1950s for *Picture Post* magazine, the photographer Grace Robertson outlined to me exactly what it was like to be a woman working within a male establishment and the ways in which this affected and directed assignments.

Some of the women whose work I have included wrote their own histories in the form of autobiography, and these works have their own special place within a women's history. Veering from the intensely personal to the wildly anecdotal, they present a self-made picture of a group of women determined to make their way in photography and in society. The writings of *Picture Post* photographer Merlyn Severn are full of the particular vanities which only autobiography can produce, and have formed my picture of Severn as opinionated, irascible, energetic and mystical in her perception of the photojournalistic process. To some extent my perceptions of Merlyn Severn's life are her perceptions, making history-writing more problematic and intriguing than ever.

All of the women discussed in this book are ones whose work and personalities were peculiarly fascinating to me, both because of their

place within women's culture and because of the efforts which they made to progress within the medium. I became intensely interested in the life of the Suffragette photographer Norah Smyth, trying to recreate the thinking of this young woman as she took up a camera to record the work of the East London Federation of Suffragettes among the poor working women of Bethnal Green and Bow. I tried, too, to imagine the feelings of Elsie Knocker and Mairi Chisholm, the two 'Women of Pervyse', as they photographed ruined buildings and decaying corpses from their first-aid post in Belgium during the First World War, and to place their work within a context of women's documentary photography. The excitement – and horror – which these women must have felt when they encountered situations so far removed from their own backgrounds and cultural experiences is almost impossible to convey.

Coming up to the present, it could not be my task to detail all of the women active within contemporary photography; instead I have concentrated on some of those who have continued to work within a radical tradition and to look particularly at photographers whose primary impetus has come from their involvement with feminism. I have perceived feminist photography from the early 1970s to be the natural corollary of the work of earlier women, many of whom possessed a keen and well-developed consciousness of themselves as women photographers. Thus natural connections form between workers like Madame Yevonde and the contemporary feminist Jo Spence, as they do between the concerns which directed the work of both Edith Tudor Hart in the thirties and the Hackney Flashers group in the late seventies.

None of the women discussed in this book worked in a vacuum. All of them were impelled to move into photography because of deeply felt convictions or needs, either political or personal. The Suffrage movement inspired many women to take up cameras to record a monumental period in their lives. The First World War and the opportunity it gave to women to travel abroad and experience the realities of international conflict also prompted a new women's photography. The radical socialism of the thirties likewise encouraged many women into photography, as did the thriving studio movement, which promised employment, security and social mobility. For those whose work was already established at such times of social upheaval, the photographing of events and areas of particular significance to women served to broaden the scope of their own picturing: the studio portraitist Olive Edis moved beyond studio practice and into documentary when called upon to photograph women serving as nurses abroad during the First World War, and the London photographer Lena Connell created an image of the leading members of the Suffrage movement which served to present them as heroic and glamorous, all in the service of the women's cause.

The history of women's photography in Britain does not begin at

1900, although this is the starting point for this book. I have attempted to make some connections between twentieth-century women and their Victorian predecessors who were active in photography from its very beginnings. The history of nineteenth-century women's photography has yet to be written, and within the scope of my research for this project I have seen only tantalising glimpses of it. It is certain, however, that its resonances were felt throughout the years which followed 1900.

I have concentrated on exploring areas of work which I have judged to be of significance in the recreation of a women's photographic history, and not on trying to list and chronicle all the women active in the medium since the turn of the century. Because of this selective approach, some women photographers of great skill and energy have been omitted, sometimes because they had no precise connection with the areas upon which I had chosen to concentrate, and sometimes because I could not perceive their connection with a women's tradition. Two who particularly come to mind in this context are the portrait photographer Jane Bown and the landscapist Fay Godwin, both of whom have produced work of great significance.

In looking through Vanessa Bell's snapshots at the Tate Gallery, reading the letters which passed between her and her family, watching Helen Muspratt recreating a portrait session in her Swanage studio, reading of Lisa Sheridan's first meeting with the Royal Princesses, I have felt not only excitement but also an immense gratitude to these women who have given some of their history to me.

Val Williams,
London, 1986

PHOTOGRAPHY IN TRANSITION: AN OVERVIEW 1840-1939

In the 1840s an Englishwoman, Anna Atkins (1797–1871) published a scientific study of algae illustrated by photographs. *British Algae, Cyanotype Impressions*, which was followed in 1864 by *Cyanotypes of British and Foreign Flowering Plants and Ferns*, established her as one of the first producers of a photographically illustrated book. Even more significantly, her work established a more general place for women within both the scientific and photographic establishments at a very early date. Anna Atkins was the daughter of the zoologist John George Children FRS, whose association with early advances in photography dated back both to his attendance in 1839 of meetings of the Royal Society at which William Henry Fox Talbot had outlined his discovery of the process of 'photogenic drawing' and to his acquaintance with Sir John Herschel, the astronomer and scientist who was responsible for work on the cyanotype or blueprint process between 1819 and 1842. Atkins, a botanist and skilled draughtswoman who worked closely with her father, was quick to see the potential of the cyanotype for the accurate recording of specimens from her extensive herbarium. Writing in the introduction of *British Algae* she commented that it was 'the difficulty of making accurate drawings of objects as minute as many of the Algae and Conferva' which had 'induced me to avail myself of Sir John Herschel's beautiful process of cyanotype to obtain impressions of the plants themselves.'[1]

Although much of the history of nineteenth-century photography in Britain is still unresearched, and lies outside the scope of this survey, it is unarguable that the work of early nineteenth-century photographers resounded throughout the present century. The great explosion of activity within photography which followed Henry Fox Talbot's work with the calotype process[2] during the late 1830s and the 1840s made the medium accessible and attractive not only to those who were intrigued by the technical problems which photography presented, but also to those who saw its undoubted commercial potential or who sought to use the medium as a social recorder. Women were amongst these early practitioners, taking an active part in all photographic developments during the early years. Yet the customary bias towards the work of men throughout cultural history in general and photographic history in particular has rendered

their efforts especially obscure. Some of them have emerged as major artists, used as examples of Victorian practice in most standard works; the majority have been forgotten. Their fascinating history has yet to be fully constructed.

The relevance of the work of nineteenth-century women to this present survey lies in an exploration of the ways in which women created traditions which remained their own, and the ways in which they worked within emerging mainstream photographic traditions – studio portraiture, documentary photography, pictorialism and so on.

Studio portraiture was one of the major areas of women's practice during the nineteenth as well as the twentieth century. The early popularity of daguerreotypes, developed in 1839 by the Frenchman L. J. M. Daguerre in a process which involved the formation of an image on the silvered surface of a copper plate,[3] brought the public flocking to see themselves so glowingly, magically pictured. The general wonderment of men and women who for so long had relied on the artist's brush and pencil to produce a reflection of themselves produced vast opportunities for those who entered commercial photography from the 1840s. In 1852, Miss Wigley of Fleet Street, London, invited 'the public to inspect these portraits, taken by the agency of light, combining wonderful likenesses, instantaneous sitting, delicately coloured portraits, sufficiently portable to enclose by letter'.[4] Here was photography's magic. For the customer the daguerreotype was easy, quick and lightweight enough to be sent through the post. In its fine leather case, trimmed with gilt around the image, even coloured, it was a symbol of status available to those who had baulked at the expense of a painted portrait.

A year later, Mrs Smith of Lakenham suggested beauty to her clients in the form of daguerreotype portraits which promised 'Specimens of the beautiful delineations of the human face divine'.[5] Women such as she were well aware, even during photography's infancy, of its ability to flatter while at the same time purporting to be the art of the real. The studio portraitists of the twentieth century continued to use photography in this way, refining the process to such an extent that by the late twenties workers like Dorothy Wilding were remodelling traditional concepts of elegance and beauty, presenting women through a medium which represented reality but which was also open to intricate and subtle manipulation. Studio portraiture, however, not only gave its practitioners the means to present fashionable concepts of beauty, and most particularly of women's beauty, but it also opened avenues of self-sufficiency and independence which were to be of enormous importance to women who wished to be free of financial dependence upon their families. As long as the public wanted photographic portraits, the opportunities for studio workers remained numerous, and demand was not confined to metropolitan sensibilities. Studios flourished in provincial towns throughout Britain – as they continue to do today; they required

1 Anna Atkins, *Festuca ovina* cyanotype, 1854 *Victoria and Albert Museum*

only a little capital for their establishment and relied on the swift expansion of business to finance future growth.

Until the introduction of the Kodak camera in the late 1880s, photography remained largely inaccessible to people who did not wish to involve themselves actively in its practice – to get a photograph one had to visit a photographer. But as the use of cameras became more and more widespread as the century neared its close, studio portraiture became more exclusive, and distinct styles began to develop from photographer to photographer. Looking at a selection of nineteenth-century daguerreotypes, their sameness of style and presentation is clear; the mere acquisition of a photographic likeness was enough to attract the paying customer to the studio. By 1910, photographers were having to evolve distinct personae to maintain business, and within studio portraiture well-defined specialisations had begun to emerge. By the early twenties, men and women were visiting the photographer not to receive a mirror image of themselves – the novelty of this had long since worn off – but rather to involve

13

themselves in a collusive fantasy. While daguerreotypists like Wigley and Smith had used the newness of the technical processes to bring customers to the studio, later practitioners like Lallie Charles, Dorothy Wilding and Madame Yevonde took care to underplay the technicalities of their work. Photography, its original inventions long discarded, had to re-create its mystique. While continental modernism undoubtedly influenced those women working with photographic portraiture from the twenties onwards, one can usefully look back to the origins of British photography to observe the impetus towards experimentalism, born of a need to survive in a commercial sphere as well as of a wish to explore the boundaries of the medium.

Photography took another leap forward when Blanquart-Evrard introduced albumen paper in 1850. (This paper, coated with eggwhite before sensitisation with silver salts, gave a smoother surface and finer detail than the calotype and salted papers used previously.)[6] For those mid-century photographers who moved into the medium as amateurs, the albumen print was infinitely more attractive than its predecessors, and it was during the 1850s that a significant group of women began to practise photography. These women were aristocrats, aware of photography's newness and hence its relative exclusivity, and conscious of its potential as a means of recording family life and everyday events. This aristocratic photography marked the beginning of British women's move towards a highly directed domestic photography, later continued in women's snapshot photography.

Lady Fanny Jocelyn was one of the many aristocratic women who used photography to record family life. The granddaughter of the First Viscount Melbourne, stepdaughter of Lord Palmerston and wife of the Seventh Earl of Shaftesbury, Anthony Ashley, she made most of her photographs at Broadlands, the home of Lord Palmerston. Her work concentrated on the portrayal of the three families with whom she was intimately connected, the Ashleys, the Cowpers and the Jocelyns. Like many of her contemporaries, Lady Jocelyn made photographs with the express intent of arranging them in an album, a use of photography which became increasingly important as the century progressed. This use of photography, to assert and describe the family, was adopted and adapted by significant women workers in the next century, notably the painter Vanessa Bell and the photographer of royalty, Lisa Sheridan. Such portraiture also established women within the sphere of educated amateurism, with many upper-class women joining the new photographic societies from the 1850s onwards.

Another aristocratic woman who used photography in the 1850s to delineate a family history was Lady Harriette St Claire, whose principal subjects were the Ellice, Balfour and St Claire families. Both Harriette St Claire and Fanny Jocelyn portrayed the aristocracy as stalwart protectors of home and countryside, grouping and re-grouping, acutely aware of their sense of place in a society under

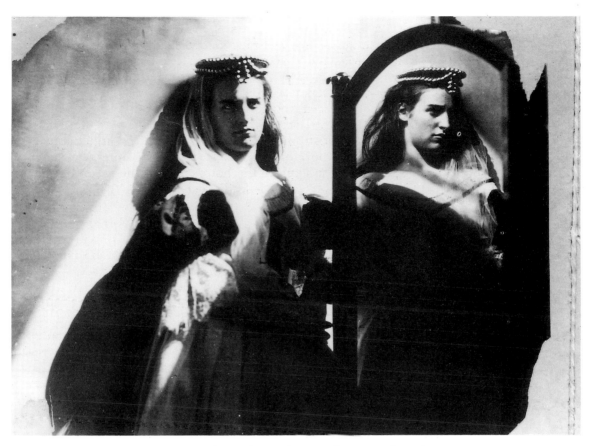

pressure as Britain moved into the industrial age. Photography gave these women the opportunity both to identify a personal history of their own families and to place those families precisely within a certain schema. A family, once photographed, assumes a particular reality, fixed in time by its portrayer, solid against a portico or a stone balustrade, its class and its preoccupations firmly established.

For virtually the first time, the aristocracy and gentry could begin to construct their own histories, abandoning their reliance upon painters. From that time on, they have been seen, through photography, exactly as they have wished to be seen, exactly as social, economic and political circumstances have suggested that a particular image suits a particular time. One of the notable absences of British portrait photography throughout its history is that it has so rarely attempted to challenge society's norms. Portrait photography has always been manipulated by the power and influence of the status quo. From its very beginnings, it has been used to produce a favourable impression of upper-class lifestyles.

The women photographers of the 1850s constructed an image of themselves so real that it represented truth – it convinced a class that

2 Lady Clementina Hawarden, untitled photograph, 1850s
Victoria and Albert Museum

3 Julia Margaret
Cameron, 'Mary Hillier
as St Agnes', *c.* 1869
*Victoria and Albert
Museum*

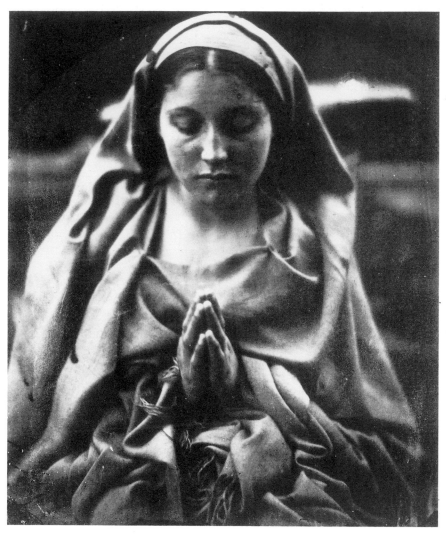

its preconceptions about itself were valid. Working during the early
1930s, Barbara Ker-Seymer portrayed younger members of the
aristocracy as extravagant and brittle, but after the Second World
War austerity and the rise of socialism required that the society
portraitist Betty Swaebe pictured the wealthy upper classes as discreet
and staid.

Within the framework of a photographic tradition largely formed
by prevailing social mores, a distinct line of innovators began to
emerge during the 1850s. One woman who departed from the usual
themes of aristocratic picture-making was Lady Clementina Hawarden
(1822–65). While other titled women had sought primarily to chron-
icle, Lady Hawarden explored the medium with acute perception.
Rather than seeking to convey solidity and unity, she made significant
experiments with posing and with surface, creating a picture of a

secret world of echoing interiors, mysterious draped windows and dramatic figures (plate no. **2**). Hawarden explored surface and texture and the use of light in the way that later twenties innovators like Helen Muspratt were also to do. Many of her photographs prefigure the romanticism which appeared so strongly in the pictures created by Cecil Beaton and Peter Rose Pulham during the twenties and thirties. European modernism played a significant part in leading young photographers working in Britain into experimentalism, but the effects of early British work are just as significant. Hawarden's employment of mirrors as a major device within her photographs, and her inventive use of fabric backgrounds, connects with many important later photographers, including Ker-Seymer and Muspratt. Hawarden also exhibited her photographs at exhibitions organised by the Photographic Society, establishing women as competitors for accolades and public praise early in the history of the medium.

Another woman who influenced later photographers was the portraitist Julia Margaret Cameron (1815–79). From her rudimentary studio on the Isle of Wight, she created a completely new way of looking at her sitters. While earlier women had seen their subjects as an integral part of their surroundings, inextricably linked with the artefacts of their class, Cameron displaced them, making village girls into characters of Arthurian legend, picturing her servants as holy virgins, sanctifying or making heroes of women who, in Fanny Jocelyn's or Harriette St Claire's photographs, would have been indistinct figures, hovering behind the main family group or lurking unseen beneath stairs. Cameron's most frequently used model, Mary Hillier, appears as an Arthurian queen, a Madonna, St Agnes (plate no. **3**), and an angel, presenting views constructed around some of the central theories of womanhood. Her photographs are brutal and resonant with pain; her use of intense close-up precluded inclusion of landscape or domestic features. Cameron's portraiture was to prove immensely important to women photographers working in the next century, not least because she proved how effectively they could work outside commercial or domestic practice. Her great-niece, Vanessa Bell, produced a snapshot chronicle of life at Charleston which repeated many of Cameron's picturing devices, and she too made significant experiments with dramatic close-up photography in her photographs of Duncan Grant and her sons, Quentin and Julian Bell. Another major worker, Madame Yevonde, in her colour portrait series, *Goddesses and Others*, made during the late 1930s, referred again to some of the central myths of a past culture, displacing society women and introducing them as Medusa, Hecate and Minerva.

Side by side with the practice of photography, many British women from the 1850s onwards were attracted to the making of photo-albums. Some of these albums existed primarily as a means of displaying the women's own work; others were constructions of

family photographs, drawings and *carte de visite* studies made by commercial studio photographers. One such album belonged to Margaret Bembridge, and combines photographs of members of her family with those of eminent Victorians. The production of these early, personal presentations anticipated the popularity of the family album, continuous throughout the next century. The use of collage in these albums, their combination of photographs and drawings, indicated many later developments. Most importantly, they introduced whimsy into photographic productions. So important an element of twentieth-century British culture, particularly within the visual arts, this whimsical reordering and rescaling paved the way for the later British surrealists, who relied heavily on manipulative methods.

Both photography and the making of albums were practised by women of the Royal Family; Queen Victoria and her daughters all shared a keen interest in the medium, and Alexandra, Princess of Wales, emerged as a practitioner of some importance. Her attendance as a student of photography at the London Stereoscopic School made it fashionable and acceptable for young women to enter formal photographic study, paving the way for a large influx of women between 1900 and the mid-1930s. Alexandra also played some part in the popularising of the Kodak camera. If the Princess of Wales was prepared to use a simple camera, and to send her photographs to Kodak to be developed (albeit by a special Royal section of the Harrow factory), then snapshotting was obviously a respectable and dignified occupation for women. She photographed a family holiday in Scotland and a Norwegian cruise in 1893; she also took the camera outside the family, making documentary studies of the people who gathered on the roadside to watch her on ceremonial occasions. Such a practice was part of an emerging tradition of candid street photography which was to inform so much documentary work during the 1930s.

While many nineteenth-century non-commercial women photographers looked towards their families for the crucial elements of their picture-making, some were beginning to perceive photographic opportunities outside the domestic sphere and to move into documentary and reportage which depended for its subject matter on the exploration of occupations and lifestyles which lay outside the particular social class of the photographer. This move was vitally important in preventing women's work from being too intensely self-reflective of class and family. During the 1890s, for example, Louise Warenne, an Englishwoman living in Ireland, compiled an album of photographs of life in rural County Cork. It contains not only the customary photographs of friends and relations, but also studies of working women seen within the context of their everyday lives. From such small beginnings there developed a documentary method which was to give rise to some of the most significant areas of women's photographic work during the next century. Social

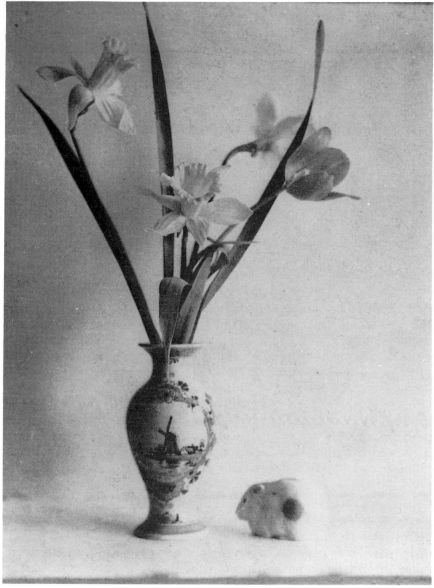

4 Agnes Warburg, 'My First Colour Print', 1908 *Royal Photographic Society*

documentary photography was not a movement which women had deliberately to break into during the next century; by 1890, their place within it was already established. As photoreporters, certainly, women did not emerge with strength until the late 1930s; but as social documentarists they were active from the beginning of the century, with workers like Norah Smyth emerging in 1913 to document the lives of working-class women in London's East End, and Elsie Knocker and Mairi Chisholm taking their cameras to the trenches during the First World War.

As photography became a medium increasingly accessible to all,

the educated amateurs of the Photographic Society struggled to retain their exclusivity. The pictorialists, who emerged as a group in the first years of the new century, sought to re-mystify photography not only by the use of complicated compositional constructions, but also by the development of ornate and elaborate printing processes. If snapshot photography had taken photography beyond painting, then pictorialism attempted to take it back, at the same time resisting modernist moves from Europe. Women photographers played an important part in this new move within photography, and women's pictorial photography continued throughout the inter-war years, altering little as other areas of photography responded to social and aesthetic pressures. Writing in 1926, the photographic critic F. C. Tilney remarked:

> Of hobbies that are a direct means of culture amateur photography is almost the only one left. It brings its devotee face to face with Nature for a study of her moods, to apprehend her Majesty and rejoice in her smiles. It sends him out of doors, not to pursue his ends in a restricted spot, but to go far afield on a perennial Wanderjahr, accumulating those experiences of observation which broaden and enrich the mind.[7]

Photography as a hobby rather than as an occupation was attractive to the new middle classes of Britain, who had time to spare and money to spend. Their political instincts were conservative, they wished to extol the beauties of house and home, yet they lacked the rolling acres and country houses which had provided the pictorial material for their nineteenth-century predecessors. Pictorialism, with its emphasis on beauty and its use of subjects from nature, provided a link with the Victorian aristocracy which was particularly satisfying for the socially aware middle classes. It was also complicated and expensive enough to make it out of the reach of the working-class photographer with a simple Kodak.

Amateurs who adopted the pictorialist stance domesticated and miniaturised nature, and brought it within the confines of the suburban garden or the afternoon walk. Just as the snapshot photographer was democratising photography, so the pictorialists made their own claim on the British landscape and the exotica of foreign parts. One of the leading pictorialists of the early twentieth century was Agnes Warburg (1872–1953). A founding member of the Royal Photographic Society's Pictorial Group, established in 1920, Warburg was an early experimentalist in the Raydex and autochrome processes, the latter a form of screen-plate colour photography invented by Auguste and Louis Lumière in 1903.[8] 'My First Colour Print' (plate no. **4**), made in 1908, depicts nature as the pictorialists most wished to see it, tamed and dignified, much as Warburg's aristocratic forebears had perceived it. The picture shows daffodils and tulips in an ornate vase, nature rearranged and refashioned through the photographer's direction. Whereas the titled amateurs of some fifty years earlier had seen nature contained and reordered on a large

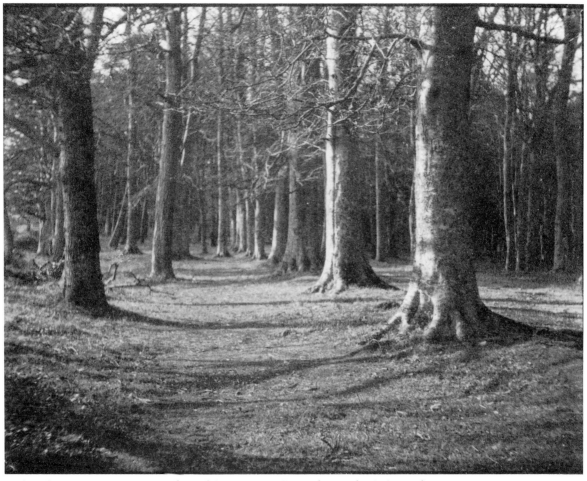

5 Agnes Warburg, 'Winter Woods', 1901
Royal Photographic Society

scale, the new amateurs reduced its proportions, brought it into the drawing room and made it their own. In another photograph, 'A Lady and Two Men in a Garden' (1929), Warburg pictures three people standing behind an ornamental flowerbed. The size of the people dwarfs the bed and presses home the point that the arrangement of the plants was ordered by the human hand and is not the product of some natural wilderness. The motif recurs throughout Warburg's work. Her 'Mayfield Roofs from the Middle House Garden' (1933) shows a group of homes foregrounded by a plot of land under cultivation, so that the symmetry of the buildings is matched by the order of the rows of plants. In 'Well in a Spanish Garden, Aleciras' (1937), she centres her photograph around a garden artefact, and in 'The Dreaming God' (1935) she concentrates on outdoor statuary. Most of the plants and trees in Warburg's photographs are controlled by gardeners, or are towered over by constructions of some kind, and nearly every natural feature which she portrays bears some mark of human intervention: when she photographs the sea, there is often

a boat dominating the picture; a river is traversed by a stone bridge; a view across hills is bisected by an iron fence. Warburg photographed wherever she travelled, both within Britain and abroad: in Sweden, France, Spain and Madeira in the twenties; in Africa and Yugoslavia in the thirties. Her perceptions of each country were the same: untroubled by exotica, her gardenscapes and still lifes symbolised the domestic – and it comes as no surprise to discover that Agnes Warburg retired to Box Hill, that most benign of wild landscapes.

Another woman who took her camera into the garden was Kate Smith. Smith's photographs, produced from 1912 until the early thirties, emphasise the sylvan. They portray young women either nude or clothed in diaphanous garments. For Smith, nature was beauty, a place in which young women wandered endlessly, listening to birdsong, smelling flowers, dabbling in a pond. For her, nature existed, through photography, as complementary (and complimentary) to the romance of women's bodies. Just as Warburg had brought flowers into the house and placed them in vases to stress human control over nature, Smith domesticated it by a series of poetic tableaux. The titles of her photographs 'The Dewdrop in the Sunbeam', 'Alas! Poor Dryad', 'Pixy and Fairy Tables', 'The Listener' and 'Some Secrets May the Poets Tell' capture precisely the timbre of her work. Writing about Kate Smith's work in the 1926 edition of *Masterpieces of Photography*, published by the Royal Photographic Society, F. C. Tilney remarked:

> Miss Smith is a true amateur in that she makes charming pictures of her own friends. Her models have been literally brought up in the way they should go pictorially, and are set invariably in some pretty corner of wild nature where a diaphanously draped figure can appear without the accompaniment of any incongruous object. The nymph or sylph or hamdryad is usually occupied with the gentler aspects and objects of nature. Miss Smith spares us all Ovidian horrors. It is contemplation of a flower, of some insect in air or water, the inhaling of a fragrance, or the listening of a song bird. I do not know Miss Smith's method of teaching little birds to pose. Perhaps the taxidermist lends a hand.[9]

Even Tilney seemed struck by Kate Smith's continual repetition of the same themes: 'It is something to strike so charming a line of picture-making by the camera and for so many years to maintain interest and freshness in so limited a scope, but Miss Smith does it.'[10]

Such an interest in 'Nature and her moods' remained present in women's pictorial photography until the Second World War; Rose Simmonds's land and seascapes portray trees bent in the force of a gale, sand formed into a pattern by the sea and the swirling progression of a wave. Produced in the late thirties, Simmonds's photographs seek to convey wildness but actually succeed in miniaturising natural forces.

One woman photographer who was heavily influenced by the pictorialists of the twenties was the landscapist Mrs K. M. Parsons.

6 Kate Smith, 'Earth's Bounty', *c.* 1925
Royal Photographic Society

Mrs Parsons concentrated initially on needlework, 'always working from my own designs, for I considered pattern of the highest importance, and an original result well worth the trouble and time involved'.[11] Her urge towards patterning, her instinct for the decorative, extended into her photography. Her first moves towards landscape work were made after a visit to Norway, where she observed a landscape dramatic and suggestive enough to appeal to any pictorialist. Mrs Parsons's descriptions of her work echo the concerns which earlier women like Warburg and Smith had pursued:

> My whole idea was to picture lovely boughs, clad in leaf or in flower, showing their exquisite shapes against a deep blue sky. And, indeed, this carried me a great way along the path towards beauty of expression, but not far enough. In time I began to feel the 'Good Earth' calling me, and my love of landscape was born.[12]

Mrs Parsons had no qualms about altering nature to suit her decorative purposes, and by the most direct means:

> When setting out landscape hunting, I slip into my bag a small pair of clippers or a pair of scissors. These are invaluable for cutting any blades of grass that come too near the camera, causing out-of-focus blurs so difficult to eradicate by after-work on the print, or small branches on a nearby tree, undesirable for the same reason. Done carefully, this wild gardening is never apparent to anyone else, and by

> this means I often find that I can use a larger stop, so helping my recession and sending my clouds to their proper distance.[13]

At first a studio worker, Mrs Parsons opened a business in Amsterdam, but finding this unsatisfactory and unprofitable, eventually moved into book illustration, contributing photographs of animals to *Zoo Magazine*, and providing all the illustrations for *Photographing Children*. Unlike most of her fellow pictorialists, Mrs Parsons was acutely aware of and sensitive to documentary moves, and during the 1930s she worked for *Illustrated*, the first of the new-style picture magazines. This interest in documentary photography in turn extended to film, and during the forties she produced many, working at one time for the Ministry of Information. Her work took her to 'factories, coal-mines, operating theatres and pubs'.[14] A worker of great interest, Parsons was one of the few to move in and and out of the highly styled forms of pictorial photography.

That the face of photography changed after 1900 is undeniable. While drawing and painting had been leisure pursuits of the upper and middle classes, photography's potential cut across strict class boundaries. Photographic education became increasingly available to women and, as the century progressed, ever larger numbers of women took advantage of opportunities offered at trade schools and private colleges. Social change presented openings in photography that did not exist during the nineteenth century. Many women took their cameras with them when they travelled abroad to become war workers, and the intensity of this new experience resulted in photographs which firmly established women as social documentarists. The Suffragettes, with their acute consciousness of the effectiveness of dramatic publicity, produced postcards and badges illustrated by photographs made by studio portraitists who supported the cause. For the first time, women controlled and directed their own image in the cause of politics. Like the documentarist Norah Smyth, other militant women recognised the monumental nature of their effort and were aware of their ability to achieve their chosen ends; anxious to record their progress, they used the simple tool of photography.

Photography's historians have not reflected in any significant way the role of women as image-makers. Women's careers as photographers were frequently short, often interrupted by marriage and by child-bearing, and historians have tended to concentrate on photographers whose careers reached full maturity. From 1900 women began to use photography for a multitude of different reasons, to earn a living, to promote a cause, to record a significant moment, absorbing new influences, yet retaining a link with their Victorian past. Photography was, and remains, a means of com-munication and an art form exceptionally accessible and useful for women. More than any other tool of expression, the camera moved women into the public arena of the applied arts; versatile, portable and infinitely adaptable, its use proliferated.

■ CHAPTER TWO

NO COCKNEYS IN THE EAST END: WOMEN DOCUMENTARY PHOTOGRAPHERS 1900-1918

Of the women who were active as the makers of documentary photographs from the beginning of the century, only Christina Broom, who began work both as a press photographer and as a recorder of urban topography as early as 1902, could be called a 'professional' photographer. Her contemporaries, by contrast, most often used documentary photography because it reflected other interests and was a useful tool. Alice Dryden, collaborating with the craft historian Margaret Jourdain, provided the illustrations for *Memorials of Old Northamptonshire* 'driving herself and her camera around the country in a dogcart'.[1] In 1904, the garden designer Gertrude Jekyll published *Old West Surrey*, using her photographs of 'old Surrey buildings and landmarks, villagers at work or rest outside their unrestored (but all the more photogenic) cottages, and the tools and utensils of their daily lives'.[2] She also selected from her own photographic record of her garden to illustrate much of her earlier and subsequent writing on garden design.

By 1914, then, a tradition had been established of women using documentary photography in ways which suited their different and specific purposes and according to predilection and circumstance. Neither Broom, Dryden nor Jekyll adopted the late nineteenth- and early twentieth-century use of candid photography as exemplified in the discreet, detached observation of photographers like Frank Meadow Sutcliffe and Paul Martin. Both Sutcliffe and Martin had pictured the world as full of vitality, as a kaleidoscopic spectacle of trades and crafts and distinguishing costume – 'fishermen mending nets, workmen digging up the roads (strangely wearing tall bowler hats and suits like those of office workers), tinkers and old market women in high-styled Victorian bonnets'.[3] The style which they evolved affected the production of British documentary photography enormously, and reverberated through to *Picture Post* and beyond. For many of those who later took up photojournalism – a hybrid of press, candid and documentary photography – the stance became obligatory, particularly for war photographers working from the late thirties onwards. It indicated not only a kind of political detachment, allowing photographers to see themselves as reporters rather than participants, but also a peculiar machismo.

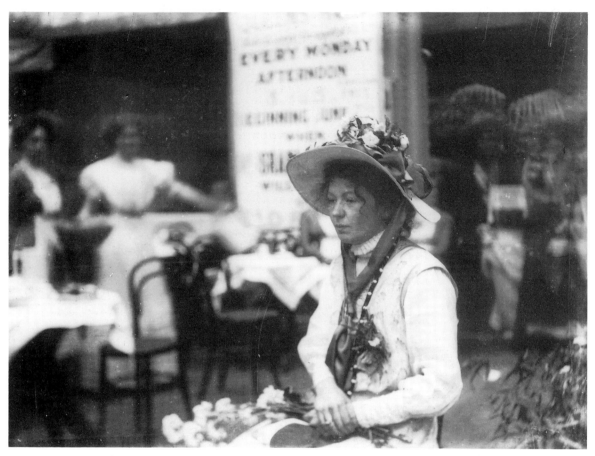

7 Christina Broom,
Christabel Pankhurst
at the International
Suffragette Fair,
Chelsea, 1912
Museum of London

Women's documentary work between 1900 and the late 1940s, when some women were finally absorbed into a firmly established photojournalistic tradition, was fragmentary, built up not so much by women working within established or developing modes of photography, but by women using photography for diverse and often very personal reasons. Until the end of the First World War, this was manifest in an extremely particular and direct way: method and product were geared to an understanding of the situations in which the individual found herself. Women documentarists usually set out to record rather than to captivate, and the avoidance of the dramatic and the candid was a primary influence upon each of them.

Christina Broom (1863–1939) practised photography from the early 1900s until her death. Her earliest work appears as a collection of topographical studies of London made in 1903, many of which seem to have been used as view postcards. These studies show a deserted city, its wide vistas broken only by the occasional passer-by or horse-drawn vehicle. Mrs Broom's was a dignified, static photography which dealt with grandeur and status, with organised pageantry and celebration, and with an England which presented

26

itself as an ordered and stratified society. Her self-styling as a 'Press Photographer' misleads when considered in contemporary terms, for although she photographed important events and personalities throughout her career, she was essentially a recordist who eschewed the primary task of press photography, which is to dramatise and bring the news to vivid life. This quality, together with the seeming lack of viewpoint or political centre in her photographs, has made Christina Broom something of an oddity within photographic history and has often deprived her of the serious consideration she deserves. Her photographs cover an enormous range of subjects, from Suffragette marches (plate nos. **7** and **8**) to a detailed record of thirty years of Oxford and Cambridge boat race crews, studies of Shackleton aboard *Nimrod*, Santos Dumont flying his first motor dirigible at Hurlingham Club, the First Women Police and Nurse Cavell's funeral. In particular, they concentrate on the portrayal of an imperialist England, whose focal points are the monarchy and the military. It is perhaps her emphasis on these power élites which has made her photography so difficult to assimilate into prevailing theories of documentary photography, built as they are around concepts of documentary as an exploration of areas of social concern or as an

8 Christina Broom, Suffragette procession, London, 1909
Museum of London

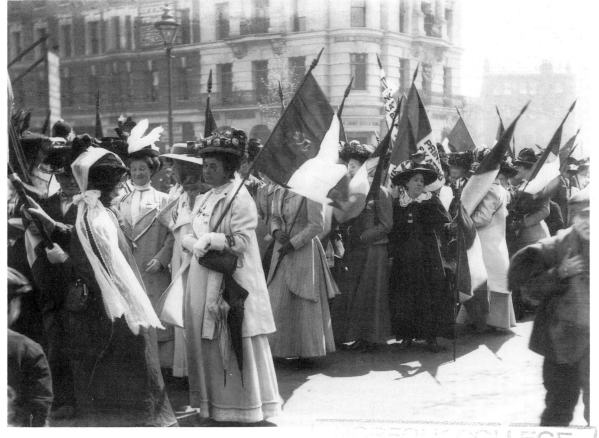

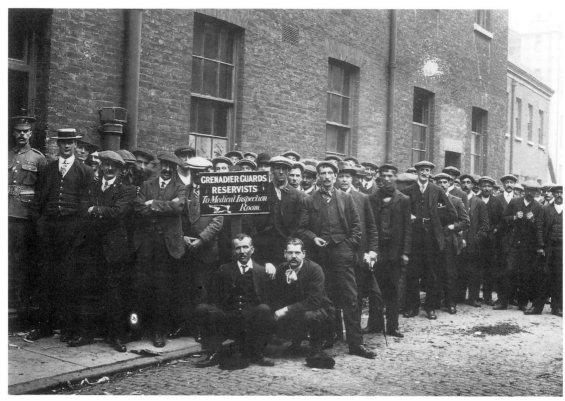

9 Christina Broom,
Reservists re-enlisting
in the Grenadier Guards,
Wellington Barracks,
5 August 1914
Imperial War Museum

instrument of public education.

Though far removed from the humanism of Norah Smyth, the structure and intent of her photographs have just as much relevance for the reconstruction of an English social history. Where Smyth dealt with issues which fitted very much into the vocabulary of English documentary – poverty, the exploitation of labour, the insufficiency of pre-Welfare State educational and social provisions – and attempted through her photographs to portray some of the work of radical groups such as the East London Federation of Suffragettes, Broom concentrated on the portrayal of the absorption of British and colonial people by militaristic or quasi-militaristic systems and groupings. A photograph taken in August 1914 of Reservists re-enlisting in the Grenadier Guards at Wellington Barracks (plate no. **9**) shows a crowd of working-class men waiting to receive medical inspection. The picture is a powerful one, not because of its vitality, but because of its very lack of it. The men are without animation: some are smiling and making an effort to pose for the camera, but the majority just stare bleakly, and on the far left of the photograph stands a soldier in charge of the queue, completely expressionless. It is as if the men, even at this early stage in recruitment, before they are uniformed, have already begun to disappear into the melting-pot of service anonymity. Such photographs are

28

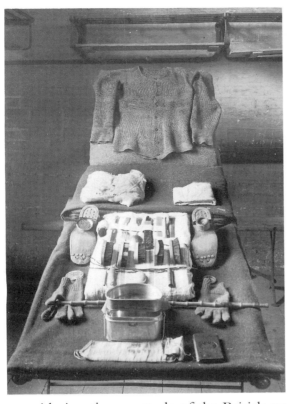

10 Christina Broom, Kit of an Irish Guardsman laid out for inspection, *c.* 1914
Imperial War Museum

important in considering the use made of the British working class by First World War politicians and military leaders.

Another of her photographs from 1917 is of the Scots Guards on parade in gas masks at Wellington Barracks. While the earlier study shows working people in transition, this depicts men completely depersonalised, masked, uniformed, identical in stance, dressed, directed and controlled by the military. Even more intriguing is a still life made by Broom of the kit of an Irish Guardsman laid out for inspection (plate no. **10**). The obsessive ordering of clothing and toiletries has always signified the extreme emphasis on orderliness in service life, and this photograph illustrates exactly the minute detail of arranging a soldier's kit – even to the extent of the ends of a cane being laid beneath each thumb of a pair of gloves and the exact positioning of a pair of boots, one on each side of a set of toiletries. The photograph has an uncanny sense of presence; it is laconic, yet, set squarely in the middle of the frame, allowing no intrusions, human or otherwise, it exudes documentary power, standing as a pure record of how things were at a precise moment. There are no archival indications about the intended use of the photograph, although it was probably destined for some internal record, to stand as an emblem of the nature of service life.

For all its concern with a patriarchal society, Christina Broom's

11 Christina Broom,
Members of the First
Women Police at the
British Women's Work
Exhibition, Princes
Skating Rink,
Knightsbridge, 1916
Imperial War Museum

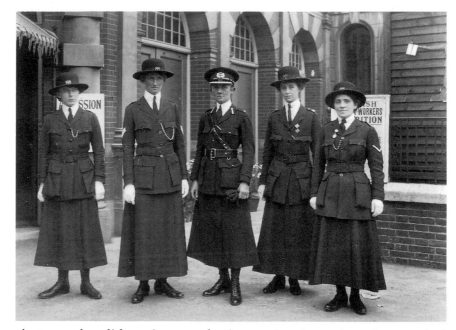

photography did at times make interesting incursions into topical
women's issues. Like many of her photographic contemporaries,
Mrs Broom witnessed women going into uniform, and she brought
to bear on her groups of uniformed women the same kind of
orderliness which she had employed in her studies of uniformed
servicemen and the artefacts of service life. In her May 1916 photograph
of five members of the First Women Police, posed outside the British
Women's Work Exhibition at Knightsbridge (plate no. **11**), she
portrays each of the women standing in the same position, hands and
feet identically arranged, neither smiling nor frowning, their faces
like masks against the photographer's gaze. Christina Broom was
not a photographer who would make demands of her portrait
subjects, yet for all her apparent emphasis on record-making a
statement does emerge. These five women look decidedly bizarre in
their ill-put-together uniforms. Apart from the more accurately
tailored coat and skirt of Miss Mary Allen, the senior officer, none of
the uniforms seems quite to fit its wearer; the high round shirt collars
make the women's necks seem disproportionately long, and the
wide-brimmed bowlers perch on top of their heads like coconuts on
a shy. A photograph which at first appears to be about order and
military smartness begins to assume a distinct absurdity. The posing
of the five women allows for no animation to dispel or redeem that
absurdity, and there is no idea of function or usefulness, only of the
bland wearing of uniform. Other photographers of this period who
dealt with women in uniform, notably the studio portraitist Olive
Edis, who accompanied the Queen Mary Auxiliary Ambulance
Corps (QMAAC) and the Voluntary Aid Detachments (VADs) to

France during the First World War, were far more preoccupied with the work which women in uniform undertook or in tracing the day-to-day routines of their service lives, and in Edis's portraits uniforms appear much more as working clothes than as ceremonial costumes.

While Christina Broom's documentary work does not indicate the stylistic beginnings of the type of women's documentary photography which began to emerge in Britain during the First World War and became increasingly directed during the thirties and forties, the work of Olive Edis does. As the only woman photographer commissioned either by official sources or by the press to make documentaries of the war,[4] she brought to her assignments both a high degree of technical stylistic awareness, doubtless acquired during her training as a successful studio worker, and an acute perception of the use of documentary. Looking through her deep-toned photographs, mounted in albums at the Imperial War Museum, one is struck by the depth of the record she made, and by her ability to vary her photography from the precisely arranged portraits of the interiors of the women's living and rest quarters to the more informal pictures of women working in hospitals, in clothing depots and as ambulance drivers.

By 1916, over eight thousand British women VADs were serving as auxiliary nurses in military hospitals.[5] They received little or no payment for their work, which also included cooking, clerical work, dispensing and storekeeping,[6] so members had usually to be able to fund themselves. Drawn as they were from a sector of society whose young women had no real previous knowledge of work, the existence of Edis's record is all the more important. Where Broom photographed the much more familiar absorption of working class men into the armed services, Edis was photographing something new, not only to her in terms of photographic practice, but also to the women who were her subjects. Their excitement and energy emerges clearly in the many portraits which Edis produced. Many of her photographs are more successful than Broom's simply because she pictured people at work, occupied with a round of tasks which were obviously of great importance to the success of the war effort. But her war workers have a grace and presence which speaks of their confidence as skilled and informed women. Even Edis's grouped portraits, frequently taken during the women's rest time in their common rooms, have a kind of balletic construction which makes the background and the figures posed against it seem unified and purposeful.

Edis's study of the interior of the YMCA Hut at No. 3 Camp at Abbeville (plate no. **12**) reflects her concern with the patterns created by the minutiae of the workers' everyday lives. By posing her group sitting or standing up, facing the camera or with their backs to it, Edis displaces and at the same time portrays the importance of uniform. By insisting, through her photograph, that the interior of the hut was a personalised, homely setting rather than a temporary foreign refuge, Edis saw the women as attempting to assert certain

12 Olive Edis, Interior
of YMCA Hut at No.3
QMAAC Camp at
Abbeville, *c.* 1915
Imperial War Museum

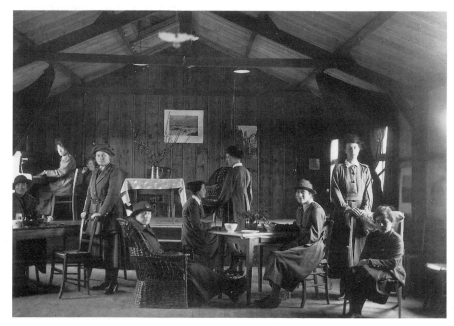

values – of home, of womanliness and of independence – which Broom's photographs clearly refute. Edis's photographs, like the portraits produced by the women who portrayed the leading figures of the Suffragette movement, the WSPU, owe something to hero worship; the women who emerge from her photographs retain and create a particular glamour.

The central theme of Edis's work during the First World War is her creation of a documentary of busy and accomplished women. Although operating in a war zone, the women whom she portrays seem to function forever in an organised, unflurried context, servicing, maintaining, tending a private sphere quite separate from the actual theatre of war. Edis's photography does of course intend and foster this; her control of light and shade invests interiors with a luminosity which sometimes serves almost to sanctify the participants in her photographs. By creating so many images of women working calmly and quietly, and by placing her emphasis on the women's corps as a smoothly operating support service, Edis made a documentary about women's participation in the man's business of war which has many and complicated resonances. Anything but mere record-making, her photographs act as an affirmation not so much of war itself, but of her faith in British women to serve the national effort. Her ambulance drivers are cheerful and active (plate no. **13**), her office workers serene, her workshop organisers benevolent. Unlike most of the women who recorded women's war work, Olive Edis was already a skilled studio photographer. In her wartime documentary, she brought together this skill and her own feminism to create a powerful document of women in the services.

Among the number of women working in nursing services during the First World War who recorded their experiences in diaries and in photographs were Elsie Knocker and Mairi Chisholm, who became known as the 'Women of Pervyse'. They were members of Dr Hector Munroe's flying ambulance corps, formed in 1914 to assist the Belgian Army, and that year were instrumental in establishing a first-aid post in the ruined village of Pervyse, just behind the trenches. For the next three years the two women cared for casualties, showing enormous courage as they moved their post from building to building as the bombs destroyed one house after another. Both women were badly gassed in 1918 and had eventually to abandon their nursing work.

Elsie Knocker and Mairi Chisholm, who was only eighteen when she began her war work, were two of the most important document-arists of the First World War. They photographed everything which came under their gaze during their time as nursing workers in Belgium, and the range of their picture-making is considerable. Within their photography, they emerge as central characters; like participants in a play, they appear frequently, photographed by each other against the setting of the ruined architecture of much-attacked Pervyse, outside the door of their first-aid post (plate no. **14**), standing with Belgian soldiers beside flooded trenches,[7] next to a shell-hole in 1914,[8] in ambulances, in dugouts, standing on roofs trying to spot wounded soldiers through binoculars,[9] even recording the details of the interior of their bedroom.

Olive Edis and Christina Broom sought to identify the character-istics and lives of others in their documentary; they operated as professional, assigned photographers. Knocker and Chisholm, by

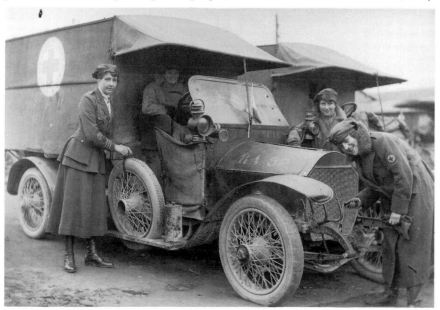

13 Olive Edis, VAD ambulance drivers cleaning cars, Etaples, *c.* 1915
Imperial War Museum

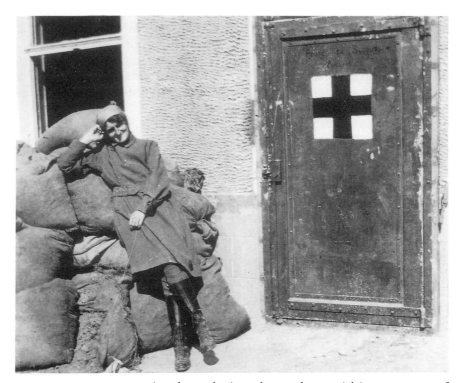

14 Mairi Chisholm,
Elsie Knocker outside
the third Poste de
Secours, Pervyse, 1915
Imperial War Museum

contrast, were committed to placing themselves within an arena of activity. The difference between the two methods is important, for while other women in the 1930s and forties continued, through ever-refining methods of photojournalistic documentary, to picture 'the world outside', self-picturing documentary was very much a phenomenon of this early period, deriving much from Victorian methods and perceptions. Knocker and Chisholm were surrounded, in Pervyse, by the bizarre architecture of bombardment. Throughout their collection of photographs, ruined and desolate buildings appear, together with ruined corpses. But there is no attempt at drama. A photograph made in 1914, 'Dead French soldier on the bank of the Yserc at Pervyse',[10] is horrific only in that it is a manifestation of the depredations of war; there is no attempt to compose the photograph to create a focus of attention on the details of death and decay. The picture stands as a simple, almost bland statement of something seen and observed, a part of everyday life. Another even more noteworthy photograph, 'German dead by the Yserc', made in December 1914 (plate no. **15**), appears again as something encountered on an afternoon walk; beside the banks of a quiet stream, a skull grimaces from out of the reeds; nothing disturbs the scene.

Almost all of the women who produced diaries and photographs of the First World War had responded with great enthusiasm to the calls for support for the war effort. Given this, the photographs and writing which they produced are surprisingly lacking in propagandist

intent. Their photographs on the whole have little to do with portraying heroism but much more with recording the rhythm of women's everyday lives and the novelty of their surroundings. It is in this tenor of recording that some of the main differences can be observed between their practice and that of the 1930s and forties, when documentary again assumed a more public face and a more accessible style and began to be absorbed into a corporate, publicly recognised sphere of reporting as exemplified by *Picture Post* magazine.

Our contemporary experience of the procedures of war perhaps makes it difficult to comprehend the peculiarly sociable and eccentric structures and personalities which contributed to the back-up of the allies during the First World War. This almost bohemian atmosphere which existed alongside the squalor and privation of war conditions produced circumstances which many of the volunteer women felt bound to record and to explore in their diaries. Elsie Corbett, the twenty-two-year-old daughter of an English MP, was the privileged child of an upper-class family. She entered Red Cross service in Serbia with such experiences as these behind her:

> When war broke out in 1914, I had had four London Seasons, followed by shooting parties, in England, Scotland and Ireland; and Highland Gatherings with their Games and Balls. I had been presented at Court; and was in the Abbey itself for the Coronation of King George V, a most glorious spectacle. I went to a Court Ball that year, as well as to the Caledonian Ball, and 'stood in' at the Butes' house for rehearsals of the sixteensome reel that was its highlight . . . I had been to a Cambridge May Week and had gazed with awe and reverence at Agneta Frances Ramsay, the first woman to qualify for a First Class Honours Degree, although she was not allowed to take it. When my cousin Lilian came to stay with me in London we had an orgy of theatres, to which we had not been allowed to go until we were grown up. We saw the sunset radiance of Ellen Terry and we adored Gerald du Maurier and the lovely young Phyllis Neilson Terry. And we sat by my open window far into the night, smoking cigarettes that were allowed to me but not to her, and dreaming our so different dreams of the future.[11]

Connected through her mother with the militant suffrage organisations, and interested in nursing since childhood, Elsie Corbett's reminiscences and the photographs which she took in Serbia are a strange combination of post-Victorian travelogue and grouped portraits, with considerable emphasis on portraiture of Serbian peasants and photographs of military action. Looking back from current perspectives, this mixing of album photographs and action pictures does seem bizarre, but it reflects the eerie mingling of customary social attitudes and curiosities with acute danger and adventure. Some of Elsie Corbett's photographs appear to spring directly from the pages of an intrepid lady traveller's album; some have the decorum of garden-party poses, while others, like 'The first wounded of the Great Advance being loaded on to our ambulances'

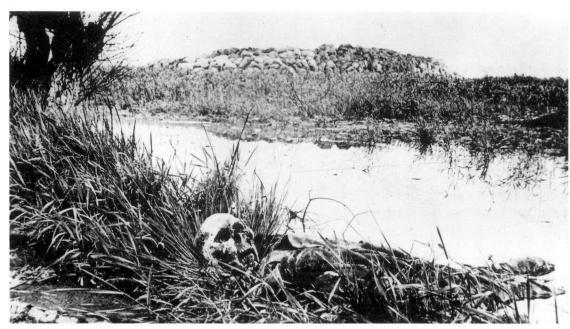

15 Elsie Knocker/Mairi Chisholm, 'German dead by the Yserc', December 1914 *Imperial War Museum*

and 'A rough road on the Advance' indicate the extent to which these early women documentarists recorded the engagements of war. To suggest that the viewpoint of documentarists like Elsie Corbett and the Women of Pervyse was one of innocence or naïvety would be to undermine the impact and direction of their work, and to make dangerous assumptions about photography. However, it is true that these women came to photography free of any substantial connection with current British traditions, and with a sensibility which allowed them to vary their methods according to their perceptions of events. Adaptability was an essential requirement of war, and its manifestations appear in Elsie Corbett's diaries as well as in her photographs. Describing conditions at the first nursing unit at which she was based in Serbia, she writes:

> My sittingroom was quite outstandingly squalid, even by Baraques standards. It was a small anteroom between two wards: I had a deck chair, a table and a small stove, very difficult to keep alight. On the stove was a saucepan in which the surgical instruments were sterilised by day and in which I heated my midnight meal, a revolting mixture of all the scraps left over from the Unit's supper.[12]

In both words and photographs, young women like Elsie Corbett expressed a freshness and confidence in their picture-making which came not only from their lack of exposure to preceding documentary traditions, but also from a recognition that their work stood as a validation of their experiences, as tangible evidence that they, as women of the middle and upper classes, had participated in particular, even cataclysmic, events. Just as a postcard from the seaside or a

picture in a family album stands as evidence of a happening at a particular time, and in a tangible way proves the identity or the status of the sender or the photographer, so these photographs show not so much a wish to communicate with some wider audience the conditions of war or the culture of foreign lands, but rather a substantiation of the fact that they were *there*. Functioning almost like snapshot photography, but with important differences, this wartime record-making was destined for an album rather than for a newspaper or an archive, for personal consumption rather than for public use. As a method in women's photography, it does not appear to have continued after the beginning of the 1920s, making it a strangely isolated strand within British documentary photography during the present century.

Florence Farmborough (1882–1978), who had gone to Russia in 1908 and was teaching English to the daughters of a medical family in Moscow when Germany declared war on Russia, emerges much more clearly as a documentarist who had a strongly developed sense of the dramatic potential of war photography. Like all the women volunteers who participated in war work, she was deeply committed to the defence of the allied nations and, along with the daughters of her employers, trained as a voluntary aid worker and joined the service of the Red Cross. Like the Women of Pervyse, she was an eclectic worker, photographing events, people and places as they

16 Florence Farmborough, 'Body of a soldier in an Austrian dugout', 1916 *Imperial War Museum*

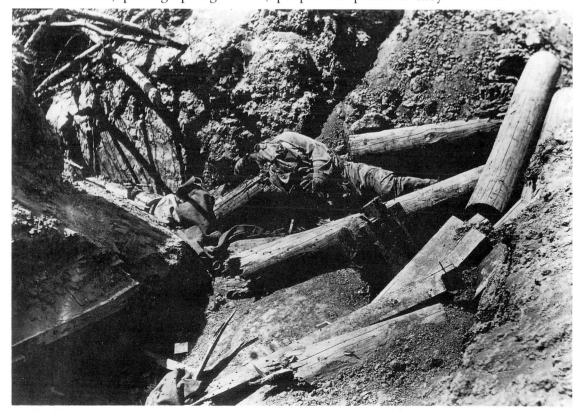

came along rather than structuring her work around particular areas of concern. But, unlike Knocker and Chisholm, she paid little attention to her own role in the documentary, emerging much more as an observer than as a participant. Farmborough's record thus lacks the self-awareness which pervades the work which the Women of Pervyse produced in Belgium, and instead goes more deeply into the concerns of dramatic picturing. Many of Florence Farmborough's photographs are complex and highly directed. Her 'Body of a soldier in an Austrian dugout', dated 1916 (plate no. **16**), is a complicated structure which identifies the crazy diagonals of the bombed-out dugout with the equally bizarre angling of the soldier's body. Another photograph from 1916 concentrates on a complex arrangement of barbed wire stretched between posts, criss-crossing like a child's cat's cradle. Such sophistication clearly reflects Farmborough's intention not merely to record but to transmit her perceptions of the physical landscape of war. Just as her photograph of the dead soldier in an Austrian dugout is placed and made poignant by the juxtaposing of the soldier's body against the broken diagonals of the trench supports, so in this photograph she has worked with the macabre contrast between a plantation of young trees and a plantation of posts supporting barbed wire. This link between the natural and the unnatural shows Farmborough working towards a visual definition of the architecture of war, of the perplexing visual situations created by the building and destroying which conflict engenders.

Farmborough's picture-making was particularly astute when she considered the groupings made by soldiery in transit, and time and again she concentrates on the structure and dynamic of massed men on the move. Again it should be remembered that the situations presented to Farmborough were ones which, before her service in the Red Cross, were entirely foreign to her; like Christina Broom she may well have noted the ceremonial bearing and grouping of troops at home and on dignified parade, but she would have had no experience of photographing men thrown together in progress towards the battle lines. The photographic opportunities which she seized prove her intention of achieving more through photography than the securing of evidence and the validation of experience which can be felt so strongly in the work of other women war documentarists. She can be seen to be progressing beyond this, and through to methods and intentions which make her work seem far more strongly allied to a more modern conception of committed photojournalism. Farmborough is one of the first women documentarists of this period who can be placed as an early representative of dramatic documentary picture-makers. In her 1916 photograph 'Raw recruits on their way to the front, early spring' (plate no. **17**), one can sense the trepidation of the men marching through the snow, still recognisable individuals strangely bound together as a group by their clothing, and by their common direction. And equally strongly can be sensed Farmborough's

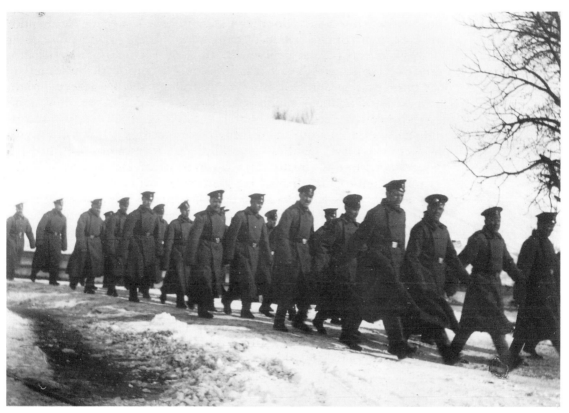

concern, her interest in the war, her understanding of the ambivalent status of the newly recruited men.

If the First World War gave British women an opportunity to escape the confines of a sheltered and constricting style of life, and at the same time prompted many of them to extend and develop an embryonic documentary tradition initiated in the nineteenth century, then the involvement of middle- and upper-class women in the Suffrage cause perhaps served to produce an even greater awareness in the minds of these women that they had become makers of history, and potential chroniclers of that history.

The Suffrage movement produced an enormous volume of documentation – photographs, diaries, pamphlets, reminiscences and collections of contemporary ephemera such as postcards, banners, jewellery and so on. Women had never before documented their history so completely, had never had such a strong conviction that their history, in words, pictures and developing theories, was directed and formed by them. Many historians have placed the 1930s as years in which documentary photography began to be influential in Britain, but its real beginnings and, for women, the period of its greatest freedom and individuality, can be placed during the first twenty years of the century.

17 Florence Farmborough, 'Raw recruits on their way to the front, early spring', 1916
Imperial War Museum

One of the most important visual documentarists to emerge from the Suffragette movement was Norah Smyth, chief co-worker and organiser with Sylvia Pankhurst in London's East End. The daughter of a wealthy Liverpool merchant, Smyth was an influential and directive figure within the East London Federation of Suffragettes (ELFS) between 1914 and 1918, and although she has been eclipsed by the more flamboyant personality of Sylvia Pankhurst, there can be no doubt that the partnership between the two women was one of equals in determination and effort. More specifically, Norah Smyth performed several vital roles within the leadership of the East London Federation: she moved with Sylvia Pankhurst to a house on the Old Ford Road in Bow to establish the initial base for the Federation's activities; she took primary financial responsibility for the Federation's work, and in her memoirs of the 1914–16 period Sylvia Pankhurst comments frequently on Smyth's contribution: 'People in terrible need constantly appealed to us. Often I was constrained to take the food from our table to give to starving people, sometimes the blankets from our beds. Smyth had a board in her room covered with little bits of paper intended to record the repayments of unfortunate people to whom she had lent her money.'[13] After exhibiting a display of toys made at the Federation's factory in the East End at a society gathering in the country house of the Astors, Sylvia Pankhurst reflected:

> I wondered at this huge company gathered here, this great extravagance and display, and thought of the poor little house in Bow, and our own frugal household. Smyth, just then, had decided to spare more of our cash for the movement, and to leave more food for others we must substitute margarine for butter, and maize for wheat flour, and to make other such economies.[14]

From the writings of contemporaries and historians, Norah Smyth emerges as an administrator, a financial bulwark, a militant activist: 'a sturdy woman, who formed a People's Army of Defence and drilled recruits in street fighting tactics'.[15] Perhaps her most significant area of activity, however, was her organisation, sponsorship of and creative contribution to the East London Federation's newspaper the *Women's* (later *Worker's*) *Dreadnought*. Looking back at the *Dreadnought*, it seems to have few connections with our present-day conception of an influential illustrated journal of propaganda, a conception formed mainly by the socially concerned picture magazines which were appearing in Britain by the end of the 1930s. Used partly as a vehicle for Sylvia Pankhurst's political philosophy, and partly as a means of disseminating information about the ELFS's activities, the newspaper appears as a somewhat dull assemblage of text and photographs. Yet the emergence of the *Dreadnought* in the East End is, both for women's politics and for women's documentary-making, of great interest. Like the documentary which was made by women working overseas during the First World War, Smyth's photography, some of

18 Norah Smyth, 'A Home in Bow (mother at work, infant sleeping)', London, 1915
International Institute for Social History, Amsterdam

which appeared in the *Dreadnought*, and much of which did not, was an acute and personal testimony to *being there* when history was being made, and to participating in the making of that history.

The difference between this early twentieth-century documentary photography and that which followed it during the twenties and thirties is substantially one of direction and intention. Although there are similarities between Norah Smyth's photographs of early ventures in childcare for the poor and Edith Tudor Hart's photographs of welfare provisions in the 1930s, the motivations of the two women were radically different. Smyth's intention, and her achievement, was that of a community member, determined to create a detailed record of a movement within which she was a leading protagonist. Some of her photographs were used as a means of communicating with the public; the majority were a documentation of a community of which she was an integral part. Edith Tudor Hart, Gerti Deutsch and other women documentarists of the thirties and forties constructed their work very much more as political or public communicators,

19 Norah Smyth,
Bromley children.
Published in the *Women's
Dreadnought*, 22 August
1914
*International Institute for
Social History, Amsterdam*

aiming for publication and propaganda. Thus this early twentieth-century work has far more in common with women's community photographic projects emerging from the early seventies than it does with the more journalistically inclined products of the thirties, just as documentary photography in the thirties connects more profoundly with the candid observations made by late Victorian and early Edwardian English photographers.

Norah Smyth ceased working directly with Sylvia Pankhurst in 1924, and although it has been said that her time with the ELFS 'stripped her of most of her shares and all of her illusions',[16] she continued to correspond with Sylvia until her death. Smyth's family was based in Florence, and by 1933 she was working as a secretary in the library at the British Institute there.[17] At the outbreak of the Abyssinian conflict, Smyth returned to Britain, and it appears that her involvement with radical causes did not continue. The absence of photographic activity, both before and after the parting with Sylvia Pankhurst, leaves us with a picture of Smyth as a woman for whom photography was essentially a tool, a particularly effective and direct means of recording the radical moves which Pankhurst, Smyth and the other members of the ELFS made in the East End.

She was essentially an 'insider' photographer, uninterested in and disbelieving of the phantasmagoria of London poverty which had so haunted the Victorian imagination, and which had lain behind the work of nineteenth-century writers like Dickens and Morrison, even infiltrating the work of later documentarists like Bill Brandt and Humphrey Spender. Her work contradicts popular thinking about the Edwardian urban poor, around whom had been constructed a powerful drama peopled by characters whose motivations were strong and clear, either towards the good or the bad, and whose actions were always directed by the extremities of their situations. Throughout her photographic record of the East End, Smyth expresses profound disbelief in the pageant of grotesqueries which had so often symbolised East End life and returns to the private, interior lives of families for her documentation.

Writing more than fifty years before Norah Smyth's photographs began to appear in the *Women's Dreadnought*, the novelist George Eliot developed her theory of documentary realism, and her method and conviction prefaces the kind of work which Smyth was to produce in East London:

These fellow-mortals, every one, must be accepted as they are: you can neither straighten their noses, nor brighten their wit, nor rectify their dispositions; and it is these people – amongst whom your life is passed – that it is needful you should tolerate, pity, and love: it is these more or less ugly, stupid, inconsistent people, whose movements of goodness you should be able to admire – for whom you should cherish all possible hopes, all possible patience . . .

It is for this rare, precious quality of truthfulness that I delight in

20 Norah Smyth,
Mother and Infant Clinic
at Poplar, 1914
*International Institute for
Social History, Amsterdam*

many Dutch paintings, which lofty-minded people despise. I find a source of delicious sympathy in these faithful pictures of a monotonous homely existence, which has been the fate of so many more among my fellow-mortals than a life of pomp or absolute diligence, of tragic suffering or of world-stirring actions. I turn without shrinking from cloud-borne angels, from prophets, sibyls, and heroic warriors, to an old woman bending over her flower-pot, or eating her solitary dinner, while the noonday light, softened perhaps by a screen of leaves, falls on her mob-cap and just touches the rim of her spinning-wheel, and her stone jug, and all those cheap common things which are the precious necessaries of life to her.[18]

While the 'monotonous homely existence' of George Eliot's working rural people may have been a world away from the poverty and social deprivation which Norah Smyth encountered in the East End, the documentary method which the two women used is rooted in the same conviction – that the picaresque and the dramatic should be eschewed in favour of a detailed rendering of the fabric of everyday life, informed by an intimate and loving knowledge of 'all those cheap common things'. Both Smyth and Eliot penetrated the interior existences of working people, and particularly of working women, and through their shared experience of kitchens and bed-rooms, shopping, eating and bringing up children, they document the evidence, slowly and painstakingly, about poverty, about resilience and, in Smyth's case, about the details of social reform rather than its philosophical zeal. Smyth's documentary was informed exactly by the subjects which it sought to document, and by the pragmatic and educative structure which Smyth and Pankhurst created in the East End. The major achievements of the East London Federation in Bow

and Bethnal Green and Poplar rested primarily in the ability of the group to recognise particular needs and to reorganise and improve specific aspects of the everyday life of women and children in the East End. Smyth's photographs, in their close detailing, in their use of groupings, and their attention to procedures, were in absolute accord with the direction and implementation of Pankhurst's reforms.

Like Pankhurst, Smyth believed that women's lives in poor working-class areas were rendered intolerable not just by outside forces – bad housing and inadequate education and health care – but also by an inability to organise and manage available resources. While the radical reforming missions which had so characterised philanthropic work in the East End during the last century had given succour to the poor, the ELFS advised community participation, a direct involvement by mothers and their children in their own destinies. Their introduction of Montessori teachers to instruct infants, the provision of vegetarian menus in the cost-price restaurants which the Federation established for working people, the establishment of small-scale factories and day nurseries for working mothers, were measures far removed from the patriarchal systems of mission and

21 Norah Smyth, 'As They Came to Us': Nurse Hobbes and one of the war sufferers brought to the 'Mothers' Arms'. Published in the *Women's Dreadnought*, 23 October 1915 *International Institute for Social History, Amsterdam*

borough. Smyth's photographs reflect exactly the steadiness of the Federation's work, the careful relationship between it and the families with whom it worked. No secretive, candid photographer operated within Sylvia Pankhurst's arena; rather a familiar co-worker known to women and children alike stood behind the camera, photographing lines of children in the nursery, groups at rest together on mattresses on the floor, playing on the flat roof of the ELFS nursery headquarters 'The Mothers' Arms', individual children sitting with their nurses (plate no. **21**). And the gazes which are returned to hers are complicit, mutually recognising. Those who had been characterised as slum-dwellers, presented as spectacle to an amazed public by the believers in the phantasmagoria, emerge as individual women and children. They were frequently photographed as members of groups, but each had a defined individuality. Even the familiar iconography of the Suffragette movement – the banners, the posters – do not appear in Smyth's document. There are few street photographs, few signs of an interest in the usual impedimenta of street signs and urban characters which were typical of so much urban documentary of the period. While documentary photographers had traditionally defined their subjects by dress and by occupation, the women whom Smyth photographed were not open to this kind of descriptive photography. Internalised and specialised, Smyth's photographs present neither individual dramas nor characterisations, but rather a composite documentary whole.

Norah Smyth stands as the first and certainly one of the most important women workers within photography to identify herself and her work with the women's cause and with community movements. She emerges as a pioneer, an instigator whose documentary has a radically educative end, and this alone places her apart both from her contemporaries and from later documentarists. As one of the principal organisers of the *Women's Dreadnought*, Smyth was able to fit her photographs into the overall conception of the newspaper, showing herself as an early mirror to later contemporary developments and ideas of worker control and collective editorial responsibility. Because of her very direct editorial involvement with the *Dreadnought*, she was able to deploy her work in accordance with the aims of the movement to which she belonged. Her knowledge of the people among whom she worked, the mutual respect which she and they shared, led her away from received documentary reportage forms – if indeed she was aware of such forms in any significant way. Smyth's East End was an East End without cockneys or coshers, without dens or urchins. Undramatised, uncharacterised by her camera, the face of poverty was demystified and rid of the ghosts and goblins of the Victorian imagination.

RECONSTRUCTING THE IMAGINATION: DOCUMENTARY PHOTOGRAPHERS IN THE 1930s

It has become a commonplace to equate the 1920s with modernism and the 1930s with documentary realism. 'A moment did come,' wrote the novelist Storm Jameson,

> roughly at the end of the feverishly energetic twenties when the moral and intellectual climate changed. Almost before they knew what was happening to them, writers found themselves being summoned on to platforms and into committee rooms to defend society against its enemies. Writers in Defence of Freedom, Writers' Committees of the Anti-War Council, Congress of Writers for the Defence of Culture . . .[1]

Reading through contemporaries' memoirs, the acuteness of the urge towards political documentary is striking, not just for its own inherent power, but for its strength of reaction against twenties' modernism and for the universality of its aims. Stephen Spender, considering the thirties in 1978, reflected:

> the essence of the modern movement was that it created art which was centred on itself and not on anything outside it; neither on some ideology projected nor on the expression of the poet's feelings and personality. One might say that the moment thirties' writing became illustrative of Marxist texts or reaction to 'history' – and to the extent which it did these things – it ceased to be part of the modern movement.[2]

Spender's conclusion, that to be modern meant 'to interpret the poet's individual experience of lived history in the light of some kind of Marxist analysis',[3] reflected the major restructuring of the imagination which was essential to the emergence of a British documentary form.

The positioning of writers and artists as documentarists became familiar in the thirties. The studio photographer Helen Muspratt (b.1907) who, during the late twenties and early thirties, had made modernist experiments with solarisation in her treatment of portraits of the dancers Hilda and Mary Spencer-Watson and the chamber singer David Brynley, engaged in two significant documentary projects during the thirties: a series of photographs of Russia made in 1936 (plate no. **22**) was followed by documentation of mining communities in the Rhondda Valley in 1937 (plate no. **23**). Muspratt's

WOMEN PHOTOGRAPHERS

22 Helen Muspratt,
*Russian collective
farmers near Kiev, 1936*
*Courtesy of the
photographer*

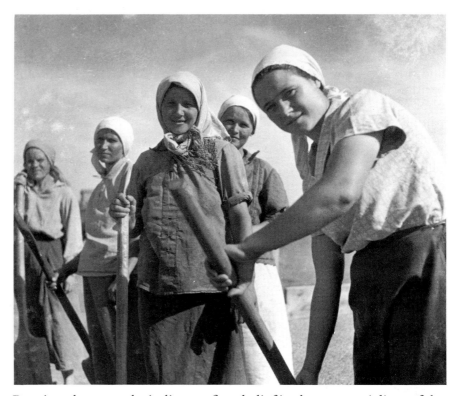

Russian photographs indicate a firm belief in the new socialism of the Russian republic; her photographs of working-class Muscovites show large, bold portraits which express a buoyant confidence, and her close documentation of state and collective farms shows a concern with the kind of photographic fact-gathering which was so typical of documentary methods. One of the tenets of this photography was that it should have a direct social purpose, to be used as an instrument of change or a means of persuasion. The photographs of this visit to Russia formed the basis of a lecture series which Helen Muspratt gave throughout the Second World War and they became one of the ways in which leftist workers within the trade union movement (including Helen Muspratt's husband, Jack Dunman) illustrated Soviet achievements.

With the exception of this kind of collaboration between activist and artist and of the important campaigning photographs taken by Edith Tudor Hart throughout the thirties, documentary photographers usually failed to liaise with the politicians, economists and scientists who struggled to establish both a radical propaganda machine and to involve working-class men and women in new political and cultural moves. Despite the stance of the Workers Camera Club as a support group for worker-photographers, no recognisable proletarian photography movement emerged in Britain during this period. The photographers who were associated with the group, Tudor Hart,

J. Allan Cash and John Maltby, were leftist progressives committed to the working-class cause, but they could not be called worker-photographers. Documentary photography also failed to be taken up by the radical pamphleteers of the thirties. The Communist Party and the Left Book Club, both of which achieved large circulations for their publications, took only partial account of the power of the photographic image, although the use of photography in radical pamphlets was certainly important. A 1935 Communist Party leaflet, *Heartbreak Homes: An Indictment of the National Government's Housing Policy* written by Michael Best, uses a whimsically styled drawing with no dramatic impact on its front cover rather than one of the highly emotive photographs of London's slumlands which were being produced by documentary photographers. Perhaps coincidentally, perhaps significantly, the women writers of these pamphlets were far more inclined to use photographs in their work. Rose Smith, whose *Women Into the Ranks, Massacre of the Innocents*

23 Helen Muspratt, Mining village, Rhondda Valley, South Wales, 1937 *Courtesy of the photographer*

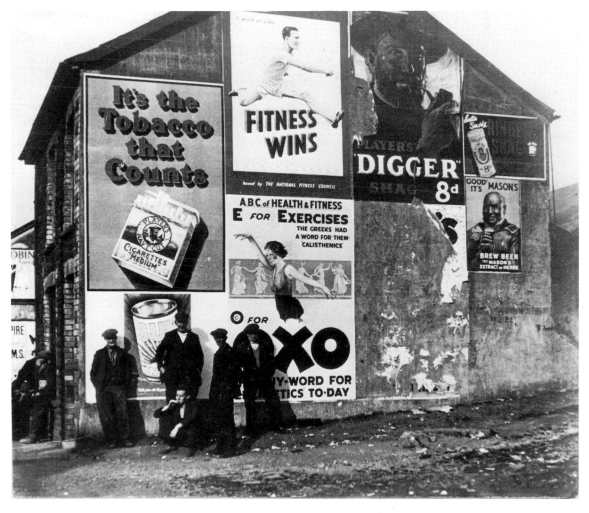

(about child health)[4] and *The Price of a Dinner* (about the conditions of mining families)[5] appeared between 1933 and 1936, used documentary images, and in the former even photomontage, to illustrate political points.

The scarcity of photographs in the immensely influential and fashionable Left Book Club editions is also symptomatic of both the failure of the politicised documentary movements of the thirties' left to take up photography as an instrument of propaganda, and a lack of visual consciousness among the British left. And it was particularly unaware of the work being done by women workers on the plight of the family and the needs of women and children.

So where did women's documentary photography find its outlet? Norah Smyth had maintained control over the use and direction of her work by her involvement with Sylvia Pankhurst in London's East End. Margaret Monck, although of the left, saw her documentary work in the East End not so much as an agent of change but as a journey into political and social awareness and self-discovery. Helen Muspratt, since the late twenties an essentially modernist studio practitioner, reconstructed portraiture in the service of the left and from her own political convictions. Gerti Deutsch adapted her incisive, purist European eye to the journalistic patterns of *Picture Post*. However, it is from the work of the *émigrée* Viennese documentarist Edith Suschitzky (from 1934, Edith Tudor Hart) that our most distinct picture of the classic woman documentarist working in Britain during the thirties can be drawn.

Edith Suschitzky (1908–1978) arrived in London from Austria in 1933, a refugee from Nazism. She was already established as a photographer, and her art training at the Dessau Bauhaus had already inspired her to make important experiments with concepts of space and form (plate no. **24**) within a realist structure. The forces which channelled her early modernism into leftist documentary work from the thirties through to the fifties were the twinned revolts against fascism and capitalism which informed so many of Britain's artists during this time. 'In those days,' said Margaret Monck in a recent interview,[6] 'you had two enemies, fascism and Hitler'; many would have added international capitalism as the third. Edith Suschitzky also brought with her a training in the Montessori teaching method, an important development in education (also brought to the East End by Sylvia Pankhurst and Norah Smyth during the First World War) which freed children from education by rote. Thus, there existed a combination of political activism, photographic skill and an understanding of progressive educational ideas, together with the modernist European way of seeing, which disregarded entrenched British photographic traditions. The exodus from Europe and the growing Nazi threat propelled many European women into the mainstream of British photography. As well as Edith Tudor Hart and the *Picture Post* documentarist Gerti Deutsch, the studio portraitist

Lotte Meitner-Graf, who left Austria in 1938, managed the Fayer Studio in Grosvenor Street until 1953, and Edith Kaye, who had left Germany at the same time as Kurt Hutton, ran the *Picture Post* darkrooms from the late thirties to 1958.[7] Helen Muspratt employed refugees from Germany and Czechoslovakia throughout the war in her Oxford studio.

By the time Edith Suschitzky arrived in London, she had already

24 Edith Tudor Hart, 'The Giant Wheel (*Reisenrad*), Prater Vienna', late 1920s *Courtesy of Wolfgang Suschitzky*

begun to record progressive educational moves and to see her photography as a means of communicating new ideas about structuring society to the public. Her series *Mit Bildern aus dem Wiener Montessori Kinderheim* was published before 1931 in Austria. Edith and her brother Wolf, who also became a leading photographer in Britain, were introduced into an important progressive circle as soon as they arrived;[8] the Tudor Harts were teachers, psychologists, writers, progressive entrepreneurs, political radicals. As a family, they had a long tradition of feminism: Beatrix Tudor Hart was an important educationalist who had run the well-known Platts Lane nursery school from 1924, and she had connections with Sylvia Pankhurst.[9] Jennifer Jones, Beatrix Tudor Hart's daughter, remembers the supportiveness and cultural awareness which existed in her family: 'I was encouraged to become an architect by my parents – my grandfather was the English painter Percyval Tudor Hart, my father was an entrepreneur who employed Wells-Coates to design Lawn Road Flats and started the Isokon bent plywood furniture factory. My mother had already paved her way as a working woman – an educational psychologist and author.'[10] Alex Tudor Hart, who Edith was to marry in 1933, was a doctor, a committed member of the Communist Party and an activist.[11] During the 1930s he practised medicine in the mining communities of the Rhondda Valley. While the marriage was not long lived, the Tudor Hart connection remained an important one for Edith, giving her access in those early years to progressives in child education, health care and politics. By the end of 1934, Edith Tudor Hart had photographed Dartington Hall for the *Listener* (29 November 1933), shown her photograph 'Sedition' in the Artists International Association's exhibition *The Social Scene* (September–October 1934), contributed a photograph of two children to illustrate Dorothy Braddell's article on bathrooms in *Design Today* magazine and constructed a photomontage to be used on the cover of *New Homes For Old* in September 1934 (plate no. **25**). Here she presented a powerful contrast between the old failures, graphically described in images of slum streets and miserable housing, and the new promise of socialism, represented in clean, well-ordered estates. These differences were acutely felt in the thirties, and for Edith Tudor Hart photomontage was a dynamic medium through which to express her concern.

Throughout the decade, Edith Tudor Hart continued to concentrate on specific issues, all of which were concerned with radical causes. The Spanish crisis of the late thirties saw her photographing Basque child refugees for the *Christian Science Monitor* (26 October 1938, 'Basques Bask in the Peaceful Sunshine of Britain') and the economic decline of the mid-thirties prompted a photo essay on Newcastle's failing industry, published in the *Geographical Magazine* in November 1937. In 1939, she contributed to the small but growing number of documentary report-style books using photographic illustrations to

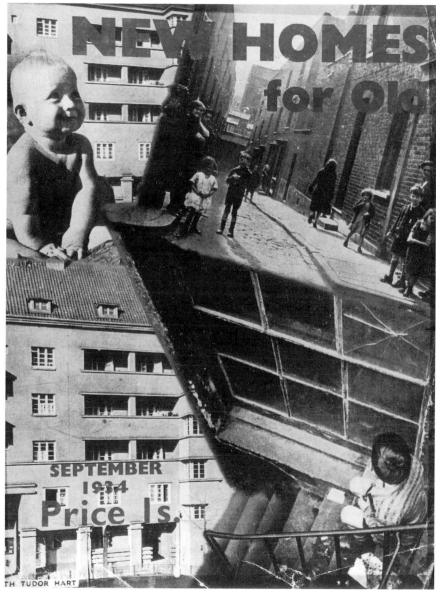

25 Edith Tudor Hart,
Photomontage used on
the cover of *New Homes
for Old*, September 1934
*Courtesy of Wolfgang
Suschitzky*

be published in Britain during the decade, most notably by the Left
Book Club, but in this instance by the infant Pelican Books, which
commissioned her to provide seven photographs of women and their
children attending clinics, joining in classes on homemaking, visiting
doctors' surgeries and getting together in the community. These
photographs, published in *Working Class Wives*[12] by the pioneer
health worker Margery Spring Rice, represent the first direct link in
women's documentary photography between Norah Smyth's work
in the East End and thirties' practice. Where many documentarists
concentrated on bringing the effects of dire poverty and social

26 Edith Tudor Hart
London, 1936
*Courtesy of Wolfgang
Suschitzky*

deprivations to the public's attention, both Smyth and Tudor Hart concentrated on the improvements which radical action and informed thinking could bring about. Other radical books which used photography to illustrate a detailed documentary almost invariably, and often with great effect, pictured the effects of unemployment, bad housing, poor nutrition and industrial decline. Wal Hannington's *The Problems of the Distressed Areas*, published by the Left Book Club in 1937, placed great emphasis on a series of powerful documentary photographs (one of which was by Edith Tudor Hart) to illustrate points in the text. The emphasis of the photographs, which included scenes of a couple with a child in a perambulator entitled 'They Walked from Carlisle To London Searching For Work', and another of three small children playing with a skipping rope in the road, called 'These Kiddies Have Nowhere but the Street to Play In', was on the direct manifestations of poverty and unemployment.

It is interesting to note that the revival of interest in 1930s documentary photography in recent years has tended to seek out those images which portrayed the effects of poverty and disadvantage in a dramatic way. Where Edith Tudor Hart is concerned, there has been a concentration on those of her photographs which not only exist as single images, but which confirm this notion of documentary photography. Her well-known photograph of a ragged child peering into the elegantly set out window of a confectioner's shop has appeared in a contemporary publication, *Camerawork* (no. 19, July 1980), to accompany text by Robert Radford; in the 1979 exhibition *Modern British Photography 1919–39* under the curatorship of David Mellor, and in the exhibition catalogue *AIA: The Story of the Artists' International Association, 1933–1953.*[13] In fact, Tudor Hart concentrated on an improving, pragmatic, visionary direction within British socialism, anticipating in her photographs the coming of the Welfare State. There were relatively few outlets for this kind of work in the late thirties. The imagination of the visionary left was to a large extent concentrated on international issues, and particularly on the threat of fascism. Those pamphlets and Left Book Club editions which did employ photographs as illustrations tended to prefer dramatic and emotive photographs whenever possible, and Edith Tudor Hart's detailed, issue-based documentary, in which each part depended on the whole, was largely unusable in this context.

Tudor Hart's photographs from the late 1930s to the mid-fifties were principally concerned with caring rather than with deprivation. By the end of the thirties, she had largely abandoned modernism and was focusing on child education, the care of mentally and physically disabled children and housing policy. Her interest in children and mental handicap was an intensely personal as well as political one, for her only child, Tommy Tudor Hart, developed schizophrenia while still very young, and his condition became incurable.[14] Up to this time her photographs of children had shown them with ideal

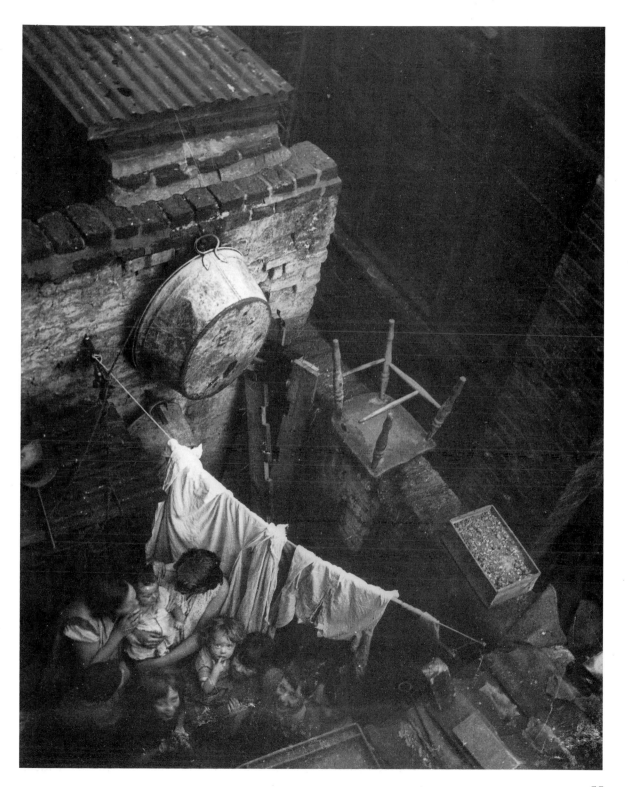

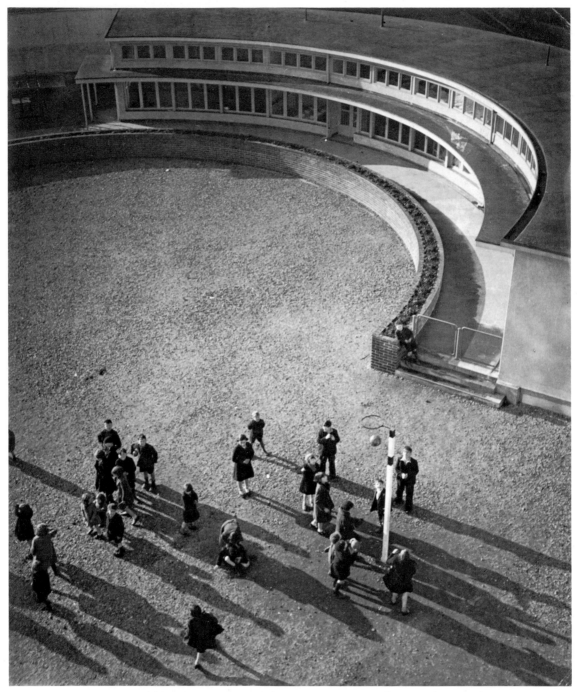

environments or within progressive education and health care. Her early training in the Montessori method, her friendship with Beatrix Tudor Hart and her movement within radical intellectual socialist circles had, to a certain extent, led her to portray a childhood utopia.

Her photographs for the *Abbatt Toy Catalogue* show small children as the perfect protagonists in the enactment of a modern theory of play and education; they give a picture of an ideal childhood, ministered to by caring adults, informed by all the tenets of socialism and modernism. (Abbatt Toys was a progressive toy-makers run by Marjorie and Paul Abbatt from 94 Wimpole Street, London. They were another important connection for Edith Tudor Hart. Beatrix Tudor Hart bought toys from the Abbatts for her nursery school.[15] Marjorie Abbatt was secretary of Artists for Peace and helped to organise the exhibitions in the fifties which resulted partly in the split within the AIA.) In these photographs, and in the pictures which she made at Beatrix Tudor Hart's Fortis Green School, she sees children as self-determining individuals within a structure of relaxed and benevolent nurturing. From the mid-thirties, Edith Tudor Hart had produced pictures which showed children in a state of innocence: photographs used in *Strand Magazine* in June 1936 picture children capering with joy at the edge of the sea, and splashing in the waves; a series for *Sun Bathing Review* (plate nos. **28** and **29**) exemplifies the campaign for fresh air and expressive physical education which had come to be the hallmark of thirties' progressivism. Her advertising campaigns for the infant foodstuff Humanised Trufood, for Ovaltine Rusks and for Pears Soap show children as sturdy and well nourished, and essentially independent. It was an image which the new utopians were anxious to promote, and to realise.

Tudor Hart's perception of herself as an insider photographer, as one who had, like many of her contemporaries, abandoned the cool tenets of modernism for the activism of radical documentary, together with her own traumatic experience of her child's mental illness, led her away from the light-filled rooms of Marjorie Abbatt's West End toyshop, and into the darker regions of the care of mentally disabled children. Tudor Hart was always true to her own experience: that her photography was so highly controlled and highly professional only added to that honesty. Using photography as a way of validating and proving experience, using it as evidence, she made an important document throughout the forties about children in care in homes for the mentally and physically disabled. During the spring of 1949, she travelled up to the Camphill School at Bieldside in Scotland with the journalist Fyfe Robertson, to make a series of photographs about the disabled children who attended the school. The photographs which she produced, made into a four-page story in *Picture Post*'s April issue, stand as one of the major documentary pieces of the post-war years. It is an important story in a number of different ways: shocked by the unimaginable horrors of the Second World War, Britain had begun to discover its conscience, and was set to establish a system of health and social care – which was to include as one of its central philosophies care for the profoundly disabled. Tudor Hart's *Picture Post* story exemplifies and propagates this awareness. The series of

27 Edith Tudor Hart, Kensal House Kindergarten, mid-1930s
Courtesy of Wolfgang Suschitzky

28 Edith Tudor Hart,
Illustration for *Sun
Bathing Review*, early
1930s
*Courtesy of Wolfgang
Suschitzky*

photographs, and particularly the one used as the leading picture of
the story (plate no. **30**), shows how Tudor Hart was managing, in
this mature period of her photography, to create tableaux which not
only express her immense personal concern for certain issues, but
which also universalise that concern. The children and their teacher
portrayed in this central photograph, captioned 'Music Helps to Free
Young Spirits Locked in Speechless Bodies',[16] 'sit and sing to the
lyre whose notes prove calming to them', and the feeling transmitted
from the photographer to the photographed is so strong and so
controlled that the photograph assumes the quality of an icon.

From the late forties, Tudor Hart's documentary, increasingly
centred around the world of childhood, becomes steadily more
intense, and, reverting to modernist first principles, begins to

29 Edith Tudor Hart,
Children at the sea, from
Sun Bathing Review,
early 1930s
*Courtesy of Wolfgang
Suschitzky*

concentrate more and more on the physical being of children, on the patterns which their limbs make in the space around them. Always an artist and thinker who looked forward with hope to the future, her photographs of children involved in physical education for the 1952 Stationery Office publication, *Moving and Growing* (plate no. **31**), show boys and girls as powerful and graceful, moving in contemporary dance patterns with fervour and intent. Approaching her late forties, and almost at the end of her career as a photographer, Edith Tudor Hart's eye was as radical and as uncluttered as ever.

Looking back to the 1930s, it is usually supposed that photography and photographers played an important and incisive part in the structuring of a British documentary movement. Our perception of documentary has become shaped so strongly by the intensity and form emerging from the United States during the same decade, notably from Walker Evans, Dorothea Lange and other workers involved with Stryker's Farm Security Administration project, that this perception has become partially transposed to a movement in Britain which was, in actuality, based far more on the output and

30 Edith Tudor Hart,
'The Lyre', Camphill
Rudolf-Steiner School,
Bieldside, Scotland.
From *Picture Post*,
April 1949
*Courtesy of Wolfgang
Suschitzky*

energy of writers than it was on that of photographers. One has only
to look at the posters and visual propaganda of groups in the thirties
in Britain, particularly material published to raise money and support
for the Spanish cause, to see exactly how underused photography
was as a means of motivating the public and increasing radical
political awareness.

The twin systems of candid and press photography which had
dominated photo-realism since the nineteenth century, and which
had excluded workers like Norah Smyth from the mainstream, had
not paved the way for an extension of record photography into
precise social documentation. Candid photography grew more and
more popular as the thirties wore on, and emerging picture magazines
ensured that the genre, with modifications, would remain the
predominant one in British photo-realism. The 'slice of life' became
a predominant mode of expression during the thirties – glimpses into
other people's drawing rooms, into the brief moment of emotion
shown by a stranger, the drama of a street accident. On the wave of
this quasi-anthropological interest, listening, observing, recording
what one heard and saw became an accepted and popular occupation
for the British public in the thirties and forties. 'In this first section,'
wrote a contemporary observer in 1939,

> have been collected photographs of primary social interest. They
> show us ourselves in all our moods, at work and at play. Here will be
> found delicate character studies of people from all ages from tiny
> children to greybeards; intimate 'candid camera' shots and 'conver-

31 Edith Tudor Hart,
Illustration for *Moving
and Growing*, 1952
Courtesy of Wolfgang
Suschitzky

sation pieces' recording our unguarded moments, graphic action
pictures captured anywhere, at the seaside, in stage and studio, in field
or factory.[17]

The urge to know, to explore, to watch the strange tribal
characteristics not of far-away peoples but of those in the next street,
in another part of town, in an interesting occupation, provided a
surge of interest in observation which became the central motivation
behind Tom Harrisson's Mass Observation project. It also prompted
the young Humphrey Spender towards documentary photography
and gave *Picture Post*'s editors the confidence to run so many of their
day-in-the-life features, to which Edith Tudor Hart and Gerti
Deutsch both contributed. These photo-essays explored lifestyles as
diverse as those of undergraduates at Girton and a group of children
in pantomime. The *émigré* photographer Kurt Hutton became one
of *Picture Post*'s most eminent workers, and he based his method
almost entirely on the assumption that what the public most wanted

32 Edith Tudor Hart,
London family, mid-
1930s
*Courtesy of Wolfgang
Suschitzky*

was access to the life of strangers and to construct from the resulting photograph their own interpretation of the scene which the photographer had presented. 'There are plenty of opportunities for mother-and-child studies,' he confided to readers of his autobiography in 1947, 'without resort to posing: the little girl and her mother sharing a mutual anxiety as they wait at the shop counter; the elaborately hidden sadness of the small boy and his mother as they wait on the platform for the train which will take him back to boarding school – I just snapped the group as I passed by, hardly stopping for it at all.'[18]

The positioning of the photographer as an agent of investigation, charged with procuring for the mass public evidence about private lives, meant that documentary work – open, political and radicalised – was, in Britain, very much superseded by a mystical and romantic concept of photojournalism, still potent in contemporary mainstream press and editorial work. Its power depended on the ability of the photograph to make an emotive point directly and quickly, without relying on the political or intellectual views of its audience. This romantic photojournalism, deriving much from the candid photography which had always been part of the British tradition, diverted attention away from the documentary photography movement attempting to become established as a potent political and cultural force in Britain. At one point in the early thirties, it did appear as if such a movement

would become a major force within the documentary framework, and that left groups being formed within photography and the fine arts would provide the kind of collectivism and radical impetus, with an emphasis on campaigning and propagandising, which had proved such an effective background for Norah Smyth's work in the East End. One of the organisations which appeared to be about to take photo-documentary forward from the point at which Smyth had ceased to produce was the East End still photography group of the Workers Film and Photo League. This East End group modelled themselves on an American left group, the Workers Camera Club, and perceived themselves as political documentarists and propagandists in the workers' cause. The revolt against twenties' modernism is perhaps nowhere better reflected than in these groups of the early thirties. They perceived themselves as workers in the cause of political change, closely allied to the left organisations of the Communist Party and the National Unemployed Workers' Movement, and firmly involved with the concept of the artist as an agent of social change. 'We just wanted everyone to use their art, whatever it was, in a political way,' reflected Nan Youngman,[19] remembering the *Art for People* exhibition organised by the Artists International Association (AIA) and shown at at the Whitechapel Art Gallery in 1939.

Helen Muspratt, working as a portrait photographer in Oxford in the late thirties, joined the AIA, and although primarily a portraitist rather than a documentarist, contributed work to radical causes. It is significant, however, that she does not remember her membership of the AIA as being a particularly important connection in her career; this, together with the general paucity of photography emerging from the AIA, suggests how slightly photographers were involved in its aspirations. The first AIA exhibition, *The Social Scene*, which opened in September 1934 in a disused shop in London's Charlotte Street, had a photographic section from which the critic T. H. Wintringham selected Edith Tudor Hart for special mention in his piece in *Left Review*: among Edith Tudor Hart's 'remarkable photographs'[20] was 'Sedition'. (It showed the audience at a political meeting and is by no means one of Tudor Hart's most remarkable images.) 'The expression on the face of one of these gentlemen is indescribable in print. The Workers Camera Club also show effective photographs, mainly of incidents in the movement.'[21] In the 1935 AIA exhibition, Edith Tudor Hart exhibited again in a section of the exhibition which was 'devoted to photographs of working-class life'.[22] Radford and Morris, historians of the AIA, document this exhibition as being the last AIA show in which the Workers Camera Club took part, and it would seem that photographers were not involved in AIA exhibitions or membership after 1937.[23] Indeed, after 1939, the Workers' Film and Photo League had ceased to operate.

That the Workers Camera Club, and the radical photographers

who had been associated with it – Maltby, Tudor Hart, J. Allan Cash – no longer played a part in the activities of the Artists International, suggests that documentary photography, unlike social realist painting, had not found the kind of energising and self-publicising political power which other radical artists felt they now possessed. By 1941, the critic Anthony Blunt was writing in the foreword to the Artists International Travelling Exhibition of that year: 'By organising painters and sculptors into an Association it provides a possible basis for wider and more rational contact between artists and their public.'[24] Two years later, the essay in the *For Liberty* exhibition catalogue read:

> The AIA has increased the scope of its aims and organization. Its cultural and sociological functions remain unaltered, so does its insistence on international co-operation between artists. But added to these more general functions it is now a professional organisation, prepared to bring the whole body of its membership to fight as an organised group for the recognition of the part which they must play in society.
>
> Membership is open to all painters, sculptors, engravers, art teachers, commercial and industrial designers, craftworkers and designers for the theatre and film, art historians, curators of art galleries, and all practitioners in the visual arts and crafts, who are required to give evidence of their professional status.[25]

Such a listing did not give photographers a high priority as prospective members. Interestingly, a radical social realist women's group was strong within the AIA during the thirties and forties, with painters examining the same kinds of subjects which were of primary concern to a documentarist like Edith Tudor Hart. In the exhibition, *Art From AIA, 1944*, held at the RBA Galleries in Knightsbridge, Elizabeth Watson showed a painting, 'Child Welfare Clinic', Eleanore Best, 'The Morning Tea Ration', and Nan Youngman was represented by 'Cumberland Market, 1933'.

The outbreak of the Second World War widened the gap between photography and the other visual arts even further. While commercial and portrait photography (into either of which category documentary photographers could fit) became a reserved occupation for men over thirty, fine artists were as liable for conscription as anyone else, and war artist posts were few and far between. Legally, women practising within either photography or the fine arts were not affected by this, but it did result in fine artists drawing further away from other practitioners into a kind of desperate protectionism. Artists in the early and mid-thirties had rejoiced in their politicised, documentarist 'non-artist' stance; John Cornford, when he became interested in politics during the thirties, wrote to his mother: 'I have found it a great relief to stop pretending to be an artist.'[26] But the beginning of war and the conscription of artists caused them to insist once again on their specialness, deepening once more the divide between the

community of fine artists and the community of photographers.

The historical structure of British photography, its inbuilt traditions, the ways in which its energies had been channelled, were all inimical to the left, issue-based documentary photography which operated with some measure of success in the thirties. We have seen how isolated Norah Smyth was within British photography; indeed, her connection with established photographic groups was non-existent, and her isolation denoted not only the radical and innovatory nature of her own work, but also the absence of any defined or coherent documentary photography practice. Most of the innovators in British photography in the twenties and thirties – Ker-Seymer, Casson, Powys-Lybbe, Madame Yevonde – who were to produce important work during the inter-war years, remained unmoved by the documentary movement as a model for restructuring and remodelling a creative consciousness. Existing as cultural dandies, outside politics, they continued to operate in a photographic sphere which had nothing in common with the twinned systems of press and candid photography. The parochialism and paternalism of mainstream photographic systems discouraged radical moves whereas many 'restructured' their imaginations to maintain and strengthen their political alliances, feeling, as Storm Jameson had, that

> Like all reformers (including self-reformers) I set about hacking down the idols. No more atmosphere, I said, no evocation of rain and moonlight, even by a word, no 'inward landscapes', no peeling of the onion to reach the core of an emotion, no stream of consciousness, that famous stream we pretend to see flowing as we pretend that the water moves under Lohengrin's swan, no aesthetic, moral or philosophic comment.[27]

The documentary photographer Margaret Monck (1911–91), working in London in the mid-thirties, did not see her extensive documentary of the East End, Clerkenwell and docklands within the context of press photography, nor did she see it as a direct instrument of social reform. In 1934, when she began to photograph street life with her newly acquired Leica, her ideas sprang not so much from classic documentary but rather from forces within British photography which had directed Paul Martin towards the trippers and street sellers of Victorian England, and had sent Bill Brandt to Ascot, to Billingsgate, to Charlie Brown's in Limehouse and to a cricket match at Eton in the mid-thirties. Photographers like Monck and Brandt must be perceived not in the light of a radical documentary system, but as primarily romantic and emotive social describers. Margaret Monck's perceived aim was not, as the radical documentarists had intended, to demystify, to use photography as a means of illuminating social problems, as a primarily educative tool, becoming what William Phillips called 'continuous with common experience',[28] but rather a desire to discover hidden worlds, to infiltrate the secret societies of the streets, to become an adventurer, an explorer, a secret agent.

33 Margaret Monck, 'Plaster hands for Harrods', an Italian craftsman working in Saffron Hill, London, mid–1930s
Courtesy of the photographer

Neither was it her concern to promote the concept of the urban phantasmagoria; the people she portrayed were undoubtedly poor and representative of some of the worst failures of English social policy towards the urban working classes, but her chief awareness was of the vitality and grace of working people, and particularly of children. Her photographs of the 1936 May Day parade in London are essentially celebratory, with the great political banners billowing high above the heads of the crowds, hopeful, bold and direct. In one

of the photographs only a banner is visible, it occupies almost the whole of the frame, with only an indistinct head appearing in the foreground. Although her political concerns are reflected in her choice of subject matter, her romantic imagination transcends pure documentary to concentrate on symbolic and emotive imagery. Likewise, her portrait of an Italian plaster craftsman making a pair of plaster hands in his workshop at Saffron Hill, undertaken as part of a series of photographs about immigrant communities in London, concentrates on the surreal enormity of the two hands (plate no. **33**) whose elegance and artificiality make a bizarre contrast with the bent back of the craftsman and the workshop litter.

For many of the young photographers beginning in documentary at this time, the East End of London became an important destination. Margaret Monck, living in 1934 at the Adelphi, just behind Charing Cross Station, set off on most days to photograph Shadwell, Limehouse and the docklands south of the Thames – 'I'd take a bus and just wander around'[29] – observing children playing on the streets, housewives in conversation with the rent-collector, men lounging at street corners. All her photographs were street studies; unlike many of her contemporaries, she did not attempt to photograph people inside their houses, nor did she act as a direct gatherer of facts. No mere observer, however, her work, as well as being a kind of voyage of self- and creative discovery, was motivated very much by her concern for the poor, by her political sympathies, and by her wish to examine pictorially the vagaries of class and economics in

34 Margaret Monck, Nanny in Hyde Park, London, mid 1930s *Courtesy of the photographer*

35 Margaret Monck,
London Docklands,
mid-1930s
*Courtesy of the
photographer*

thirties' Britain. A visit to Dowlais in the Rhondda Valley had made her aware of social injustice and the desperation of working people – 'the only shops which were open were the pawnbrokers'[30] – and her photographs of the East End of London are interspersed with series of images of nannies in Hyde Park wheeling their charges around in huge, high-wheeled prams (plate no. **34**), or of shoppers in the West End peering into beautifully dressed windows, and in one series she documents the reactions of passers-by to a beggar sitting near Charing Cross Station. Obviously, Margaret Monck saw photography as an identifier of social contrasts. Unlike the two primary photographers of the period, Gerti Deutsch and Edith Tudor Hart, Margaret Monck did not bring to her photography the incisive modernism of the European tradition. Before she had begun photography, she had studied drawing at the Heatherley School of Art, and had worked at the Lefevre Galleries as assistant to Duncan MacDonald. She had met the English painters Duncan Grant and Vanessa Bell, and her documentary photography is essentially a manifestation of the romantic English imagination rather than of the sharp inquiring intellectualism of the *émigré* European. Monck's photographs are often enigmatic where Tudor Hart's are always self-explanatory. In a Monck photograph taken in the docklands in the mid-thirties (plate no. **35**), a man hides his face in his hand while a group of men look on; the scene is one of drama and tension, but only discreet clues to a possible plot are provided.

While Margaret Monck's ideological position was, like Edith Tudor Hart's, firmly within progressive socialism, she was influenced

equally by the romantic realism of Robert Flaherty whom she witnessed making the seminal documentary film *Man of Aran* in the early thirties. Her meeting with Robert Flaherty also brought her into contact with Flaherty's wife, Frances, the stills photographer for *Man of Aran*, who became a considerable stylistic influence on Monck's later work, possibly directing her thinking towards the photographs which she produced of Yorkshire fishermen at Robin Hood's Bay in the late thirties (plate no. **36**).

Margaret Monck's husband, the film editor John Goldman, was appointed editor-in-chief for *Man of Aran*, and the influence both of Goldman's work and of the still photography of Frances Flaherty has obviously contributed to an impression given by Margaret Monck's photographs that they are fragments of a more concise whole, just as still movie photographs represent frames within the action of a film rather than as explicit narrative in their own right. Their influence, along with avant-garde cinema, epitomised for her by the early films of Buñuel, and the mystery and romantic idiosyncracy of twenties' fine artists, developed in Margaret Monck a sensibility quite different from that of mainstream British candid documentary photography.

36 Margaret Monck,
Robin Hood's Bay,
Yorkshire, late 1930s
*Courtesy of the
photographer*

69

37 Margaret Monck,
Stall holder at Brixton
Market, London, mid-
1930s
*Courtesy of the
photographer*

For her, the East End of London became a place as mysterious and as rhythmic as the island of Aran. The Italian craftsman making plaster hands for Harrods became symbolic of all the dignified *émigrés* craftsmen who practised their trades in small workshops in the poorer districts of London, just as the woman selling cabbáges on a stall at Brixton market (plate no. **37**) represents the energy and vivacity of the British working woman. She admired their dignity and their endeavour, she pictures them plainly and without overt drama and, seen within her social documentary, they escape any notion of being stock characters.

From her marriage in 1932 – 'my life changed completely with my marriage'[31] – Margaret Monck moved in a world of jazz musicians, film makers and political activists, encountering women like Frances Flaherty, Ernestine Evans, Noreen Branson and Edith Tudor Hart. This style of life, together with her earlier meetings with Bell and Grant, her movements within the world of high fashion as one of Norman Parkinson's models, her knowledge of high society, produced a peculiar and important distillation of contrasting ideas. Although her documentary followed some of the recognised procedures of thirties' work, many of her East End photographs, although appearing initially as straight reportage, are enigmatic and non-conformist; where one might justifiably see that a photograph by Edith Tudor Hart of children playing on a London street was intended to depict deprivation, a similar piece by Margaret Monck might suggest either poverty or freedom, encapsulating the ultimate dilemma of the English romantic documentarist. The only one of her photographs which is utterly explicit, and which was used for a card for the

38 Margaret Monck,
Children at Shadwell,
East London, 1937
*Courtesy of the
photographer*

Housing Centre in 1937, on the recommendation of Edith Tudor Hart, shows two children peering out from a barred cellar window in Shadwell (plate no. **38**): the photographer's feelings about this situation express no ambiguity.

Strangely enough, Margaret Monck stands virtually alone as a discreetly observing street photographer within women's photography in Britain. There appears to be no tradition of women practitioners adopting the candid stance. Even during the 1970s when candid, enigmatic documentary photography began to achieve prominence, women photographers did not adopt it as either a working method or as an intellectual process. Prominent contemporary documentarists, like Maggie Murray and Sirkka-Liisa Konttinen both, despite the enormous differences in their work, operate in what is primarily a collaborative, complicit way: like Norah Smyth and Edith Tudor Hart, they are essentially insiders. It may well be that women's documentary photography has always been grounded in a particular social and political morality. Candid street photography, with its insistence on the snatched photograph and its inherent voyeurism, has traditionally stood apart from these concerns. Margaret Monck's work from 1932 to 1939, during which year she ceased altogether to make documentary photographs, stands as a pivot beween the two traditions – her photographs are not so much snatched as requested, she collaborates with her subjects without expressing any real need to get to know them. Her sympathy was active, but did not prompt radical action.

CAREFULLY CREATING AN IDYLL: VANESSA BELL AND SNAPSHOT PHOTOGRAPHY 1907-1946

If snapshot photography is directed towards the delineation of a chronology and a definition of proof, then its casualness is inevitably challenged. Its purpose cannot truly be casual. Likewise, if a family is seen to be defined through snapshot photography, it becomes important, in exploring the nature of that family structure, to examine the construction of the snapshot model to make that definition.

The notion of family emerges more strongly through the snapshot than it does through other photographic modes. The genre of the portrait, for example, emerges as one in which individuals are placed among the apparatus of the present rather than against the backcloth of the familial past; likewise, news photography more often than not takes an individual away from the scene of domestic normality (domestic interiors reach the news only when something abnormal has happened in them) to be placed in some kind of chaotic, celebratory or monumental surrounding. Documentary, purporting to represent the normal and the everyday, reconstructs and selects from the humdrum to present a cogent version of the domestic, aimed at a particular audience or used as an instrument of a particular philosophy.

Snapshot photography poses as the only photographic genre which could be said to be naive, the result of a simple consciousness or an uncluttered wish to obtain a record and to find proof and evidence of a particular course of events, of certain individuals, or of a pattern of experience. Historians have annexed snapshot photography for this corner of the photographic movement not only because the genre is difficult to deal with, being outside a distinct and known professionalism, but also, and perhaps more interestingly, because it has concerned itself with the domestic arena.

It would perhaps be fruitful to realign snapshot photography and to establish it as a documentary rather than an explicitly casual form. Removed from its traditional base of innocent revelation and placed instead within a concept of documentary order, precise in intention if sometimes eccentric in execution, its preoccupation with the family and with the passage of time would allow its role as a marker and a recorder to be registered. With this redefinition, its relationship to other photographic modes, and its place within photo-history, could be more usefully observed.

Notions and expectations of domesticity and professionalism have been of greater concern to women artists than they have been to men, for it is the collision of family and artistic practice which has more acutely affected women. Women artists, and in this instance women photographers, have explored the nature of the family and the form, texture and content of domesticity far more fully than men have been able or inclined to do. This is not to re-annexe domestic photography from the naive to the feminine, but rather to register the centrality of the family to much of women's photography. Many of the children of women photographers, for example, were intimately involved in their mothers' practices. Amanda Hopkinson, daughter of the documentarist Gerti Deutsch, remembers that she frequently accompanied her mother on assignments and was often used as a model.[1] There is evidence, too, in Edith Tudor Hart's picture file which indicates that she used photographs of her own child and her sister-in-law's children to illustrate her political photo-documentary. Lisa Sheridan (d. 1974), who became distinguished in the forties and fifties as a magazine illustrative worker and portraitist of the Royal Family, based her practice around her home and family and, when reflecting upon her career, saw her children as providing the initial impetus towards her photography practice.

> In due course, we had two baby girls – Jill and Dinah. As I sat quietly sewing for them and watching their childish antics, I became more and more obsessed with the desire to record those fleeting moments which would never return. I knew already that, however much I tried to visualise a phase of their babyhood which had passed, the real image had already eluded me, and that in actuality I had lost something very precious for ever. It is seldom, in thinking of the past, that one can conjure up a *static* picture to be considered. The memories at once commence to wriggle and reshape themselves into a myriad of confusing forms *but my camera could register the fleeting moment*. There again was my tiny baby in her perfection, and there again my husband *at that precise moment of time* playing on the floor with the two children. Tick! Tick! The clock moves on and nothing is ever quite the same. I have always been a little obsessed with the desirability of cheating time. And there was the weapon – my simple battered old folding Kodak.[2]

From this early domestic photography, Lisa Sheridan saw herself as learning a disciplined professional practice:

> For hours at a time I used to think out the intricacies of successful photography. Not so much as yet from a technical viewpoint, for our camera allowed little variety of exposure and aperture adjustment, but as viewpoint, and how a picture could be composed to the best advantage. I used to sketch the proposed photograph on paper where faults might be forestalled. I soon discovered the value of touches such as specific objects in the background of the picture, which were only incidental to the main theme but enabled me to make an interesting photograph rather than a bald statement of fact – such as the family teddy-bear being commemorated in those early photographs of Jill

39 Lisa Sheridan,
Princess Elizabeth and
Princess Margaret at the
Royal Lodge, Windsor,
June 1936
*BBC Hulton Picture
Library*

(and then with Dinah), and the background of weather-boards, so typical of the old backyard where the children played.[3]

The familial interest which propelled Lisa Sheridan into professional photography, the interest which led her to experiment with the posing of children in casual, intimate modes, led her also to construct portraits of the Royal Family whose private lives, through photography and written journalism, became a public iconography during the forties and fifties. It has remained customary for the Royal Family to call upon eminent and innovative photographers to produce portraits of its members, and while some were chosen for their credence as glamour photographers – Beaton and Wilding were two – Lisa Sheridan was chosen precisely for her ability to imbue royalty with the qualities of domesticity. Sheridan's relaxed photographs of Princess Elizabeth and Princess Margaret (plate no. **39**) and their parents were calculated not only to reassure the British public that the post-abdication monarchy had turned against cosmopolitanism and stylishness, but also served to provide a common point of reference during the war years. Domestic snapshot photographs are comforting, emotive and stabilising – by capturing the best moments of our past they act as a reconstructor of our history, enabling us to remember the days which were good and remove from memory the ones which were bad. Transposed by a skilled and technically informed method, like the one used by Lisa Sheridan in her photographs of the Royal Family, that reassurance becomes public and universal. Seen as a stabiliser in a period of chaos,

of shaken moral and economic values, the role of the informed and knowing snapshot becomes of immense significance as an instrument to restore or maintain public calm.

Lisa Sheridan's recognition of the intimate life of the family as experienced during the infancy of her own children and the accompanying development of her interest in photography resulted in her transposing the snapshot mode on to the photographs of her famous and remote subjects. Her use of outdoor locations, rare in set-piece portrait photography in the forties, and particularly rare where royalty was involved, had the effect of bringing remote figures closer to the ordinary British person – a closeness which, illusory as it was, demonstrates the importance of this seemingly casual photography.

It would be rewarding, in terms of women's photography, to explore more fully the role of women members of the Royal Family in establishing an image of the domesticity of the monarch. Queen Alexandra documented her visits abroad with a Kodak No. 2 camera and arranged her photographs in albums with comments about places visited and people seen, making complicated and finely balanced juxtapositions of photographs and text. It was Queen Alexandra's daughter, Princess Victoria, who made the most important contribution to the genre, documenting with enormous care her family, her surroundings and her travels, and annotating these photographs in her albums, sometimes making montages, sometimes collages, but always within the sphere of the domestic. It may have been this early record-making which set the tone of royal photography from

40 Queen Alexandra, Tea party among the ruins of the Templo detto della Concordia, Girgente, 20 April 1909, including Dowager Empress Marie Feodorovna of Russia (*right*) and Princess Victoria (*centre*) *Copyright reserved. Reproduced by gracious permission of Her Majesty the Queen*

then on, with even high-glamour photographers like Cecil Beaton presenting the then Queen Elizabeth as a figure of serenity and security against backgrounds of classical calm. It was only from the time of Princess Anne's engagement, when fashion photographers like Barry Lategan began to be commissioned to photograph the younger members of the family (and when Britain was in confident mood, enjoying both prosperity and security), that the domestic image of the Royal Family in commissioned photographs began to disappear, and notions of sexuality and glamour began to play an important part in the portraits produced. While before the war the women of the Royal Family particularly influenced both through their own photographs and those produced by the commissioned photographers the kinds of photographs that were produced, the post-war predominance of men as photographers within the Royal Family – Anthony Armstrong-Jones and Patrick Lichfield, to name the two best known – and the accompanying growth of a male-dominated, aggressively heterosexual base within magazine and fashion photography from the early sixties onwards changed the direction in royal photography considerably.

Snapshot photography is primarily to do with being out of doors, closely connected with outdoor rites and celebrations of a domestic nature. Most simple snapshot cameras of the past relied heavily on sunlight to produce a good sparkling image. Thus all kinds of fine, summer-weather events became linked in the public consciousness with the taking of informal photographs. Frenetic activities did not suit the snapshot camera's technical specifications, so relatively few snapshot photographers concentrated on races or games or milling crowds – the emphasis was on loved ones and family members, not on general spectacles. They were reliant, too, on their viewers being able to recognise each person in the photograph, using it as an identifier, a marker of passing time; strangers intruding into this personal domestic experience were generally unwelcome.

In this context it is interesting to note how often the snapshot mode is used in mass-circulation women's magazines, giving editorial features an intimacy and homeliness which allow the reader to identify with strangers, to regard them as surrogate families, to establish a common set of problems shared by women. The magazines aimed specifically towards women with new babies and growing families are even more adept at using the snapshot to present theories about childcare, and even more successfully take snapshots out of the private and into the public sphere without their audiences fully recognising the transition. One of the most remarkable uses of this method occurred throughout the extensive series of photographs produced by the skilled commercial practitioner Sandra Lousada for the publication of a babycare manual.[4] All of the photographs in this series are based around the concept of family photography; they have every appearance of casual, domestic

photographs yet are highly professional and technically intricate. They are studies which concentrate on the artless idyll of family life. Although some attention is paid to the more negative aspects of childrearing, the manual above all presents babycare as light-filled, clean and endlessly rewarding.

The selection processes which snapshot photographers consistently employ, of recording good moments and rejecting the bad ones in order to reconstruct their histories in terms of domestic contentment and family achievement, become, in the hands of magazine photographers working for this specialist market, a skilled and specific technique, governed by particular rules remarkably similar to those adhered to by the snapshot taker ever since the introduction of the simple daylight camera. While the many problems associated with childcare are dealt with frequently and in some depth within textual matter, they are not transferred to visuals. Likewise, any hint of sexuality or indication of gender confusion is taboo in photographs, as are discussions of sensitive issues like child abuse and incest. The seemingly casual snapshot photograph is still presented as evidence and proof.

If snapshot photography can be seen as a way of reasserting and strengthening family life, then it must also be seen to be of the greatest importance to those who believe in families. To say that women have believed in the validity and status of family life more than have men would be to try to make simple a complicated matter. It would perhaps be more just to suggest that as long as a structure exists within which women direct the minutiae of organisation, then the snapshot, which deals primarily with the day-to-day progression of a family's life, will be of enormous significance.

The positioning of the snapshot as evidence, as a true record of events, occurs frequently in biographical and autobiographical texts. Within the scope of women's photography in general and the snapshot in particular, it is interesting to note how important Vanessa Bell's (1879–1961) snapshot albums became to her two surviving children, Quentin and Angelica, when they came, in various publications, to attempt to modify definitions of life within the Bloomsbury circle. In his introduction to a compilation of his mother's photographs, the art historian Quentin Bell writes:

> The most improbable people are imported into Bloomsbury and, even when such writers are able to get the dramatis personae right, they still seem able to invent the most extraordinary and improbable plots. Indeed they do more; in the face of the overwhelmingly abundant evidence they are still capable of imagining that this is a field in which nothing is known, in which facts are hidden and in which the evidence is suppressed.
>
> What is one to do in a case where the enquirer shuts his or her own eyes in order to proclaim that everything is suspiciously dark? Truth is great and it will prevail, said the Romans, and one can only hope that they were right. Meanwhile the only thing, so it seems, is to go on

41 Vanessa Bell,
A picnic at High and
Over, Sussex, 1928.
(*l to r:* Julian Bell, Angus
Davidson, Angelica
Bell, Virginia Woolf,
Leonard Woolf, Richard
Kennedy, Quentin Bell.
Backs to camera, l to r:
Clive Bell, Francis
Birrell)
Tate Gallery Archive

making the truth known. Even this tiny crumb of evidence may dispel some misconceptions concerning the social history of the group and give it a reasonably accurate idea of how a Bloomsbury family looked and amused itself . . . Well then, here without shame or reticence is a part of the information that these curious people desire. A photographic record of Bloomsbury at home, Bloomsbury, as the French say, 'in its slippers'.[5]

Quentin Bell's comments are of significance when considering the nature, intention and initial audience of Vanessa Bell's photographs, but note the words of her other surviving child, Angelica Garnett, thinking about her mother's photographs in 1984 and reflecting on their status as evidence.

Not long ago I was sorting out the family photographs, nearly all taken by Vanessa. I thought I knew them well enough and that the job would be merely mechanical, but I found it highly emotive and disturbing, particularly in relation to my book [*Deceived With Kindness*, 1984]. What had I said? What picture had I drawn and how true was it? How did it compare with this assembly of black-and-white images stuck to the page, rather like the keys of an old piano whose notes

tinkle suggestively in the stale air of memory? Their message is one of happiness and enjoyment; they convey so much better than the written word the moments of vitality that have receded, leaving in their wake a world of shadows.[6]

Both Quentin Bell and Angelica Garnett see the photographs which their mother made from 1907 to 1946 as evidential, intimate pictures which, through the public interest in their personae, have acquired the status of documentary. They are a set of photographs which Quentin Bell would have 'hesitated to inflict upon the public' had he not believed that they would serve to correct a continuing series of errors about the private life of Bloomsbury. They are being used to prove a point, to act as documentary proof, to assert one set of suppositions and to disprove another. Interesting, then, that Angelica Garnett, attempting to reconstruct her own history, should see the conflict between events remembered and events recorded by means of the snapshot camera. Where Bell sees the photographs as an unanswerable riposte to the magnifications and distortions of the Bloomsbury mythology, Angelica Garnett sees the difficulties in accepting one individual's selective record as impartial documentary. Snapshots, masquerading as innocents in a sophisticated and knowing world, have a credibility so immense that even those who are accustomed to interpreting visual matter may simply accept them at face value, as an unchallengeable definition of how things really were. Strange it may seem that the snapshot, with all its underlying stimuli and direction from turbulent personal relationships and needs, its role as the chronology-maker of family life, should be regarded as so much more strongly and straightforwardly evidential than the images which emerge from documentary and the press.

Vanessa Bell's practice of keeping a family album is well in keeping with the nineteenth-century tradition with which, in spite of her bohemianism, she identified strongly. As a self-appointed guardian of her family's image, she established that within a domestic, familial photography, often directed by women, snapshot photography need not be accidental. That her work in photography has for so long been disregarded by those interested in her life and work indicates that for art historians and biographers alike snapshots remain incidental. Vanessa Bell's stance as the classic amateur photographer (her films were developed and printed at the local chemist's and seemingly never enlarged from a very small snapshot format) enabled her to retain her photography as an essentially private practice.

Vanessa Bell assembled her albums with care. The eleven volumes are in chronological order, and the name of the person photographed and the date and location of the image is written under each portrait.[7] The earliest album contains her photographs dating from 1907, and the remaining ten begin in 1911 and end in 1946. Apart from the albums picturing the years from 1917 to 1927 and from 1936 to 1946, the time span of each album is from between one and three years.

The collected albums represent over thirty-five years of concentrated snapshot photography, all of it devoted to the depiction of personal and familial relationships. Although Bell's photography remained firmly rooted within the traditions which formed the snapshot method, by the thirties she was employing in her studies of the painter Duncan Grant, with whom she shared Charleston for many years, and sometimes of her husband Clive Bell, sophisticated and complicated methods of portraiture, though still transmitting these through the form of the snapshot. Like all amateur snapshot photographers she still relied on bright outdoor light to make her photographs succeed, but unlike many she used the medium to present profound and perhaps unacknowledged truths.

Many of the Bloomsbury women were prolific makers of snapshots. Ottoline Morell, Virginia Woolf, Vita Sackville-West and Dora Carrington all possessed and used snapshot cameras. Woolf, for example, is pictured by Vanessa Bell holding a box camera at Blean in 1910, and was taking pictures of her family and friends as early as 1897. Interestingly, Woolf also worked with her sister on the illustrations for *Orlando*, with Vanessa using her daughter Angelica as a model for Sasha the Russian princess as a child. Of the results Woolf commented:

> The photographs are most lovely, and I cannot thank you sufficiently for the pains you have been at, I think with a little re-arrangement one or two might do: a trifle young, that's all, but I'm showing them to Vita, who doesn't want to be accused of raping the under-age.[8]

Woolf also commissioned photographs for *Orlando* from the London society photographer Lenare, but when pressed, arranged for photographs to be taken by either Leonard Woolf or herself.

> I wanted to ask you if it would be convenient should we call in on Sunday on our way back; at Long Barn. It has now become essential to have a photograph of Orlando in country clothes in a wood, to end with. If you have films and a camera I thought Leonard might take you.[9]

Perhaps nowhere more than in the process of organising the photographic illustrations for *Orlando* can the collective Bloomsbury attitude towards photography be seen more clearly. As innovators themselves, the chief members of the Bloomsbury group paid little heed to progressive moves within photography. Preferring to use either her own and her sister's snapshots as illustrations for *Orlando* or the conservative portraits produced by Lenare, Virginia Woolf and her associates exhibited quite clearly that, for them, photography was a family matter, often casually executed but by no means always predictable or orthodox in subject matter.

For Virginia Woolf, the existence of a visual family mythology was significant in that it spawned many matriarchal and maternal figures, in particular her great-aunt, the Victorian portrait photographer

Julia Margaret Cameron. Virginia Woolf both respected and deprecated her great-aunt; the Bloomsbury avant-garde held no brief for photography within the fine arts but admired the kind of fantastic eccentricity which Julia Margaret Cameron represented. 'I want to prove her base and noble,' she wrote of Cameron to Vita Sackville-West in 1926, 'it fits in with her oddities. I might spend a lifetime over her.'[10] Shortly afterwards she wrote to her sister Vanessa asking, 'have you any of Aunt Julia's letters? I remember reading some, to mother, I think; but can't find any here. I'm now writing about her, and it would be a great advantage to have some of her actual words, which I imagine were extremely profuse, to quote.'[11] The Hogarth Press edition of *Victorian Photographs of Famous Men and Fair Women*, which brought Mrs Cameron's photographs again to public attention, was published later that year, with an introduction written by Virginia Woolf. Three years before, Woolf had written the first draft of *Freshwater*, a comic performance piece about Mrs Cameron and her ménage. As early as 1919 she had formed the idea of a burlesque about her great-aunt, writing in her diary in January of that year:

> One second – I must note for further use, the superb possibilities of *Freshwater*, for a comedy. Old Cameron dressed in a blue dressing gown and not going beyond his garden for 12 years, suddenly borrows his son's coat and walks down to the sea. Then they decide to proceed to Ceylon, taking their coffins with them, & the last sight of Aunt Julia is on board ship, presenting porters with large photographs of Sir Henry Taylor and the Madonna in default of small change.[12]

Her visualisation of a setting for *Freshwater* was expanded in a letter to Desmond MacCarthy: 'The idea is to have masses of Cameron photographs, shawls, cameos, peg-top trousers, laurel trees, laureates and all the rest.'[13]

If such observations say more about Julia Margaret Cameron's personality than her art, the style of which was far removed from the snapshotting favoured by the Bloomsbury circle, for both Woolf and Bell the notion of a photography informed by eccentricity was part of their familial inheritance. All that was needed was to transfer this notion to the method of snapshotting – which Vanessa Bell duly did. It was a concept which found particular favour among a circle of friends highly susceptible to the bizarre and to the extremes of dress and behaviour which, rightly or wrongly, had characterised Julia Margaret Cameron as a great Victorian eccentric.

Sometimes Vanessa Bell acknowledged her great-aunt's influence directly, as in her 1935 study of Angelica Bell as Ellen Terry, or in her portrait of Eve Younger at Charleston, *c.* 1930 (plate no. **41**); at other times the influence was less direct, as in her thirties experiments with close-up portraits of Julian Bell, Duncan Grant and Quentin Bell. But if her appreciation of her aunt's legacy was clear (and acknowledged, too, in her hanging Cameron's portraits of her

42 Vanessa Bell, Eve
Younger at Charleston,
c. 1930
Tate Gallery Archive

mother, and of Tennyson and Herschel, in the hallway of 46 Gordon
Square after the liberating move from South Kensington in 1904),[14]
Vanessa Bell rejected Cameron's extroversion. In her snapshot
photography she created not only what Angelica Garnett described
as 'her private world, a world from which she excluded all except her
most cherished friends and relations, but within which she created a
dazzling interior',[15] but also placed in her snapshot burlesque those
whom Mrs Cameron might well have revered. 'I feel that the subject
matter of a photograph should be a little absurd,' Vanessa Bell
remarked to her son Quentin,[16] and her deliberate absurdity, her
knowing and complicated creation of the bizarre, was inimical to
the received idea of the snapshot as a naive device. Of the two
photographers, it is probably Mrs Cameron who was the more
naive; her photographs in the end defy classification as belonging to
the absurd, and exhibit a high seriousness and religiosity quite
unallied to Vanessa Bell's irony. From Studland in Dorset in 1910,
Vanessa Bell wrote to Clive Bell: 'I have sent Norton a photograph
of Marjorie for his mantelpiece and I am sending another to Adrian. I
suppose they will soon be spread abroad.'[17] Vanessa Bell is probably
referring here to a photograph of Marjorie Strachey on the beach at
Studland wearing an inelegant bathing costume. Her circulation of
the photograph to her friends only partially mirrors Julia Margaret

Cameron's practice of distributing her works within her own circle; more important is her conscious extension of the snapshot's role as a personal *aide-mémoire* and its enlistment as a comic device.

Any notion of Vanessa Bell as a naive photographer must be discounted. As a painter she was highly skilled and articulate, a sophisticated worker who was well organised and powerful within British cultural circles as well as within her immediate social and domestic sphere. For such a knowledgeable artist to choose the snapshot camera to record both her own life and the lives of her family and friends signals definite intentions about the meaning and direction of her photographic work.

Notwithstanding the enormous attention that has been paid to the lives and works of members of the Bloomsbury group over the years, and more recently Frances Spalding's biography of Vanessa Bell and Angelica Garnett's *Deceived With Kindness*, Vanessa Bell remains a chameleon-like, strangely inaccessible figure. Her direct connections with feminism were few, although her indirect ones, through Virginia Woolf and the Strachey women, were numerous. She was, however, clearly undaunted by accepted late Victorian codes of behaviour, pursuing a deep belief in personal, social and sexual liberty. The risks she took in her abandonment of her marriage and her subsequent affair with Duncan Grant, the withholding of her daughter's true parentage from Angelica, the precariousness of her emotional life at Charleston had not only to be vindicated, but also celebrated and eternalised. The snapshot, with its overtones of innocence and its stance as objective historian, served as an ideal vehicle for these needs. Using the tool of a seemingly casual photographic record of home life, Vanessa Bell created a picture of ease and relaxed sophistication, an idyll which was difficult to challenge.

There are no rainy days at Charleston, no tearful scenes, no sleepless nights, only picnics and dressing-up and theatricals and amity between friends. Not so much Bloomsbury at home, in its slippers, but Bloomsbury in the Garden of Eden. The tensions which characterised the Charleston ménage, the kind of electricity between visitors and hosts recorded by many of its habitués, are simply not apparent in these photographs. Indeed, snapshot photography would be singularly ill-equipped to deal with such nuances. The kinds of compromises and complications which the group of people centred around Charleston had to deal with, the exceptionally powerful, ironic and secretive figure of Vanessa Bell, representing, as she did to many in the dandified and sexually ambiguous circles in which she moved, sometimes oppressive domesticity, were beyond the reach of the snapshot camera. Far more suitable to the medium were the tableaux of the absurd put together by Roger Fry, Boris Anrep and Duncan Grant outside the walled garden in 1924 in which a paper eagle hovers above Anrep's head while Fry and Grant pose, kneeling.

43 Vanessa Bell,
Duncan Grant as a
Spanish dancer,
Charleston, 1936
Tate Gallery Archive

44 Vanessa Bell,
Angelica Bell as
Peaseblossom,
Charleston, 1925
Tate Gallery Archive

Likewise, as a celebration of the grotesque and the impromptu is a photograph of Duncan Grant dressed as a Spanish dancer at Charleston in 1936 (plate no. **43**). Here a huge figure with cardboard limbs lumbers forward from a painted screen. The whole of the picture is tilted crazily; blurred leaves intrude from one side of the frame; a garden wall makes a diagonal slant across the horizon, and like a character from a nightmare the grotesque cardboard woman, with huge breasts and muscled arms, is testimony to the power of dressing-up. In another snapshot, made in 1932, Frederick Ashton, wearing an elaborate head-dress, gesticulates like an admonishing clergyman, wreathed in some diaphanous fabric. These pictures indicate that while 'the subject matter of a photograph should always be somewhat absurd', the absorption of grotesqueries by the innocent medium of the snapshot photograph could also render them harmless. If the complicated and fragile Charleston way of life could be transposed into simple absurdities, then quite possibly that existence might seem more secure. And if, in the hands of a perceptive and mature artist like Vanessa Bell, the snapshot could assume the role of court jester, then it could also be used as a presenter of calm and normality.

Bell's life as a painter was never fully reconciled with the domesticity which was such an important part of her existence, so the photographic

record which she created for over thirty years is a justification as well as a celebration of a domesticity which was sometimes triumphant, sometimes threatening. She identified extremely closely with her children, and used her snapshot photography to take herself directly to the centre of the preoccupied, idiosyncratic society of infants. While early photographs of her son Julian are quite tentative, with the child pictured distanced, as part of a group or in the custody of a nurse or grandmother, betraying, too, that peculiar quality of the snapshot to make a constantly mobile child still and surprised, her later photographs of her children register an intimacy, a physical and spiritual closeness that is almost tangible. The photographs which Vanessa Bell produced of her children during the twenties show a confident recognition of the ritualistic, tribalistic patterns of childhood. One such photograph, taken in 1925, of Angelica Bell as Peaseblossom (plate no. **44**) is of the ultimate ritual, the unruly little girl dressed as a fairy, one wing poised for flight, one sadly askew. It is the quint-essential album picture, the photograph more than any other from the snapshot's repertoire which freezes the moment in time so effectively. Like most women watching their children growing up, Vanessa Bell sought to halt the passing of time. Perceptions of the snapshot as naive enabled her either to use it as a vehicle for high irony and send-up, or to direct it to the creation of an idyll of domesticity. However she used it, it was as lacking in guilelessness as any planned artwork.

The kinds of cerebral, celebratory domesticity which Vanessa Bell aspired to create at Charleston were often threatened. Her initial allegiance to Roger Fry was founded not only on mutual sexual attraction and shared cultural concerns, but also on what she perceived as his acceptance of his role as father of children and his domestic interests. From her husband Clive Bell she found little fellow-feeling in domestic, familial matters; from her subsequent lover and companion Duncan Grant she found even less. Many of her women friends, moreover, were childless, among them her sister Virginia Woolf and Dora Carrington, and visitors to Charleston, while marvelling at the robustness and bohemianism of family life there, did not come to share that particular experience of domesticity of which children were a part. Vanessa Bell's isolation, with one foot in family life and the other in the world of the dandy, male homosexual artist and intellectual, is made apparent by Frances Spalding in her description of Bell's relationship with Duncan Grant:

> In order to retain his love, Vanessa had to continue the pattern of behaviour begun in 1915; she both tolerated his sexual adventures and defused the threat presented by his more permanent boy-friends by absorbing them into her social life, even agreeing to the presence of Angus Davidson on their 1926 trip to Venice . . . Always Vanessa must have been aware of Duncan's imperfect love for her. Like Hester Vanhomerish, Swift's 'Vanessa' after whom she had been cruelly

45 Vanessa Bell,
Quentin and Julian Bell
at Asheham, *c.* 1913
Tate Gallery Archive

46 Vanessa Bell,
Duncan Grant and
Angelica Bell,
Charleston, 1919
Tate Gallery Archive

47 Vanessa Bell,
Duncan Grant at Cassis,
South of France, 1938
Tate Gallery Archive

named, she was destined to undergo what Leslie Stephen in his life of Swift described as 'a long agony of unrequited passion'.[18]

The implications of such a background for Vanessa Bell's photographing of Duncan Grant are interesting in this context. Just as Lisa Sheridan's photographs of the young princesses were to make the two richest and most privileged children in Britain look like ordinary working folk dressed in their Sunday best, so Vanessa Bell's snapshots aspired to make the most unconventional of relationships into symbols of the eternally domestic. Pictured with her children (see plate no. **46**), Grant is an easy presence, part of everyday life, without nuance, a reassuring certainty. As the thirties wore on, however, her photographic representation of him began to change, and he emerges as a solitary man, beautiful and enigmatic. A portrait of Grant seen against the background of a creeper-covered wall presents him as something almost sculptural, a physical presence informing and detailing the space around him. Incommunicative as Vanessa Bell was about their friendship and the difficulties which attended it, such a photograph reveals the strength of feeling which, for the sake of love and stability, she so carefully concealed. In a portrait made in Cassis in 1938 (plate no. **47**), Grant is pictured against a white wall, illuminated by the strong sun of southern France. His face is ageing, but gracefully, and his pose is as easy and

as relaxed as ever. For the snapshot photographer, ever anxious to cheat the passage of time, and whose photography is moulded by both love and fear, the presence of a man so unalterable by time and circumstance was indeed a vindication.

In terms of a women's practice, Vanessa Bell's work is significant. For so long, domestic photography, often directed and organised by women within the family to construct a domestic history through a record of their children and specific events and activities – holidays, days out, birthdays, infant milestones – has been judged to be an area of photography almost entirely without status. Only when the families recorded are well known, or become well known – the Royal Family, the Bloomsbury group at Charleston – do the photographs become in any way regarded as important, and then usually only as social describers. Feminist photographers from the mid-seventies to the beginning of the eighties have been vitally interested in the family, but, as Edith Tudor Hart had been in the thirties, from the specific stance of radical documentarists seeking primarily to analyse the concept of familial construction and procedure. They have looked carefully into the family structure, particularly examining the position of women and their children, but most have used this examination primarily to discuss the relationship of the child to the state, to economic and social structures and patriarchal systems. Where a photographer like Vanessa Bell used a mode which she knew was regarded as naive to emphasise her belief in the success of her own construction of family life, using the snapshotter's familiar tools of bright light and happy occasions, later feminists used sophisticated documentary methods to express ideas of the exploitative nature of family systems and the inequities which they fostered. Using the snapshot as it has always been used, as an unchallengeable presenter of evidence, Vanessa Bell propagandised her own life, making what was complex seem simple, obscuring pain and imagining an idyll. Underneath the sun at Charleston, through the snapshot camera's lens, the complicated and anguished stuff of personal relationships became the fabric of a comic masque, a mannered and secure charade. In this knowing family album, desire was transmuted by dressing-up, tragedy became a mummers' play. From this strange iconography of fairies and grotesques, these insouciant groupings of friends and children, a fantasy of family emerges clear, cogent and concise.

INNOVATORS: WOMEN'S EXPERIMENTAL PHOTOGRAPHY 1920-1940

The 1920s and 1930s saw a large influx of women into experimental photography. Looking through the pages of the highly influential *Photography Yearbook*,[1] the work of many women who were emerging as experimentalists and embracing modernist trends was clearly given considerable coverage. In the 1935 edition of the *Yearbook*, a still-life of sporting equipment by Violet Banks appeared, depicting a photogram of a badminton racquet and shuttlecocks against an arrangement of nets. The photograph is sophisticated, obviously deriving much from continental sources and the much-vaunted experiments of the Bauhaus worker Moholy Nagy, yet is still a peculiarly British manifestation of avant-garde moves. Banks had certainly taken note of photographic advances emanating from Europe (the *Film und Foto* exhibition held in Stuttgart in 1929 had been well received by British photographers and artists and was made widely accessible by the availability of the exhibitions's catalogue *Photo-Eye* in London bookshops),[2] but her composition and choice of subjects lacked the monumentality which the Germans so often succeeded in achieving. Women's experimental photography of the twenties and thirties is frequently such a hybrid, a seemingly inconsistent combination of progressive techniques with mundane styling. Experimentalists in British photography in the inter-war years were primarily pragmatic adapters of successful visual effects rather than intellectual innovators.

The Elsie Collins Studio in Sydenham, South London, submitted an advertisement to the *Photography Yearbook* in 1935, which was a perfect combination of avant-gardism and high domesticity. The design of the advertisement is dynamic with its use of diagonals and bold block lettering, but its subject matter – 'Recipes tested at the studio and photographed in process for Home Cookery Pages. Illustrations of the newest furnishing accessories and household gadgets always on file' – belies the modern design, establishing on the one hand how far commercial practitioners had accepted and utilised the wave of new ideas coming from Europe, and on the other the maintenance of a tried and tested commercial practice.

From the early twenties until the beginning of the Second World War, the flow of women into studio portrait and commercial practice

was enormous, and contemporary commentators did not fail to notice that women were being encouraged to train as photographers. In a 1925 news item, 'Photography for Girls', *The Times* reported:

> A special photography course for girls of 16 years of age and upwards from secondary and central schools will begin at the LCC Trade School for Girls, Queen-square, Bloomsbury, WC1, in September, and will continue until the following July. The fee for girls residing in London or Middlesex will be £3 a term (£9 for the year). The course is designed to train girls as assistants to portrait photographers, whose demands the school has been unable to meet. The head mistress expects that girls will find employment with firms of repute, and that the most expert and enterprising of them will ultimately become studio managers or will start studios of their own.'[3]

In April the following year a *Daily Chronicle* reporter wrote:

> Photography is a trade or profession in which employment is usually fairly steady, but the training is a rather long one, whether a girl wants to be a printer or retoucher or work in a firm where she will have to do both.
>
> There are two courses open to the beginner. She can learn the trade at the Polytechnic in Regent-street taking a two years' course, when she leaves school and paying £45 a year, or, if she is an elementary school girl, she can enter the LCC Trade School, and even get a scholarship from her ordinary school, which means that she can learn for nothing and get a maintenance grant of from £9 to £21 a year while she is learning.[4]

Young women's career expectations were seen as extensive and expanding, and studio portrait photography and editorial coverage for magazines were increasingly recognised as fields in which young women from middle-class and working-class backgrounds could achieve both social mobility and economic self-sufficiency. Commercial photography, particularly that which dealt with so-called 'women's interests' – the photographing of food and domestic appliances – was also an expanding field, and by the beginning of the 1930s fashion photography for agencies achieved similar growth.

Edith Plummer, later known as Madame Yevonde (1893–1975), established her first London studio in Queen Victoria Street in 1916. Her background and education were like those of many young middle-class women growing up in pre-First World War Britain: 'a lot of money had been spent to teach me things, and being of average intelligence I learnt neither more nor less than most girls of my generation and opportunities. But I had no idea what I was going to do with my life.'[5]

She entered studio portraiture much earlier than most of the women who produced innovative work during the twenties and thirties and, while their photography was clearly influenced by major workers in Europe, the origins of her experimentalism are rather more complex. Yevonde began her photographic career as a pupil of

the Edwardian photographer Lallie Charles, famed for her soft-focus, rosily tinted portraits of society beauties. Her time at the Charles studio provided not only a photographic education and an initiation into business practice and studio administration, but also, and most importantly, an introduction to the concept of society portraiture. It was at the Charles studio, housed in a bijou dwelling in Mayfair, that Yevonde first encountered the ornate elegance of the successful Edwardian portraitist's work:

> Their arms laden with lilies or roses, slender women with large busts and narrow hips stood or leaned against a frosted lattice window, or sat in a high-backed Chippendale chair, each finger correctly posed, every fold of the long train carefully arranged, the hair of the head and turn of the neck artfully considered.[6]

This exposure to the sumptuousness of Lallie Charles's work gave Yevonde a fascination with the portrayal of elegant women which she used, in later years, not so much to convey ideas of beauty and sophistication, as to explore the concepts which lay behind them.

As a very young woman growing up in the London suburbs Yevonde was much attracted to the Suffragette cause. While attending the Guilde Internationale in Paris, 'I had become a most ardent Suffragette and spent much of my time exploring strange corners of Paris in order to try to persuade members of the various French Suffrage Societies to go over to London and join in a monster international women's suffrage demonstration that was held that summer.'[7] When she returned to Bromley, aged seventeen, she was 'drawn more and more into the Suffragette cause. I arranged a drawing-room meeting at home in the hope of interesting and converting the girls of Bromley. I was not a good speaker, and I failed to get any converts, but they took away the pamphlets and said they would think the matter over.'[8] During this period of her life, Yevonde read widely on women's issues, studying works by Mary Wollstonecraft and Olive Schreiner, as well as John Stuart Mill's *The Subjection of Women* and 'hundreds of pamphlets and books by contemporary writers'.[9]

Portrait photography was important to the Suffragette movement, and as a reader and distributor of *The Suffragette* Yevonde would certainly have taken notice of the efforts of Suffragette portraitists to present the protagonists of the movement as figures of distinction. The Suffragette image was a highly public one, with photographs of Mrs Pankhurst appearing, beautifully attired, effortlessly serene, on countless postcards, pamphlets, badges and other ephemera produced by the WSPU's publicity machine. Yevonde was thus exposed to two concepts of women's portraiture, in both of which personal elegance, the picturing of women for publicity and show, were of the greatest importance, but whose philosophical bases were entirely at variance. Lallie Charles's women were demure and passive, wreathed in roses and bathed in soft light, while those pictured by

48 Lena Connell,
Edith Craig and Cicely
Hamilton, *c.* 1912
*The Fawcett Library,
City of London Polytechnic*

Lena Connell and Olive Edis for the Suffragette movement were gravely beautiful, conscious of their own femaleness and of its strength and powerful sexuality.

The prominent portraitists of the Suffrage movement, notably Lena Connell and Lizzie Caswell Smith, presented an image of high glamour combined with intellectual status and heroism which was central to the public perception of the movement's leaders. While the press presented the Suffragettes as forever parading, demonstrating and involved in scuffles with onlookers and police, Connell and Caswell Smith emphasised their dignity and rectitude. In her portrait of Annie Kenney, published in *The Suffragette* in June 1916, Caswell Smith portrays this working-class activist as contemplative and serene, suggesting to other working women that the militant cause was not a refuge for outlandish idealists but a genuine vehicle for the advancement of the proletariat. In her photograph of Cicely

Hamilton, published as a postcard, Lena Connell's subject emerges as a philosopher-leader, dedicated but not fanatical. Another Connell portrait, of Mrs Nevison, shows the subject as a citizen of academia, robed and hatted – another persuasive exponent of the Suffragette cause. A portrait of Edith Craig and Cicely Hamilton (plate no. **48**), again published as a postcard, pictures the two women as united in comradeship and thought. Such directed picturing in the service of a feminist cause was an important development within women's photography, and indicated just how effectively studio portraiture could be used in this context.

The work which Yevonde produced after the establishment of her own studio clearly drew on the cross-fertilisation of two very different methods of picturing women, and by the mid-thirties, she was producing complex studies and satires centred around an exploration of beauty, sexuality and high society.

From the beginning of her career as a photographer, Yevonde worked for and among other women. When she first determined to become a photographic portraitist, she decided that 'Obviously I must study with someone good, and obviously too, it must be a woman. The idea of working under a man in those days was loathsome to me.'[10] She was initially attracted to the idea of working as a pupil of Lena Connell, and was interviewed by her at Connell's St John's Wood studio. In her autobiography, she remembered: 'Miss Connell was a tall, grave woman who wore her hair parted in the middle and drawn tightly each side of her face. She wore a severe blue serge dress, and round her neck a large old-fashioned locket hung from a gold chain.'[11]

Yevonde's subsequent decision not to accept Lena Connell's offer of an apprenticeship may seem peculiar, given her early commitment to the Suffragette cause, but Yevonde's progress through photography is characterised by her opportunism, as much as by her innovation. Working for Lena Connell would have established her firmly in the centre of women's political activism, but it would not have offered her entry into the lucrative field of high society portraiture. Working for Lallie Charles did, and if Yevonde quickly recognised that Lallie Charles was a descending star, she also assimilated from her, from her studio, and from her customers, the procedures necessary for the manufacture of elegance.

While avowedly a women's photographer, Madame Yevonde's attitude to women, and particularly to unattractive women who wished to be made beautiful, was often censorious and unsympathetic. Describing Lallie Charles's clientele in her autobiography, *In Camera*, Yevonde writes of 'the gauche and rather clumsy debutante, the acid dowager with long teeth like a horse . . . the rich plain heiress without a lover, the beautiful chorus-girl with twenty-four lovers'. The strength and complexity in her later picturing of society women as legendary heroes is as undeniable as its satire is

49 Madame Yevonde,
Advertising
photograph, Washing
Day, 1937
Private collection
Original in colour

evident, but beneath it there lies a certain sexual ambivalence and ideological clumsiness which at times undermines the strength of the portraiture.

Up to the early years of the 1930s Madame Yevonde was just one studio portraitist among the thousands active in Britain, energetic, capable, opportunistic, but not distinguished. She worked, as her contemporaries did, in black and white, producing portraits for individual sitters, theatrical personalities among them, and the glossy society magazines *Bystander* and *Sketch*. When she began experimenting with colour photography in 1932, however, she emerged as one of the primary innovators of the inter-war period. A photograph taken that year was described by Madame Yevonde in *In Camera* – 'I took a girl with flaming red hair against an even more brilliant background, while she was wearing a cherry-coloured coat' – and was the first in which colour was used experimentally. 'Experimental Colour

Photograph', *c.* 1932, presents and explores ideas of glamour and sexuality. A study in scarlet, it is layer upon layer of vivid colour; the model's hair is red, her lips are red, her coat echoes the redness of the studio backcloth. Here is the elemental symbolic scarlet woman, the heroine of a hundred films, society's *cause célèbre* finally debunked by Yevonde's satiric extravagance. The photograph is as crude and as contrived as the myth which created it, and its point is brilliantly made. It also prefigures Yevonde's later project, *Goddesses and Others*, *c.* 1938, in which she satirises the idea of the society portrait and sanctifies the idea of women's heroism and strength.

Alongside her experiments with colour at this time, Yevonde also began to use bizarre theatrical props. While other studio workers like Dorothy Wilding and Paul Tanqueray had reacted against Edwardian ornateness by making their portrait subjects stand sleek and uncluttered against plain white backgrounds, Yevonde's reaction was to satirise the use of properties. Where Lallie Charles had made use of hazy windows and flowers, Yevonde searched London for rubber snakes to adorn the head of Mrs Edward Mayer posing as Medusa:

'Get rubber snakes,' I said, 'I have often seen them. They are bright green and you buy them in toy-shops.' So she went to Hamleys, Selfridges, Gamages, Whiteleys and Harrods, not to mention Woolworth's and Marks and Spencer's, and many other purveyors of children's delights; but it was the close season for rubber snakes. They were not in stock.

So two friends, to whom I had often turned in my troubles, made stiff little adders with black tape bound round wire, and gave them gold bead eyes and gold wire forked tongues. They were effective but too small and not numerous enough.

Then one day in the Strand I saw a man selling exactly what I wanted. They were sixpence each and I bought twelve for joy, although three would have been enough. They were snakes of bright green, made of rubber, with a hole in the tail for inflation. But the effect differed from my imagination, for when blown-up and coiled around the head they resembled small green motor tyres and not writhing snakes at all. So I took them to my friend Sandy and she deflated them and cut a large slice down each side and gummed the sides together. Then they refused to inflate and the air rushed out of the seams, leaving them creatures of no substance. However, she made the hole in the tail much larger and pushed in a cord, and through the cord a wire, so that the snake could be made to bend and serpentine at will. Then she painted them a dully greeny-black which gave them a sinister appearance. With sequins as their eyes and the help of the little black adders with the golden tongues we had at last a perfect head-dress for Medusa.[12]

Yevonde's description of the buying of properties for her photographs sets a comic tone repeated in many of her reminiscences about her 'Goddesses'. By the time she was making this series of photographs, she was a well-established, prosperous studio portraitist;

50 Madame Yevonde, Mrs Michael Balcon as Minerva, 1935
Courtesy of Kathy Biggar Collection: National Portrait Gallery Original in colour

she had photographed the Duchess of Gloucester, the Countess of Shrewsbury, the Mountbattens and any number of society weddings. In 1933 she had moved her studio to Berkeley Square, and attracted a prestigious clientele. Yet she chose, for her photographs of society beauties posing as heroines from mythology, to scour children's toy shops and street markets for her props, searching not for authenticity but for comic effect. Thus Mrs Edward Mayer, bathed in purple and green light, glowers into Yevonde's camera wearing grotesquely heavy make-up and a crown of snakes that are obviously and absurdly false. Again the mythology of the wicked woman, the evil temptress, is refuted, and again Yevonde had reacted against the prevailing mores of the photography of feminine beauty.

51 Madame Yevonde, Lady Bridget Poulett as Arethusa, 1935
Courtesy of Kathy Biggar Collection: National Portrait Gallery Original in colour

While debunking and satirising were primary concerns in this series of photographs, they also reflect the dual preoccupations which had influenced Yevonde's photography from its beginnings: the parallel ideas of women as strong and militant, as warriors in the women's cause, and of women as mere creatures of elegance. Yevonde's portrait of Mrs Michael Balcon as Minerva (plate no. **50**) presents a woman in a yellow satin smock and soldier's helmet holding a revolver. Yevonde's presentation of a beautiful woman equipped to do battle is a disclaimer of passive femininity, a femininity purveyed so relentlessly by the Bond Street photographers whose ranks Yevonde had vowed never to join. The photograph is a celebration of woman's strength – and yet it is also a satire upon the aggression and militancy which Yevonde had side-stepped in deciding not to continue as an active supporter of the Suffragette cause. Behind Minerva, too, the bird of wisdom perches, helpless and stuffed, and behind the bird a tattered, crazily angled backcloth

52 Madame Yevonde,
Lady Malcolm
Campbell as Niobe,
1935
*Courtesy of Kathy Biggar
Collection: National
Portrait Gallery
Original in colour*

suggests a nightmarish scene of destruction. By 1935, when the photograph was made, all Europe had begun to feel the rumblings of war, and in Yevonde's portrait of Minerva not only is there a saraband for high society, a replacement of gossamer and lace and satin by hard metal and broken buildings, but also an awareness of the entrance of women into new areas of work and thought. Still the photograph has a deliberate clumsiness; the owl is so obviously dead, the gun so obviously a stage prop: Yevonde's photographs are as unreal as amateur theatricals, yet just as moving.

Madame Yevonde's period as an innovator came to an end with the beginning of the Second World War. During the years to come, public tastes altered; neither the extravagant colour portraits of society people nor the grotesqueries of her satire fitted into the prevailing mood of stress, foreboding and economic restriction. The world which had been so vividly coloured became determinedly black and white again. Denied both the materials and the markets for experimentation, Yevonde had once again to join the ranks of studio photographers who made their living by producing portraits for service people, and resorting to the old standbys of weddings and family groups. For most of Britain's photographic innovators the war was a watershed. Many ceased to practise altogether; others adapted to the situation, only to find that the post-war climate was not in the least sympathetic to pre-war styles. Madame Yevonde's studio continued to produce portraits until the mid-seventies, but her business was much reduced. The photographer Tessa Codrington, who worked as assistant to Madame Yevonde in the sixties, remembered how her main task at the studio was to canvass for

business among couples whose wedding announcements appeared in the quality press.[13] Nevertheless, her liking for technical innovation continued. In 1961 she showed an exhibition of portraits using a technique which she had devised called pseudo-solarisation. The portraits lack the verve and wit of her thirties' experiments, but demonstrate her continuing curiosity about the application of technique.

Just before the war began, and just after the death of her husband, the writer Edgar Middleton, Yevonde made a remarkable still-life photograph which, years later, she presented as a gift to one of her young assistants. The photograph is a composition of a pelargonium plant and a gas mask, set against a pale-coloured background. The contrast between the two objects is simple and somewhat crude, an affirmation of life and beauty and a warning of death and mutilation. For Yevonde, it marked the end of an era.

Barbara Ker-Seymer (b.1905) studied painting at the Royal College of Art and the Slade in the mid-twenties. Like Madame Yevonde, her initial studio experience was with an established woman photographer, the portraitist Olivia Wyndham, a former partner of the American photographer Curtis Moffatt. From the beginning, Barbara Ker-Seymer was propelled into a world of socialites and aesthetes:

> Olivia was a socialite, also a leader of the 'Bright Young Things', so there was always plenty going on and she was invited to a lot of parties where the press were barred but she was allowed to take photographs as she was a friend of the various hosts. My job was to stay up all night after the parties developing and printing the films in order to take them round to the *Tatler*, *Sketch* and *Bystander*, etc.[14]

Cecil Beaton described Olivia Wyndham as

> Never mistress of her camera, a huge concertina affair. Although she produced some beautiful 'Mrs Camerons', the technical aspects were always a bafflement to her: mechanism had a sure way of defying her. Olivia was connected by marriage to the Queen of Spain who, on arrival at the Fitzroy Square studio wearing twenty rows of pearls the size of gulls' eggs, would say: I have left my personality behind. It was said that, halfway through Olivia's session with the Queen, the concertina camera with all the plates was dropped and the sitting became a non-event.[15]

This cocktail of non-serious amateurism, laced with talent, wit and energy, was the true stuff of the twenties. 'I became a photographer quite by accident,' wrote Barbara Ker-Seymer,[16] demonstrating not only the spirit of the times but also a reaction against the serious upper-class dedication of Bloomsbury and the Omega Workshops. Twenties figures like Barbara Ker-Seymer rejected the ruling arts intelligentsia in other ways too, countering Roger Fry's earnest efforts to restore wooden furniture and hand painting into public consciousness and upper-class drawing-rooms

with a flurry of silver backgrounds, mirrors, corrugated iron and leather. Always a keen barometer of the times, the novelist Evelyn Waugh depicted his gauche twenties hero of *Brideshead Revisited* self-consciously dismissing the earnestness of the London arts scene. 'I should like to think', says Charles Ryder of his Oxford rooms

> – indeed I do sometimes think – that I decorated these rooms with Morris stuffs and Arundel prints and that my shelves were filled with seventeenth-century folios and French novels of the eighteenth century and in Russia-leather and watered silk. But this was not the truth. On my first afternoon I proudly hung a reproduction of Van Gogh's 'Sunflowers' over the fire and set up a screen painted by Roger Fry with a Provençal landscape which I bought inexpensively when the Omega workshops were sold up. I displayed a poster by McKnight Kauffer and Rhyme Sheets from the Poetry Bookshop . . .[17]

Barbara Ker-Seymer's early thirties photographs reflect very much this departure from high bohemianism: her focus was lightness, frivolity and the glittering prizes to be won in the service of high society.

From 1931, Ker-Seymer worked under contract for the magazine *Harper's Bazaar*, producing a series of photographs of theatrical personalities, society functions and people in the news, under headlines such as:

> Society Goes A-Snacking: Snacks over an amusing club bar, with sherry or cocktails, replace the luncheon once taken in the conventional dining-room. At these bars one meets all the people one has danced with the night before, sipping 'tonic' beverages and munching dainty sandwiches, nuts, cheese puffs, or the wing of a bird.

To illustrate this text, Ker-Seymer provided eight photographs taken at the new snack club the Cutty Sark, of dramatically lit groups of people arranged in modernistic poses.[18] In another *Harper's* feature of 1931, 'London Conversations: Wit and Wisdom',[19] to which Ker-Seymer contributed five photographs of the Hon. Mrs Baillie Hamilton, Beverley Nichols, William Gerhardi and Edythe Baker, Lady Lavery and Geoffrey Harmsworth, she experiments with bold shadowing, making her subjects appear as creatures from the *demi-monde*. Here, it is evident that the great wave of German cinema and photography which had dominated the consciousness of the new avant-garde since the beginning of the decade was leading Barbara Ker-Seymer into experiments with posing and lighting quite new to British photography. Yet the combination of these continental influences with the quintessential Englishness of the features commissioned from her by *Harper's Bazaar* led to photographs strangely at odds with their context. Superimposed on Ker-Seymer's photograph of the Hon. Mrs Baillie Hamilton conversing with Derek Patmore against a background of imposing shadows are graphics which read 'I'm sure we look awfully dissipated' . . . 'No,

53 Barbara Ker-Seymer, Nancy Morris portrait sitting, *c.* 1932 *Courtesy of the photographer*

you look far too charming.' The contrast is bizarre.

By the early thirties, Ker-Seymer had seen and admired Lerski's seminal *Köpfe des Alltags*[20] and had begun to adapt Lerski's method of presenting faces of working people in monumental close-up to her own portraits of the new intelligentsia. Her portrait of Nancy Morris is perhaps the clearest example of this adaptation. Made in 1932, the photograph shows an oiled, upturned profile emphasising the muscular construction of the face and neck (plate no. **53**). Many of Barbara

Ker-Seymer's friends and artistic collaborators shared her fascination with the photographic and cinemagraphic moves coming from Germany; Brian Howard, with whom Ker-Seymer collaborated on photographic experiments in the 1930s,[21] had visited Germany in 1927, and had become fascinated by the new photography. Humphrey Spender, another friend and co-worker of Ker-Seymer, had adopted the German miniature camera, the Leica, in the late twenties[22] and while staying in Germany at the end of the decade had seen the revolutionary photograms produced by Bauhaus worker Lucia Moholy.[23] It is important to acknowledge the influence of these new German photographic advances on Ker-Seymer's style – but it is equally important to note other impetuses which directed her work.

Ker-Seymer was primarily a studio and interiors photographer. She had joined photography as an assistant to a woman who earned her living by supplying photographs of 'Bright Young Things' to glossy magazines, and for much of her career Ker-Seymer relied on the same markets. She either never took or was never given the opportunity to take her camera out on the streets and to attempt the same kinds of studies which Lerski was making of working people in Berlin. Her work was almost always geared to editorial demands. Nor did she go on to expand the embryonic documentary which she had produced for *Harper's* into a documentary of British life, as Humphrey Spender was to do while working for *Picture Post* and in his studies of working-class life in Bolton and the Jarrow Hunger

Marchers. While a photographer like Edith Tudor Hart was able to move quite easily into the mainstream of the new photojournalism, adapting her modernistic style to the demands of the popular picture magazines, Barbara Ker-Seymer remained constricted by the needs of a section of British society which wanted to be modern but needed to remain beautiful.

Similar constraints operated on Barbara Ker-Seymer when she became involved with fashion photography during the thirties through her work with the Colman Prentice agency. There she was employed to take photographs for presentation to prestigious clients such as Jaegar and Elizabeth Arden, but it was a disappointing experience for the innovative Ker-Seymer. Fashion photography was far less developed in Britain than in Europe and the United States; she found the models stolid and uninspiring,[24] and there were few other workers in the field with whom to communicate. While studio portraitists tried to make fashion photography conform to their very precise discipline, the resulting photographs were bound to be an uneasy compromise.

Ker-Seymer's most successful work, photographs which have a wit and style difficult to find in such concentrated form elsewhere in British photography, were those which were inspired by an entirely personal experimentation. 'It was a free-for-all,'[25] she says of photography in the thirties, and in the photographs of her friends Nancy Cunard, Frederick Ashton, David Garnett and Eddie Sackville-West the strength and individuality of her experimentalism is at its height. Ker-Seymer's studio in Bond Street had black walls, a black ceiling, three full-length curtains – one black, one white and one grey – and was decorated with paintings by John Banting and Sophie Fedorovitch. It was in this setting that Ker-Seymer photographed her friends and collaborated with aspiring photographers like Brian Howard, who constructed bizarre compositions of society girls wreathed around with wire. She posed Raymond Mortimer against Brian Howard's corrugated iron (plate no. **54**); Frederick Ashton against tapestry and Nancy Cunard against a tiger skin (plate no. **55**). Here was the new, post-Bloomsbury generation in a setting of industrial metal and soft embroidery, encompassing the modernists' interest in industrial forms with the aesthete's love of luxuriant surface. It was the quintessential new British photography. Barbara Ker-Seymer said recently, 'the best photographs are the ones which go wrong',[26] and in photographing her friends and associates she had the freedom to let things go wrong, staying true to the twenties' spirit of inspired amateurism.

Barbara Ker-Seymer abandoned photography on the outbreak of the Second World War – 'it seemed to be the end of things as we knew them'[27] – and joined Larkin and Company, a film unit making instructional films for the armed services. Then, after 1947, she withdrew completely from both photography and film. Unlike

55 Barbara Ker-
Seymer, Nancy Cunard,
1930s
*Courtesy of the
photographer*

Madame Yevonde and the other studio photographers who had
combined a run-of-the-mill studio service with experimental
portraiture and commercial work, Ker-Seymer's photography was
based almost entirely on her love of experimentation. She never saw
herself as a professional photographer, and thrived in the adventurous
climate of the early thirties. Without that climate, her work seemed
purposeless.

At the same time as Barbara Ker-Seymer was learning her skills
among the society patrons of the Wyndham studio in 1929, a young
woman living in the Dorset seaside town of Swanage was planning
to open her own portrait studio. Helen Muspratt (b.1907) had
moved with her parents to Shore Cottage, a stone house overlooking

the English Channel, on their return from a spell in India. The early twenties had seen the establishment in Swanage of a thriving artistic community led by F. H. Newbury, the distinguished former head of the Glasgow School of Art. Other members of this group included the dancers Hilda and Mary Spencer-Watson, and the 'English Singers', David Brynley and Norman Nottley. Helen Muspratt is usually discussed in the context of her partnership with Lettice Ramsey in Cambridge from 1932, but it was from the Swanage group that her main innovative urges emerged.

In 1929, Helen Muspratt knew little of the experimental ferment which had swept through the more adventurous London studios, although she was aware of Man Ray's work and of the output of photographers like Madame Yevonde. Nevertheless, her decision to open a studio in the centre of Swanage was a reflection of the way in

which young women throughout the 1920s saw photography as a definite and permanent career. The demand for studio portraits, particularly of children, was sufficient to provide a living for numerous small high-street studios throughout the country, and Helen Muspratt's was no exception. Working from her large glass-roofed room, designed by Newbury with Critall windows and a beamed ceiling at the rear of No. 2 the High Street, Muspratt attracted the attention of one of *Professional Photographer* magazine's correspondents as early as 1930:

> Those who realise how individual a craft, and business, photography *should* be and who trace some of the troubles which come to professionals to the dead level of unindividual mediocrity to which many studios conform, would take new heart could they visit Swanage!
>
> The air of that delightful little Dorset resort is bracing, but they would find even more stimulating the studio of Helen Muspratt, at 2, High Street.
>
> For here is the studio which, in every aspect, reflects the personality of an individual photographer. As soon as you see the outside of the premises you know that the decoration was directed by a person of ideas and taste. The portraits in the window confirm this view – which is substantiated beyond possible doubt when you meet Miss Muspratt herself in her charming reception room.
>
> Miss Muspratt's work shows great versatility of ideas and technique. Her inclinations and the situation of her studio have led her to specialise in child portraiture – and very charmingly has she done it – but equally characteristic are her portraits of men and women, some of which show quite unusual strength.
>
> Technically her work is interesting because of her modern methods, as well as for its intrinsic quality. Her lighting equipment – usually daylight, but occasionally assisted by half-watts – is entirely unelaborate, yet she produces a wide range of effects with it. She uses a half-plate 'Graflex' camera with Super-Speed Eastman Portrait Film or 'Kodura' and Kodak Bromide papers.[28]

During these early years Helen Muspratt also made some of her most exciting experiments. Her 1932 photograph of Hilda and Mary Spencer-Watson employed the technique of solarisation to render the two women as metallic statues in their exotic dance costumes; similarly, the singer David Brynley, in another solarised portrait, appears to be etched out of silver. Muspratt experimented with modernistic posing as well, as in an early thirties portrait (book cover illustration) of a woman's head; she takes the photograph to the limits of the frame, using the strong sculptural waves in which she fills the frame with an interlocking composition of hair, face and hands, all given the modernistic surface of solarisation. In another photograph from 1932 she made a composition of hands and feet which was to be echoed in the work of many other photographers during the thirties, notably by the modernistic commercial photographer John Havinden. Such compositions were an abrupt

57 Helen Muspratt,
Swanage couple, *c.* 1929
*Courtesy of the
photographer*

departure from established photographic traditions in Britain. Even
such innovative workers as Madame Yevonde had not departed
substantially from traditional posing, and neither Ker-Seymer nor
Beaton, for all their intriguing experiments with surface and texture,
had begun to explore or exploit the space within the photographic
frame as Muspratt was beginning to do. Until the emergence of
workers like Muspratt, Winifred Casson and John Havinden, British
photographers seldom recognised the challenge of format, of the
enclosed space which the confines of the photographic frame dictated.
Helen Muspratt identified and exploited this with virtuosity. Her late
twenties portrait of hands and feet bisects diagonally the oblong
format of the film, and in her solarised portrait of a woman's head, a

58 Helen Muspratt,
Busking Welsh miner,
Swanage, 1929
*Courtesy of the
photographer*

triangle of space is placed at the bottom of the photograph, emphasising and dramatising the flow of the composition through the hand and along the waved hair. In her photograph of a Swanage couple made in the late twenties (plate no. **57**), she again considers space and form carefully, and constructs from the couple's white sports–clothes a central mass of paleness in acute contrast to the tri-toned shimmering background of the studio setting. As in her portrait of David Brynley, she utilises the incisive effect of profile, allowing the sharpness of facial features to bite sharply into the background.

Muspratt's experimentation was not confined to studio portraiture, and in this she differed sharply from other inter-war photographers who tended to concentrate on one specific area of practice. Muspratt was able to move with ease from the formality of a studio sitting to the unpredictability of documentary photography. Her embryonic socialism impelled her to travel to the Soviet Union in 1936 and to visit the Rhondda Valley in South Wales in 1937. Her visit to Russia, which lasted for six weeks, gave her the opportunity to study collective farms, to observe the massive buildings of Moscow and to document people she encountered on the streets and in the market places. She was deeply impressed by the organisation of labour and agriculture in Russia, and her enthusiasm and optimism is clearly expressed in the confrontational portraits which she made there. Her photograph of young women standing with agricultural tools on a state collective farm near Kiev (plate no. **22**), in which the workers loom above the camera and appear heroic and monumental, once again demonstrates Muspratt's ability to marry technique and intent. The photograph indicates clearly the combined purpose of the women's arms and the implements which they carry in a way which is typical of Muspratt's understanding of line, space and form.

In 1937 Helen Muspratt married Jack Dunman, a leading activist in the Communist Party and a campaigner for improved conditions for agricultural workers. Her marriage reinforced her socialism, and her political beliefs in turn reinforced her documentary photography, giving it, as political radicalism had given her contemporary Edith Tudor Hart, a commitment which was rare among British documentary photographers. The desolation of South Wales did not provide Muspratt with the opportunity for the heroic portraiture which had emerged from her Russian visit, but it showed her ability to employ sophisticated picturing in the service of documentary. A photograph made during her time in the Rhondda of unemployed men standing in front of an advertising hoarding shows the men as tiny figures dwarfed by the huge signs (plate no. **23**). 'Fitness Wins' proclaims one of the advertisements, as an athlete hurdles his way towards a rugged pioneer smoking Digger Flake. Underneath and round about the desolation of South Wales refutes capitalism as resoundingly as the advertisement extols it.

Like Madame Yevonde's, Helen Muspratt's career extended from

59 Helen Muspratt,
Paul Nash, Swanage,
1934
*Courtesy of the
photographer*

the inter-war years into the 1970s. Her longstanding partnership with Lettice Ramsey, during which she photographed many of the Cambridge figures of the thirties – among them Julian Bell, Donald McLean and Anthony Blunt – was central to the success of her career, giving rise to a second Ramsey and Muspratt studio in Oxford in 1937 when she also handed over her Swanage studio to her sister Joan. For many women photographers, marriage and the bearing of children meant the abandonment of professional work; for Helen Muspratt, always the primary income earner for her family, these commitments meant her efforts were redoubled, though in the field of routine studio work and at the expense of her experimental ventures.[29]

Ursula Powys-Lybbe (b.1910), who was to become prominent during the thirties for her use of photomontage, made her entry into photography as a portraitist of society people. In 1930, at the age of

twenty, she enrolled on a photography course at Gear and Wickison's school in Marylebone. There, in a class of six students, mainly young women of her own age, she was given a thorough grounding in the techniques of processing and camera operating, as well as lessons in the studio procedures of finishing, mounting and retouching. From the beginning of her career, she regarded herself as a professional career photographer, and her progress through the 1930s and beyond shows how aware she was of the pragmatic applications of experimental photography and of the changing needs of the studio photographer's clientele. In 1932 Powys-Lybbe went to Egypt and opened a studio in Cairo where she specialised in portraits and undertook commissions for commercial concerns, including the Shell Company and Egyptian Railways. Her ability to angle her camera either high above or deep below her subject became a distinguishing feature of her photographs throughout her career, and is clearly evident even in these early Egyptian works, among which were modernistic compositions of the domed roofs of Cairo and a model-like Shell garage.

When she returned to England, Powys-Lybbe opted not for a studio-based practice but rather for a portrait business under the catchy title 'The Touring Camera', the object of which was to photograph London's well-to-do in their home surroundings. The practice was not new – Compton Collier had worked in the same way from her Hampstead home at the beginning of the century – but it was rare enough to set Powys-Lybbe apart from other workers at a time when studio photographers were numerous and competition was keen. By 1937 she had begun to experiment with photomontage, developing a system of portraiture she called 'Composite Portraiture' and which involved 'projecting the head and shoulders of the sitter centrally on a page, and surrounding it with smaller pictures depicting the life of that person'.[30] During the 1930s photomontage had become increasingly popular because of its direct and instantaneous appeal to a wide public. John Heartfield and Edith Tudor Hart had both used it to promote political causes: it caught the eye of the casual viewer immediately, and did not demand the same kind of attention which Helen Muspratt's portraits or Barbara Ker-Seymer's series for *Harper's* might require. Photomontage often indicated, although it might not necessarily involve, some kind of social satire (though satire is entirely absent in the work of Ursula Powys-Lybbe); it had the effect of reducing those portrayed to a comic level; it humanised those who might otherwise appear as super-human. Society glossies like the *Tatler* and *Sketch*, operating as they did within an extremely circumscribed area of society and by necessity featuring the activities of the same groups of people week in and week out, were enthusiastic buyers for such innovative and eye-catching photography. They were not magazines to venture into high modernism, but they saw in the photography of workers like

Powys-Lybbe and Angus McBean a means of relieving the tedium of page after page of conventional Society portraits. Montage and superimposition in particular brought the magazines to life and gave them an air of being adventurous and zany.

Ursula Powys-Lybbe's montages for the *Tatler*, which she made in continuous series for the magazine for the eighteen months before the beginning of the Second World War, were designed to take readers directly into the lives of the denizens of high society by simple but compelling means, and their styling is consistent throughout the series. She places the subject of the portrait in the middle of the frame, and arranges around that portrait a number of photographs which describe the subject's home, her interests and her possessions. Around her portrait of Lady Mary Lygon (plate no. **60**), Powys-Lybbe arranged photographs of both her London home and her house in the country, thus firmly establishing Lady Mary's social position, and her wealth, in the viewer's mind. Powys-Lybbe then goes on to list, in pictorial form, her interests and preoccupations. The telephone on a side-table indicates Lady Mary's energetic social life, and its informality. It is also another sign of wealth – few working people owned a telephone in the 1930s. On the far right of the montage, she places a photograph of a woman's dressing table, thereby stressing not only that Lady Mary was rich, property owning and a leading socialite, but also that she was attractive and concerned about her appearance. Below these photographs is a picture of a horse, held by a disembodied arm, and a collection of racecourse passes. From these two photographs, one understands not simply that Lady Mary was interested in horses and the outdoor life, but that she had a groom – faceless because, in the scheme of things, he was unimportant except as a man to hold a horse – and that she participated as a spectator in that most aristocratic of sports, horse racing. Throughout the photographs contained in this montage, social distinctions are most carefully drawn, emphasising all the time Lady Mary's privileged status, her position as a woman with servants, her access to the best positions on the racecourse stand. Horses, telephones, houses and mirrors become emblematic of a particular lifestyle, a particular income bracket, a precise social standing. Ursula Powys-Lybbe's montages are very specific: there is no ambiguity, and not a hint of satire. Their primary interest lies in the fact that innovative techniques were being used to extol and to perpetuate an age-old social system. The construction which Heartfield and Tudor Hart had used to promote radical political beliefs was being used to make attractive and accessible the lives of the rich and famous.

Magazines like the *Tatler* existed in the thirties, as they exist now, because the public is voyeuristic. The gossip columns similarly flourish to indulge the public with an endless and intimate view into the lives of people more materially fortunate than themselves.

Powys-Lybbe's montage of Lady Mary Lygon peeps through the keyhole, penetrates the bedroom, the drawing-room and the stable block, notices the racecourse passes hanging casually on a hook, draws attention to the Pekinese dog which rests on the grass as carefully combed as a duchess. There was no space in the markets which were available to Ursula Powys-Lybbe for social satire or criticism, and the photographer certainly had no inclination towards either. The montage method made it possible to collect a great deal of information on a single page, and the long caption beneath the photograph emphasised any points which might have escaped the viewer's attention.

The *Tatler* series was based almost entirely on the portrayal of women as domestic creatures, people who based their lives around their families and their possessions, their houses, their horses, their dogs. These women had hobbies but not occupations, and even a portrait of the writer Rosamond Lehmann goes to some lengths to emphasise that Lehmann's creativity (illustrated by the writer's tools which appear in the photograph) is matched by an equal concern for domestic matters. The montage is a simple description of traditional English values, presented in modish, experimental form (plate no. **61**). Even the photograph's title, 'Rosamond Lehmann, Her Home, Her Children and Her Hobbies', omits mention of Lehmann's status as a writer; no attempt is made to distinguish her from, for example, 'Lady Weymouth, Family and Many Attractive Possessions' which appeared in the *Tatler* in December 1938; 'More Sidelights on Character: Lady Cadogan and Belongings', published in May 1939; and 'Lady Caroline Paget, Her Home, Her Hobbies and Her Recreation' of July 1938. Interestingly, in the only extant montage by Ursula Powys-Lybbe which features a man as its subject ('Portrait of Daniel Sykes, 1939) the small pictures which surround the central portrait are a pacing tiger in a cage, a pair of skis, a passport, a piano, a motor car, a gramophone and a row of books. The composition suggests a man of action, a traveller to foreign parts, a sportsman, a hunter of wild animals, as well as an intellectual, a cultured reader of books, a man who plays the piano. The presentation is dynamic, far removed from Mary Lygon's dressing table and well-manicured horse. Wealth and class may be the background of the picture, but well in the foreground are energy, determination, skill and intellect. The contrast is a telling one. At the end of the 1930s, England still expected the women it saw in photographs to be passive, busy and contented; the potential for action lay with men.

Ursula Powys-Lybbe joined the WAAF when war began, serving from 1942 on the planning staff of Operation Overlord[31] and from 1944 for Air Military Intelligence. After the war, she moved to Australia, and it was during her time as a photographer there that her real visual strength was realised. With a partner, the Australian broadcaster Claire Mitchell, Powys-Lybbe established a second

60 Ursula Powys-
Lybbe, Lady Mary
Lygon, 1938
*Courtesy of the
photographer
Collection: National
Portrait Gallery*

'Touring Camera', but one which had a very different clientele from that which she had sought out in London in the thirties.[32] Touring New South Wales and Victoria in a Dodge Command car, and later in a Buick towing a caravan, the two women visited isolated farmsteads and rural communities to photograph country families, their children, their animals and their domestic routines. Two photographs from this time – the arched form of a dead gum tree (1949) and another of the daughter of a sheepfarmer in Victoria – show the extent to which Powys-Lybbe's early instinct for clean modernist lines and her understanding of form and texture had been reasserted. Far removed from the slickness of her *Tatler* montages, the photographs show an intense admiration for the dynamic power

THE TATLER
No. 1944, SEPTEMBER 28, 1938

ROSAMOND LEHMANN. HER HOME. HER CHILDREN AND HOBBIES

Ursula Powys-Lybbe, A.R.P.S.

A composite photograph of a very talented young-married, down Oxford way. The Dovecot in the garden of her home, Ipsden House, is a view of which she is very fond. The second subject is of the interior of the house, showing a picture painted by her husband, Wogan Philipps, who has done a lot of good work. The masks of Tragedy and Comedy symbolise the fact that Rosamond Lehmann has written a play called *No More Music*, produced by Berthold Viertel. The cast included her sister, Beatrix, who was appearing in *Mourning Becomes Electra* at the time, Jack Hawkins, Jane Baxter, and Margaret Rutherford. The book titles need no explanation. This clever author uses no typewriter and has no secretary. Hugo, photographed with the Cairn terrier, is her eldest child. Next admire the exterior of Ipsden House, which is situated in the most beautiful part of the country, and last, but by no means least, there is Sally, the youngest child, complete with kitten.

61 Ursula Powys-Lybbe, Rosamond Lehmann, 1938
Courtesy of the photographer
Collection: National Portrait Gallery

of the countryside. The skeletal gum (plate no. **62**) is reminiscent of her Egyptian photographs in its angled perspective, and her sheep–farmer's daughter is monumental and heroic, just as Helen Muspratt's Russian farm workers had been. She is a pioneer woman, pictured against the rolling clouds of the huge Australian sky, a world away from Mary Lygon's hobbies. Here is a woman with purpose, a woman with work to do.

Most of the women who made photographic experiments during

62 Ursula Powys-Lybbe, 'Dead Gum Pattern', Australia, 1949 *Courtesy of the photographer*

the twenties and thirties were constrained by the markets for their work. Winifred Casson (*c.*1900–1970) was one of the rare exceptions. She is also one of the most obscure of British photographers. Had it not been for the interest shown in her by the indefatigable collector and photo-historian Helmut Gernsheim, and the careful preservation of some of her works by her contemporary John Somerset Murray, she would have remained merely a name in a long litany of forgotten British photographers of her time. By the beginning of the thirties when Casson came to Somerset Murray for photographic tuition at his Sloane Street studio, surrealism was well known to the British avant-garde through numerous publications from Europe, but photographers had been slow to become involved. The surrealist

63 Winifred Casson,
'Figure Study with
Model and Terra Cotta
Vase by Henry Ellison',
c. 1935. (Laboratory
work by John Somerset
Murray)
*Courtesy of John Somerset
Murray*

movement was dominated by painters, and it was largely they who had made the first experiments with the different medium. The painter John Banting was experimenting with photography in collaboration with Barbara Ker-Seymer in the early thirties; Humphrey Jennings, the painter, film-maker and photographer, was involved in the British surrealist grouping from the mid-thirties, and E. L. T. Messens, who was resident in London from 1938, had been making surrealist photomontages from as early as 1926.

Casson had been interested in surrealism long before it became popularised by the 1936 exhibition at the Burlington Galleries. Somerset Murray remembers that she was an early admirer of Cocteau, Chirico and early Buñuel,[33] and she had financed the magazine *Film Art*. She was fascinated by the photographic process and in Somerset Murray she met the perfect teacher. Thus Casson's photographic surrealism was not, as it was in the post-1936 work of Angus McBean, a reflection of the upsurge in popular interest in surrealism but rather the product of a real commitment to the movement. While Angus McBean was 'surrealising' actresses for the

117

64 Winifred Casson,
Surrealistic study, 1935
*Courtesy of John Somerset
Murray*

65 Winifred Casson,
'Les Mains d'un Poete',
c. 1936
*Courtesy of John Somerset
Murray*

Sketch, showing disembodied heads appearing through holes in the floor, marooned in eerie seascapes, surrounded by desolate landscapes and floating through clouds, using the artefacts of the surrealists for comic effect, Casson's photographs were pure experiments, removed totally from the opportunistic innovatism of many thirties' workers. In her 1935 'Figure Study with Model and Terra Cotta Vase by Henry Ellison' (plate no. **63**; photograph by Casson, laboratory work by J. S. Murray), she experiments with the human form just as the surrealist painters were doing. The central theme of the photograph is one of dislocation and displacement: silvered leaves sprout out of a torso, and the bound arm of the model behind it is at odds with the rhythmic flow of the woman's body. The binding of the arm with black and white fabric bracelets divorces the model's hand entirely from her body, making it seem like an object with its own separate

force and presence. Another photograph, dating from 1935 (plate no. **64**), was constructed by Casson on her 'surrealist table' – 'a dining table surfaced by an iron sheet but with non-rectangular shape'[34] – and continued and expanded upon the ideas expressed in 'Figure Study with Model and Terra Cotta Vase'.

Again, in this photograph, which Casson handcoloured using Velox dyes, a Kodak product intended for amateur use, she was experimenting with surrealist ideas of disembodiment. The photograph portrays the human body but dismembers it at the same time; the bending body of a woman is seen from behind, while the green head of Monsieur Fantomes gazes stonily out of the photograph, connected to the woman's back by an angled ruler. At the bottom of the composition a wooden hand, tinted purple by Casson, clutches at a glass ball. The components of the human body, real and artificial, drift like fragments of a dream on the metallic surface of Casson's iron table. Another photograph, 'Les Mains d'un Poete' (plate no. **65**), again uses silvered leaves and a dislocated hand emerging from the sleeves of a limp jacket to replace ideas of photographic realism with surrealist constructs. Casson returned to such motifs time and time again in her photographic experiments, intensely curious about the potential of photography to transcend the real.

Winifred Casson worked with photography for no more than five years. She exhibited rarely and her work was published only in some of the progressive yearbooks. (Most notably, she exhibited at the Chelsea Arts Club in 1935 and her work was published in the *Photography Yearbook* in 1936.) When the Second World War began she left London, and no photographic work after this time has emerged.

For women photographers, the inter-war years were a time of great enthusiasm and enormous productivity. Within the context of British experimental photography, women's work stood at the centre of things, operating in a specialised and rarefied atmosphere of creative excitement. The coming of war and the resulting abrupt shift away from experimental work in the arts signalled the end of these innovative moves by women in photography, and experimentalism did not reassert itself during the post-war period. Not until the re-emergence of a women's photography in the mid-1970s did similarly significant photographic experiments take place, and then with a radically different intent.

WOMEN PHOTOGRAPHERS AND PICTURE POST

Groups of women working together within photography is a recent practice, and one informed by contemporary feminist thoughts about collectivism and the uses of photography. Within photo-history it is difficult to find a similar arena in which women's work was used consistently, under the same constraints and with the same potentialities. As we have seen, women's documentary photography during the 1930s had no recognisable platform. That decade is generally seen as a highpoint for British documentary, yet efforts and achievements were spasmodic and unrecognised, most of it filtered into the specialist press, whether specifically leftist or connected with the cultural avant-garde. Documentary photography did not really make an impression in mainstream, mass-circulation publishing until the advent of *Picture Post* in 1938. While *Picture Post*'s forerunner, *Illustrated* (1934–39) broke some of the same ground, the circulation success of *Picture Post* was a new departure in English magazine publishing.

Picture Post became important when the outbreak of the Second World War established a set of national values, distinguished by an overriding sense of the goodness and order of British life. It was at this point that British documentary photography became first and foremost reportage, diverting its energies from an exploration of leftist mores and progressive cultural moves to become primarily an instrument of reassurance and domestic propaganda. Without the reassertion of national pride which was a necessary component of the domestic war effort, it is unlikely that *Picture Post* would have found quite the loyal mass audience it did. *Picture Post* represents the adaptation of liberal leftism to new nationalistic and expressly patriotic values without a reversion to jingoism. Its workers, who were not, as a rule, drawn from conventional Fleet Street circles, were inter-nationalist in concern and humanistic in ethics. An early infusion, in the persons of Stefan Lorant, Kurt Hübschmann and Hans Felix Bauman, moved the magazine away from a rigid partisan nationalism towards a focus of anti-fascism and traditional British values. (Hübschmann and Bauman changed their names to Hutton and Man because of anti-German feeling.) The fruitful years of *Picture Post*, under Tom Hopkinson's editorship, brought into being a merging of

66 and 67 Grace
Robertson, From
'Shearing Time in
Snowdonia'. Published
in *Picture Post* 11 August
1951
*Courtesy of the
photographer*

documentary work and press photography quite different from anything the British public had encountered during the thirties: a photographic methodology – that of the picture story – in which carefully planned photo sequences were used, with text, to illuminate some aspects of British life. Constrained by the need to stay at home during the war years, *Picture Post*'s team of photographers and writers held a weekly mirror up to Britain, their underlying philosophy emerging as a particular muscular optimism intended to stress the fortitude and inventiveness of the British under stress. Even after the war, *Picture Post* retained its stylistic devices. Photographers and correspondents were sent abroad, but the driving force of the magazine remained the same: to present people living everyday lives.

Picture Post has been accorded a place of significance in British photo-history for reasons which are frequently illusory. Just as the new documentary of the thirties was to remain a largely undeveloped force within propagandist art forms, so the picture story did not endure as a vital and influential strand of reportage photography, effectively disappearing after the demise of *Picture Post*. What *Picture Post* did do, most successfully, was to give documentary photographers the opportunity to work outside specialist, small-circulation publications, using the financial and administrative resources at its disposal to publish extensive picture stories which would have

been classed as un-newsworthy in any other publication. Thus a photographer like Gerti Deutsch was able to expand her work from its fairly circumscribed base in portraiture and the documentation of musicians and to use the documentary skills developed during her early experiments in photography in Vienna during the early thirties. In the absence of a politicised point of view, such works would probably have remained unused, and would certainly not have been shown to a mass audience. As editor of *Picture Post* during its most vital years, Tom Hopkinson might be said to have de-radicalised documentary photography, taking it out of the specialised area which it occupied and allowing distinctly apolitical photographers like Gerti Deutsch and Merlyn Severn to operate as documentarists.

The experiment was not always a success. Merlyn Severn (d. 1970), a ballet and fashion photographer invited by Hopkinson to join the post-war staff of *Picture Post*, found both the construction of picture stories and the need to get along with reporters problematic. In her 1958 autobiography, she remembered her uneasy relationship with the *Picture Post* journalists:

> An added difficulty in my case was that nearly all the journalists were convinced Socialists, while I happen to come from a Tory background;

68 Merlyn Severn, 'Swan Haven at Abbotsbury'. Published in *Picture Post* 13 July 1946
BBC Hulton Picture Library

so that they were always on the watch to take offence at some fancied slight to the working-classes. They had plenty of occasion – but my Tory background was not the cause of it. The photographer, like any other artist, is a classless creature himself; but he is bound to be socially heartless. Living in and for his eyes, he thrives on extremes, on splendour and on misery. A glimpse of the tenebrous squalor of the Gorbals, a glimpse of that curious world of high society which Proust called 'the banquet of the marvellous beasts', fill him, equally, with a fantastic joy; while the sight of healthy proletarian children eating subsidized bread and milk in subsidized council houses afflicts him with a boredom too profound for tears.[1]

Coming to *Picture Post* in 1947, Merlyn Severn brought her highly developed technical skills and her interest in pattern and form engendered by her dance photography to portray everyday British life. While the opinions she expressed show little perception of the new social and economic reforms which characterised the post-war consciousness in Britain, they do indicate that photographers working for *Picture Post* could be allowed to see themselves as non-radical photographers who used the documentary and photo-essay as a picturing device rather than as a political tool.

From the beginnings of the magazine, the idea of a photographic team as a loosely connected élite was preponderant. Writing in the foreword to Merlyn Severn's autobiography, Tom Hopkinson reflected:

> Since their work was so exacting, all arrangements for travel, money, passports, inoculations and so on, we made for them. On the job, the journalists who went with them were told to put pictures first, handling all difficulties themselves, and worrying only secondarily about their own articles – since, if they came back with too little information they could get more over the telephone. But pictures, once missed, might never be caught again.
>
> All this caused one newly joined journalist to describe our pampered photographers as 'Royal Children'.[2]

Merlyn Severn was the only woman to be employed as a full-time *Picture Post* staff photographer, and her status as an employee rather than as a freelancer is important. It would be difficult to understand how she became a photoreporter unless it were clear that the decision-makers at *Picture Post* believed in photography as a discipline which could be applied successfully to any picturing method, provided that the photographer was highly visually aware and resourceful. The sense of collective purpose which emerges from *Picture Post*'s stories comes, then, not from any bonding between photographers, but rather from an editorial basis. Perhaps more than any other single development in documentary photography, this marks the diverting of self-determining documentary photography, based on conviction and political will, away from mainstream editorial reportage work. What was established in its place was the concept of photographers as artists–reporters, allowed their own aesthetic licence but controlled firmly by the editorial hierarchy. The strength of the *Picture Post* team, the remarkable quality of images and presentation which the magazine brought to the British mass-publishing market, has remained as a model within British photojournalism, obscuring the very definite failure of photoreportage in Britain to establish itself outside editorial control. The style of picturing and sequencing pioneered by *Picture Post* became so dominant in the photographic consciousness that it precluded any parallel moves; lacking other markets, photojournalists and the mass-circulation picture magazines became synonymous and interdependent. It is thus interesting to observe the ways in which an individualistic, non-documentary practitioner like Merlyn Severn adapted, or failed to adapt, to the *Picture Post* schema. Her ballet photographs had been brought to public attention in 1936 with their publication in *Ballet in Action*,[3] but that year her studio, financed with a legacy, got off to a shaky start: 'I had no friends, no introductions and no experience, so it is hardly surprising that my total commissions during the next two months amounted to photographing one baby and one admiral (retd.).'[4]

Like the enormously successful photojournalist Bert Hardy, Merlyn

69 Merlyn Severn,
From 'An Experiment
Succeeds: Keeping a
Home Fire Burning'.
Published in *Picture Post*
2 March 1946
*BBC Hulton Picture
Library*

Severn's work for *Picture Post* only really began after the war had ended. But there the parallel ends. Both had enlisted in the armed forces – Hardy into the army, Severn into the WAAF – but where Hardy's army life provided him with even more photographic experience, Merlyn Severn found herself interned on Guernsey for the duration. Hardy could not have been more emblematic of the adaptable, energetic pressman, taking each assignment as it came, getting along happily with journalists, feeling deeply for the conditions of the deprived, war-shaken working classes. Where Severn was able

to write of the 'tenebrous squalor of the Gorbals' filling a photographer 'with a fantastic joy', Hardy's account of his visit to Glasgow with the Communist writer Bert Lloyd presents the more humane face of reportage:

> The poverty was worse than anything I had known around Blackfriars, and that was saying something. The long narrow streets were lined with high tenement blocks with grimy, uncleaned windows, and tattered rags for curtains. There was a tremendous amount of vandalism and drunkenness. Slowly, as we walked the streets, the misery of the place began to get to us.[5]

Where Hardy saw an assignment as a partnership between journalist and photographer, Severn saw the journalist as an unnecessary irritant, and only with the writer Fyfe Robertson does she seem to have been able to maintain a working relationship of mutual respect. (In her autobiography, Merlyn Severn states several times that she wrote her own texts to accompany pictures, but Tom Hopkinson, who edited *Picture Post* during her employment with the magazine, does not believe this to have been the case.) Her view of the photographic experience is also vastly different from that of the other photojournalists employed by *Picture Post*, and it separates her even more decisively from the prevailing trends in reportage photography in Britain. Where photojournalism in Britain in the 1940s was informed by the ethics of press photography – the dramatic usage of the single picture to arrest public attention, tempered by a certain social concern and a wish to penetrate beneath the surface of the news – Merlyn Severn saw each of her photo-stories as being the product of a mystical state of excitement and transcendence. She described the process in her autobiography:

> After a certain point, the process became self-perpetuating. Once the second stage is reached, a stage which I used to call '*The Dicky-bird sings*', the heavens could fall without disturbing 'Its' concentration. I can only describe this stage as the sounding of an inaudible warning bell, a sort of vibration which, spreading through the relaxed and generalized expectancy, causes it to tense itself; and then, across 'Its' consciousness there drifts something, as it were the end of a rope trailing from a balloon. On this rope's end the expectancy swoops and closes; and immediately the whole consciousness experiences a sensation which I can only describe as levitation – a sense of being without weight, of being completely supported by the air around; so that one can stand, kneel or lie in what would normally be very painful postures for an indefinite period of time without discomfort. And it is in this 'air-borne' state that the vision comes.[6]

Such an instinctive way of working, reliant on inspiration and a certain empathy with the situation or people being photographed, makes Merlyn Severn, excellent technician that she was, an even more perplexing figure within British photojournalism of the forties. Even Tom Hopkinson, a sensitive editor with no real quarrel with

the vagaries of the creative process, had difficulty in reconciling the needs of a weekly magazine with those of a deeply reflective and introverted photographer. Certainly the stories which Merlyn Severn produced for *Picture Post* after the war are lacking in depth, and do not impress with the kind of style and perception that can be seen in the photo-essays produced by some of the other women who contributed to the magazine. It was perhaps because *Picture Post* had certain definite and perceivable views about the role of women within photojournalism that she was simply unable to fit in to the kind of assignments which women like Edith Tudor Hart, Gerti Deutsch and, later, Grace Robertson established as their own territory.

Severn's most controlled and reflective stories occurred when she was able to create some sort of emotional distance between herself and her subjects; she had done this with her photographs of dancers before the war, perceiving them as graceful machines, kaleidoscopes of light and shade, moving objects rather than personalities. While working for *Picture Post* she was most at ease and most in control when she was able to photograph what she perceived as theatre – either real theatre in the form of stage production, or the theatre which resulted when she observed the patterns of natural history. Animals and birds she saw as being innocent of politics, an aristocracy in an essentially plebian world, just as the ballet dancers moved through a pre-ordered, predetermined story. Her most effective story for *Picture Post* was a four-page essay with text by Fyfe Robertson about swans at Abbotsbury in Dorset (plate no. **68**; 13 July 1946, 'Swan Haven'), in which the swans, rearing and stretching their wings to repel intruders, become balletic and legendary. The story displays both the technical control which Merlyn Severn possessed as a photographer and her understanding of pattern and form. By contrast, 'Girls With A Problem to Solve' (8 December 1945), a three-page story with text by Hilde Marchant, picturing home training courses for young women at Morecombelake in Dorset, lacks fluidity. It shows young women shopping, cooking, making lists and pumping water, but in all but the powerful initial photograph the unease between photographer and photographed is palpable.

Merlyn Severn's career at *Picture Post* was not lengthy. She joined the staff in 1945, and in 1947, first as a freelancer for *Picture Post* and later as a staff photographer for the *Central African News Review* in Rhodesia, she found a way of life and a landscape more suited to her than post-war Britain. Removed from the socialist mores which she felt had been so much a part of *Picture Post*, she found the politics of South Africa much less problematic.

One of the women workers who adapted with more ease to the *Picture Post* organisation was Edith Tudor Hart, whose work for the magazine was a continuation both of her own earlier documentary

70 Gerti Deutsch, Street market in Vienna, early 1930s
Courtesy of Amanda Hopkinson

and of the kind of community recording pioneered by Norah Smyth. In fact, working for *Picture Post* gave Tudor Hart an opportunity to construct photo-essays for mass readership, moving her work on from what was basically editorial illustrative photography or contributions to the radical press into a context in which she could explore an idea in some depth. Tudor Hart's photoreportage work for *Picture Post* was not at all extensive, but the stories she produced were exceptionally important. Her post-war photo-essay which pictured children working with clay at King Alfred's School in Hampstead, London, shows her still preoccupied both with progressive education for young children and with picturing utopia rather than the manifestations of urban poverty.[7] It required no real alteration in Tudor Hart's method to produce photo-essays for *Picture Post*.

Similarly amenable to the requirements of *Picture Post* was the Viennese photographer Gerti Deutsch (1908–79). Already a skilled and mature worker when she arrived in London in 1936, and with a strong documentary sensibility evinced in her early, detailed picturing of street markets in Vienna (plate no. **70**), and of musicians, Gerti Deutsch produced a body of work for *Picture Post* from 1939 to 1950 which shows how successfully a woman photographer could work within the structure of the magazine. Unlike Merlyn Severn, Gerti Deutsch was always a freelance contributor to *Picture Post*, but her marriage to Tom Hopkinson gave her the kind of access to and stability within the organisation which other freelancers found difficult to cultivate. Her work for *Picture Post* not only fitted much more closely than Merlyn Severn's into the prevailing style of wartime photojournalism in Britain, but it also fitted into the narrow,

specialist documentary field within which women photoreporters often operated and which, more importantly, they were seen to be especially fitted for. One of Gerti Deutsch's first stories for *Picture Post* (19 November 1938) was 'Village School, Leicester Square', describing the activities at the Ecoles de Notre Dame de France, a French school catering primarily to Italian children living in the area. The story is important because it shows Deutsch as a photographer in transition from modernism to humanistic *Picture Post* reportage. Picturing passers-by outside the school, she makes full use of the spatial components of the scene: taken from above, the shadows of the pedestrians give the picture angularity, while a tilting lamppost contributes another diagonal. Later in the story, the photographs are mellow, atmospheric close-ups portraying children, as *Picture Post* so often did, as warm and busy companions filling their own space with activity and energy. Apart from that first photograph, which shows the school as small and alone, dwarfed by its larger or more commercial neighbours, the essay concentrates on emphasising the school as a contented, thriving centre of industriousness. The story signals the beginning of Gerti Deutsch's adaptation to the accredited style of *Picture Post*, its focus a propagandist, domestic pattern of photoreporting.

It is perhaps a paradox that one of the main failures of *Picture Post* as an innovatory model for future photojournalism lay in its continuing use of certain formulae for constructing photo-essays, particularly where its women photographers were concerned. The effect on its photographers was to produce a conformity of style and method. Another Gerti Deutsch story (24 June 1939) about sports day at a preparatory school presents an idyllic scene, with children, parents and school in perfect harmony. Its affirmation of the English system of privilege and class is far stronger than anything produced even by élitist portrait photographers like Madame Yevonde.

Despite Merlyn Severn's conviction that leftism dominated the output of the magazine's photographers and journalists, *Picture Post* in fact asked very little of its photographers in terms of incisive social comment. The quality of its picturing was high, and its use of layout and printing process guaranteed to give the photographs maximum impact, but *Picture Post* photo-essays have a sameness and a comparative blandness which, in the final analysis, blurred the identities of the individual photographers who producd them. For women photographers this was particularly telling. Certainly Merlyn Severn fought against being assigned the kinds of stories which were thought to be of particular interest to women, and Gerti Deutsch too had the occasional opportunity to pursue her chief interest, photographing the artistic community. But the major part of all the women's output was the construction of essays which showed the non-controversial side of public welfare and education. Only Edith Tudor Hart, who worked very infrequently for *Picture Post*, brought to some of her

stories the force and social criticism which had so distinguished her work in the 1930s.

Although *Picture Post* under Lorant's and then Hopkinson's editorship, and more spasmodically under successive editors, appeared to give documentary photographers their first real non-specialist platform, allowing them the freedom to produce large-scale photoessays which would be well produced and widely circulated, the magazine's immensely strong editorial direction and its commitment to a mass, patriotic audience did little to advance the cause of documentary photography in Britain. The kind of commitment to the women's cause which had appeared in the undoubtedly less accomplished photographs made by Norah Smyth in the East End during the First World War, the expressed need to record faithfully the precise rhythms of working-class women's lives without any propagandist objectives, played no part in the editorial thinking which lay behind the stylisation of *Picture Post*, and has played little part in mainstream photoreportage since. The very success of *Picture Post*, the way it has been used by successive commentators and historians to represent the acme of photojournalism in Britain, must do much to account for the non-emergence of documentary photography as a force for public education.

From the late 1930s onwards, Gerti Deutsch's work concentrated increasingly on issues connected with education and child health. A story made in 1940 ('While Mothers Work', 20 July 1940) and

71, 72 and 73 Gerti Deutsch, Nursery school, London. Published in *Picture Post* 25 February 1939 *Courtesy of Amanda Hopkinson*

subtitled 'A Day in the Life of a Day Nursery' was accompanied by a text by Lady Reading, a leading figure in the National Society for Day Nurseries, on the virtues of nursery education for the under-fives. In the text, women 'working in the war effort' are encouraged to set up their own nurseries despite the fact that 'for the present the elaborate equipment of pre-war Day Nurseries is beyond our power'. The story, clearly designed to persuade women with children to go into full-time work, is by its very motive distanced from the women's documentary pioneered by Smyth. It is directed towards exemplifying and, to an important extent, justifying the state's interpretation of a woman's role. It is this, and the ramifications of this, that made *Picture Post* in the end a blind alley for women photodocumentarists, and that perhaps accounts in some part for the non-emergence of women as photojournalists in the widest possible sense. While Edith Tudor Hart's earlier photographs of the Fortis Green Nursery School in London show children as free and anarchic,

Gerti Deutsch's 'While Mothers Work' shows them as organised, controlled and firmly disciplined. While the Fortis Green pictures celebrate the nature of childhood, the 'While Mothers Work' photographs provide reassurance that the state under pressure could cope with the children for whom it was increasingly taking responsibility. The two sets of pictures are a world apart. Interestingly, an earlier Deutsch story, made before the pressure of war began to be felt, and again exploring the activities of a nursery school ('Nursery School', *Picture Post* 25 February 1939; plate nos. **71–73**), is a much freer set of pictures, with the emphasis not on calmness and order but on the ever-altering rhythms of a young child's play. Children are pictured as they are, moving from one activity to another, sometimes at a loss for what to do next, sometimes at odds with each other, sometimes totally absorbed, alone in their own worlds and only occasionally moving into the consciousness of others. This earlier story was a real exploration of pre-school education; the later

one is much more nearly a propagandist exercise. The underlying message of all the Deutsch stories for *Picture Post* in a climate of war and of post-war austerity was that existence under stress was manageable, that order would come out of near chaos.

If *Picture Post*'s role during the war was an important one, its post-war function was just as fundamental to the stabilising of a nation. As Europe polarised, it became increasingly important to illustrate how Britain could provide for its population without any radical change of social and political course. A 1948 Gerti Deutsch photo-essay, 'The Child Who Wouldn't Eat' (31 July) with text by Katherine Butler, pictures a Devon home for children, many of whom were experiencing emotional problems. The leader pictures show a child refusing to take food from her anxious mother; taken indoors, crowded by domestic impedimenta, they portray a family under stress. The remainder of the story, made at the Devon home, is photographed entirely out of doors, in bright sunlight, the children playing with animals, paddling in a stream and eating healthily and without constraint. The message of the story is clear: for every painful domestic problem there is a cogent solution, created by a caring society. For the families emerging from the war years, the message must have been reassuring.

By the time Grace Robertson (b. 1930) began making stories for *Picture Post*, the framework for women's photography within the overall structure of the magazine was familiar and well established. Grace's father, the journalist Fyfe Robertson, had worked with Merlyn Severn, Edith Tudor Hart and Elisabeth Chat on *Picture Post* stories, and Grace began her career on the magazine with an intimate knowledge of its workings. She had no need to change either her photographic method or her political thinking. By the 1950s the presentation of topical issues by picture story and text was a part of the British consciousness.

Grace Robertson's account of her time as a contributor to *Picture Post* is an invaluable description of the making of a photoreporter in the early fifties.[8] One of her vital early contacts in photojournalism was the agent Simon Guttman, still an established influence in photography, who was responsible for placing her first published *Picture Post* photograph.[9] Remembering Guttman, Grace Robertson writes:

> [he was] a photographic agent who was deeply committed to photojournalism and really cared about the quality of images and their value in the communication of ideas and news. My early, and only, training was having Simon's keen – and sometimes harsh – eyes scrutinise my contacts.[10]

Bearing in mind both the lack of a coherent photographic education system and photography's placelessness within the scheme of the arts in Britain, the advice of an independent critic like Guttman must have been of great significance to a photographer embarking on a

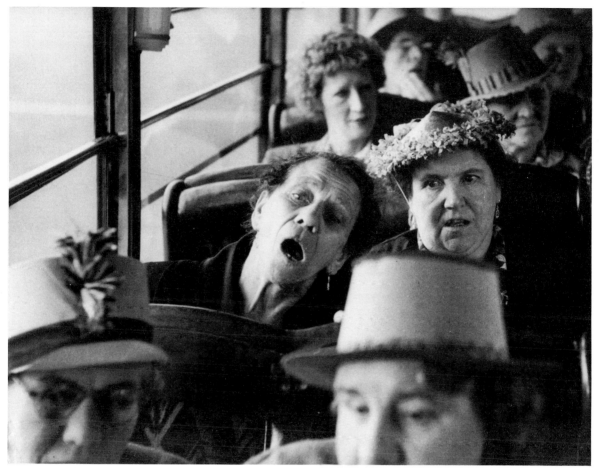

photojournalistic career at that time.

The values which Grace Robertson brought to photojournalism were very different from those which earlier workers on the magazine had adhered to.

> My photojournalist days, coming so soon after the war, were coloured to some extent by the knowledge that world conflict was over for the time being, and I think we were all buoyed up by the excitement of a fresh new world lying ahead, an infectious feeling that undoubtedly arose from the belief that my generation had just missed some unique experience.[11]

Her stories for *Picture Post* have an assurance and ease which is not generally present in either Severn's or Deutsch's work, despite their stylistic strengths. From the beginning, Grace Robertson was a photojournalist rather than a documentary photographer, constructing magazine stories rather than individual photographs.

> The writers, of course, I got to know better than anyone else, since I worked alongside them constantly. *PP* laid great stress on the advan-

74, 75 and 76 Grace Robertson, From 'Mother's Day Off', a photo essay on a women's annual pub outing, 1954
Courtesy of the photographer

tages of the 'team', and every effort was made to make sure the writer was present during the whole shooting of the story, even though he could probably, sometimes, have collected all his material within an hour or so, and returned to the office.[12]

Acceptance of the photojournalist as a professional worker within journalism was not new – Bert Hardy's photographs were always made with press publication in mind – but few women before the 1950s had the confidence fully to see themselves, and their work, in this way. By the fifties the photoreporter was such an established part of photography's range of practitioners that it required no particular departure from current trends to become one, and Grace Robertson's entry into journalistic practice shows a received knowledge of the method of sequenced photo-essayism not so readily available to her predecessors.

> There were three distinct ways of working: I could think up my own story, shoot it, print it, and submit it to the picture editor. I could put up an idea for a picture story, and then, if it was accepted, I would have the advantage of going on location with one of the *PP* writers, although sometimes, if my idea was a purely visual one, requiring no accompanying text, I went off on my own. My story 'The Kitten Comes to Town', for example, said all that was needed in pictures. The third way was to work on a commissioned feature, which came with certain advantages, not least the increased pressure resulting from the knowledge that back in the office people were eagerly, anxiously, waiting for you to deliver, and on time. Eventually I was kept so busy working in the third category that I no longer had the need to present further ideas.[13]

The writer Oswell Blakeston certainly saw Grace Robertson as one of a new kind of woman in photography:

> 'It depresses me how my line of photo thrives on depression. Things-gone-wrong give me my most striking pictures. You know old X said, "Photography's washed up, boys, now there are no more hunger marches" and that was a cynical wisecrack yet shrewd in its fashion. I do wonder what will happen to my type of feature stuff if the world really gets down to scrubbing out the blots.'
> The speaker was a man who had made his mark in the weeklies; and he relapsed into grim silence as he reviewed in his mind his recent successes – starving peasants in Mexico, a derelict murder house in a slum, the after-war desolation of country in the East . . .
> 'Well,' I ventured, 'I think when things get better, there'll be more women photographers working for the magazines. They seem able to deal with optimism and record it in an arresting way. They don't need a disaster to get a punch picture.'
> Of course I was thinking of Grace Robertson; for, at the moment, she hasn't many English rivals in the man's world of feature photo journalism.[14]

While it did not in the end prove to be the case that Grace Robertson's entry into British photojournalism would herald an influx of women

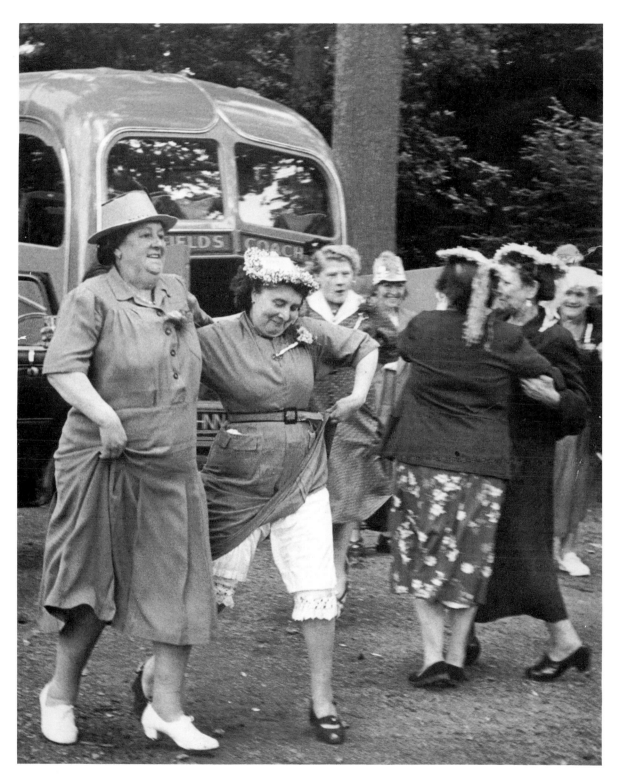

into photoreportage, it is true that her approach and her method were far different from those of her predecessors, and far more attuned to the current climate of photographic reportage. It is interesting that she was able to make use of the established *Picture Post* tradition of commissioning women photographers to create stories thought to have overriding interest for women:

> I do not think there were many women photographers in Fleet Street in the 50s, and probably *PP* was exceptional in regularly using the few who, in this country, had a feel for photojournalism, and who could handle the 35mm camera with confidence and imagination. It is true I was sometimes given a story *because* I was a woman, and – at that time – thought more suitable for that particular assignment. A close-up story on childbirth [plate nos. **77–78**] and another on the ladies' Turkish baths, came my way for this reason.[15]

It may to some extent have been inhibiting to a woman practitioner's wider interests to be channelled into such specific areas of concern, but at least there existed an area within which women photojournalists were recognised as specialists. Grace Robertson remembers *Picture Post* as one of the few large-scale publications which employed women on a regular basis[16] and recognised probably more clearly than her predecessors that *Picture Post*'s stance on women's interests provided a useful entry into photojournalism for women within a conservative milieu. Even so, the magazine still imposed strict limits on the kind of material it thought suitable for viewing by a mass public. Grace Robertson's story, 'Birth of a Baby', was not in fact used in the magazine because it was thought to be too explicit and too powerful in its presentation of the pain of childbirth. Shot intermittently over a period of six months, Grace Robertson remembers finding the story 'utterly fascinating':

> I really felt I was recording something which, when sympathetically edited, would result in a unique picture story which would be illuminating and reassuring to thousands of women approaching motherhood. Alas, the story – although judged to be a great success in terms of pictures – was 'killed' because *Picture Post* feared the realistic shots of a young woman in labour would alarm too many readers![17]

Picture Post eventually ceased publication in 1957, and for Grace Robertson a major market for freelance journalism disappeared, not to be easily replaced. From the end of 1955 her contact with the declining magazine was becoming less and less fruitful, and after 'occasionally working for minor English magazines such as *Everybodies* and *TV Mirror*',[18] Grace Robertson's involvement with photojournalism ceased.

The position of *Picture Post* within a women's photography is equivocal. It opened up to a certain number of women the prospect of well-funded work within a mass-circulation magazine which paid due respect to the quality of the photographic image. But it did not – as, for instance, *Life* magazine had done for one of its major workers,

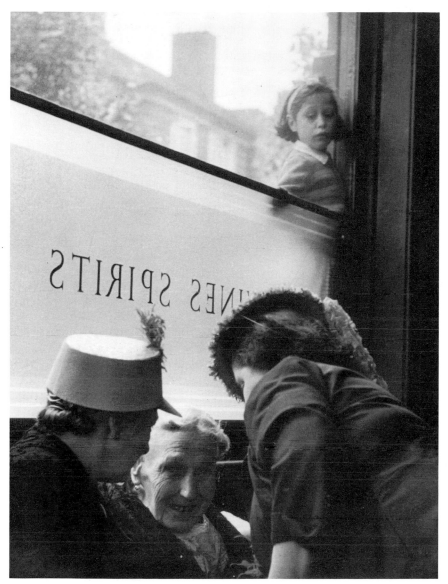

Margaret Bourke-White – promote women within the wide sphere of general-interest photojournalism. Nor did its women photographers participate in the magazine's post-war expansion towards an internationalist stance. A mainstream tradition of women photographers as internationalist or even as wide-ranging workers on national issues has still not emerged in Britain. Certainly the emergence of a specifically feminist photography in the 1970s has given women practitioners access to wider spheres, taking them particularly into the Third World, but the mainstream mass-circulation press continues to channel women workers into domestic coverage or feature portraiture. The photojournalist Eve Arnold is one of the very few

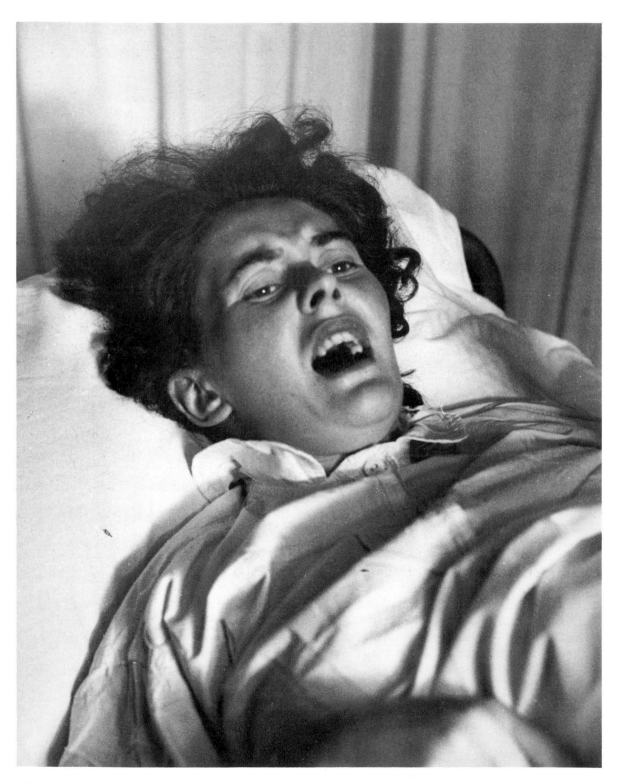

77 and 78 Grace Robertson, From 'Birth of a Baby', mid–1950s. Taken for *Picture Post* but not published *Courtesy of the photographer*

women in England who has moved away from these specific issues.

Picture Post gave photography in Britain a new credence; it established photojournalists as imposing and influential figures within the press, and has continued to be a major reference point for subsequent photoreporters. It was by no means a radical magazine; its socialism was right of centre and had little to do with the kinds of left politics which had contributed to the making of the documentary photographs of Edith Tudor Hart, Margaret Monck and Helen Muspratt. It concentrated on similar issues, but its approach was populist and traditional. For women photographers, the real double bind of *Picture Post* was that it asked women to photograph women as men wanted them to be.

THROUGH THE LOOKING GLASS: PORTRAITURE IN THE STUDIO 1900-1955

Just a few years before the beginning of the First World War, a young woman travelled up from suburban Bromley to be interviewed for an apprenticeship in studio photography by the great Edwardian portraitist Lallie Charles. Some thirty years later, Edith Plummer, by then known as Madame Yevonde, recalled vividly her first impression of the rarefied world she was about to enter:

> The address was 39a Curzon Street, Mayfair. I found a small house, somehow rather romantic. The front door was actually in Chapel Street but some of the windows looked over Curzon Street. To the right were a few old-fashioned and exclusive shops, including a baker's, a florist's, an estate agent's and Jolly's the chemist across the road. The romantic little house showed not at all that a famous photographer worked behind its muslin curtains. There was no showcase, no photographs, not even a brass plate. My mind was a blank as I waited for an answer to my ring. A small, fat butler opened the door. He eyed me insolently. In a moment he knew I had not come to spend twenty guineas, and he summed me up as suburban and too young to be worthy of notice. I told him I had an appointment and he rather grudgingly showed me into a long, narrow room.[1]

The studio portraiture movement, flourishing in Britain from the second half of the nineteenth century until the early 1960s, channelled many women into photography as a professional occupation. Independent portrait practice, operated by an individual with or without studio and office staff, and catering to the needs of a general clientele or a particular group, was especially accessible to women. It offered a means of self-sufficiency and fulfilment to those women of middle-class origins who found themselves at the beginning of their working lives unequipped to promote themselves within occupations which traditionally demanded either precise qualifications or highly developed aptitude. Women came to studio portraiture by varying routes and this gave to the structure of studio practice a special flexibility which, by the 1920s, was seen to be particularly appropriate for women. In 1924 Molly Durelle wrote in *Women's Employment*:

> Photography is essentially a woman's employment. There is not a single branch of it in which she cannot compete equally with men, and in some cases she is a much more artistic worker . . .

Provincial towns and sea-side places provide the best openings for starting a studio; in large towns the competition is very much greater. Quite a good income can be made by a season on the Riviera or some fashionable resort which would give a very good idea of the expenses of working a permanent studio. The cost of plant for a small studio should not amount to more than £150–£200. I have heard of several which have started for even less than £100.[2]

It was important for women that the profession was seen to be so accessible. Many women who established studios during the late nineteenth and the twentieth centuries did so with little encouragement except that provided by their own personal motivation to avoid the tedium of enforced middle-class unemployment.

When Edith Plummer joined Lallie Charles she witnessed the Edwardian studio operating at full stretch. As well as her premises in Curzon Street, designed to impress and flatter clients, Lallie Charles had a works building in St John's Wood, where a separate trained staff developed and printed negatives, spotted and retouched the final prints and mounted customer orders on elegant folders. The studio had expanded rapidly since Lallie Charles had begun business in 1900, inspired by the success of the Victorian portraitist and copyist Alice Hughes who 'had made a great reputation as a lady photographer . . . her success led me to think that what one woman had already done another might do also.'[3]

Alice Hughes (c.1860–c.1945) was the daughter of Edward Hughes, a successful and prosperous Academician who specialised in the painting of Court portraits, especially of women and children. She was initially brought into photography as a copyist of her father's paintings, and he would refer to her work for 'details of pose and draperies' when painting 'the pretty women [who] flocked to be painted, following the Royal lead given by Queen Alexandra'.[4] As demand for her own portraits increased and she began to develop her work independent of her father's practice, she took a course as a private pupil at the Polytechnic School of Photography and opened her own photographic studio in Gower Street in the 1880s. Her portraits became popular with her father's sitters, to whom 'she used at first to give away her pictures . . . but that became too expensive as a hobby. It was revolutionary of her to open a studio of her own and to charge for her work, but she rapidly established a reputation for producing portraits of extreme refinement and prettiness.'[5] Many years later Cecil Beaton described them thus:

Here she posed, in sentimental attitudes, the grand ladies who came to visit her in their lacy tea-gowns, fondling their pomeranians or their young and semi-nude offspring or – if not fecund – they posed admiring a bunch of Madonna lilies. The metallic sharpness of Alice Hughes' lens was at variance with the lyrical mood which she wished to convey, and although apt to be stilted and sometimes absurdly artificial, these photographs [were] for a long while treated as a high status symbol.[6]

79 Alice Hughes,
Queen Mary with Prince
Edward, Prince George
and Princess Mary, 1877
National Portrait Gallery

Alice Hughes was acutely aware of dress and pose, and of the interdependence of the two. Her portrait of Queen Mary and her three children *c.* 1890 (plate no. **79**) is so dominated by dress that only the heads of the sitters emerge as important physical characteristics. The four subjects emerge from clouds of draperies, and the baby lying in its mother's arms is dwarfed by its voluminous gown, merging with the Queen's skirt. The sumptuous drapery clearly identifies the group's class and status, and the arrangement of the figures, with the mother flanked by her children, emphasises the solidity and unity of the family unit. Recording and perpetuating the idea of the family was as important a component of society photography as it was of snapshotting at this time. Glamour and elegance were of course vital to the portrayal of both royalty and high society, but equal emphasis was put upon the idea of the continuation of a lineage. That society people chose to have their family groupings portrayed by professional studio portraitists emphasised their desire to encompass them within their perception of current fashion.

Alice Hughes demonstrated two things to the women who followed her. The first was that studio photography was an occupation which a woman could pursue successfully with only brief training; the second was that studio portraiture mirrored fashionable preoccupations. The studio photographer could innovate, but she could not deviate from received ideas of elegance. At a time when family life was seen to be of paramount importance, so Alice Hughes photographed women at its centre. By the time Lallie Charles had become a central figure in photographic portraiture, another model of femininity had been set up.

From the beginning, Lallie Charles's business was centred around the portrayal of beautiful women. But where Hughes had pictured them as aristocrats, Charles pictured her subjects as elegant innocents, seemingly untouched by the wealth which they undoubtedly possessed (and of which a visit to the Charles studio was irrefutable proof). In her meticulous attention to the creation of a romantic studio setting and to the construction of a particular easy ambience in her reception rooms and studio, she was the first of a long line of women photographers who saw the experience of being photographed as of equal significance to the final work itself. In her Curzon Street studio, Charles created an atmosphere not only of luxury and wealth, but also of feminine innocence: 'Everything seemed pink in this room,' reminisced Madame Yevonde. 'The curtains were of rose-coloured silk, the chairs were upholstered in pink velvet, and a thick-piled carpet covered the floor. Even the photographs were of a pinkish tinge.'[7] Women came to Lallie Charles to be transformed from sophisticated, worldly socialites to creatures of innocence, passive and forever girlish. She constructed a kind of Arcadia in her photographs, posing her subjects sniffing hydrangeas, dressed in lace against a softly lit window and gazing submissively towards the floor (plate no. **80**), dreamily reclining in a chair surrounded by soft drapery. Here, with only a gentle suggestion every now and then of a rich sable coat hung around the shoulders or a string of pearls looped casually around the neck of a simple dress, were the new peasant girls of the *haut monde*. And from the Curzon Street studios the photographs went to their wealthy subjects and often to the glossy society magazines where Arcadia appeared in print, sanctified by the publicists.

Lallie Charles departed completely from the family-based photography of Alice Hughes, but in concentrating instead on a style which depended for its effectiveness on ideas of simplicity and submissiveness, she in turn failed to recognise the new needs of the twenties as the public began to demand portraits which were sharp, incisive and witty. The clean lines of Dorothy Wilding's portraits from the twenties and thirties made Charles's soft romanticism seem like fudge to fire; the loss of public innocence in the First World War reverberated through studio photography.

80 Lallie Charles,
Portrait of an
unknown woman,
c. 1905
Private Collection

Madame Yevonde, who had observed Lallie Charles closely throughout her own apprenticeship, described her fall from fashionable grace:

She had photographed everybody: the smart set, the rich set, the County, Royalty, princesses and prostitutes, the wives and mistresses of millionaires . . . everyone, in fact, who could scrape up five guineas, ten guineas, fifteen guineas, twenty guineas or thirty guineas had been photographed by Lallie Charles. There was no one left to photograph. Those who had been photographed did not wish to be photographed again. They were getting tired of the pale soft pinky

146

prints, tired of the artificial roses, of the Empire furniture and the Chippendale chairs. The lattice-window was old fashioned and the bearskin rug bored them stiff. They grumbled at the lack of variety in the poses. They said the prints faded, and returned them continually. They said the photographs were not in the least like them – in the old days the photographs had not been striking as likenesses, but there had been no complaints. There was nothing but grumbles and re-sittings: people did not like their proofs, or if they passed the proofs they did not like the finished prints.

Madam, in fact, was becoming a back number. She was still as extravagant. She entertained lavishly and bought new clothes and costly furs; when she went to the theatre she had a box. But her work bored her. In her heart she knew she was becoming a back number. She could do nothing about it. Perhaps she had reached the age when it is difficult for a woman to keep going, perhaps she was tired of the hard work. Perhaps the continual procession of faces – beautiful, ugly, vacant or brilliant – which had passed almost ceaselessly before her cameras, irritated her.[8]

The experience of Lallie Charles, who ignored advances in photographic style at a time when the fashionable West End photographer ignored them at her peril, stood as a lesson to the many young women and men whose careers were flourishing by the mid-twenties. Even those operating outside the glare of fashionable metropolitan whims and fancies acknowledged how the manner of portraiture must alter as predilections in dress and manner changed with circumstances. Madame Pestel (c.1884–c.1940), who was left in sole charge of her South Coast studio after the death of her husband, was one who appreciated the need to adapt her work in line with the austerity of the First World War:

Of course, just now, although there are plenty of sitters, I notice a big change. Women are not buying so many pretty frocks and as a consequence there is not much demand for full-length portraits. Very rarely indeed are anything but head-and-shoulder pictures wanted now. Men in uniform sometimes want full-lengths, but the majority prefer to show as little of the figure as possible.[9]

She created sombre, dignified portraits, eschewing, in collaboration with her sitters, any idea of frivolity or undue attention to attire. And at the same time she attempted to ensure that her studio itself generated an air of sober reassurance at a time of uncertainty and upheaval:

'I always try to cultivate the homely feeling. It is my constant aim to get sitters interested in something outside photography. I make them talk. Most people have their pet subjects; some can be drawn into conversation on art, some on music, some on sport, and I watch for the slightest indication of what to talk about and what to avoid. It's surprising, for example, what a number of people are interested in old furniture. I like it myself: but that's not the only reason I have for

81 Dorothy Wilding,
Elizabeth Allan, 1930
Private Collection

furnishing my rooms with these genuine old pieces. Some of my best
portraits have been taken before the sitters realized that I was doing
anything more than telling them how I managed to pick up that old
Welsh dresser' . . . To add to the cosy appearance of her studio.
Madame Pestel has adopted a very unusual covering for the floor. The
whole of the space is covered with a green, heavy pile carpet.[10]

Similarly both Madame Yevonde and Dorothy Wilding, who kept
their practices afloat for several decades, remained innovators and
supremely realistic businesswomen. However elevated and stylish

82 Dorothy Wilding,
Fay Compton, late 1920s
National Portrait Gallery

their practices became, they never abandoned the opportunistic entrepreneurship which had taken them both out of a stifling middle-class suburban girlhood and into High Society.

Dorothy Wilding's entry into photography, initially as a pupil retoucher to Ernest Chandler at Walter Barnet's Knightsbridge studio in about 1911, was for her a direct means of escape from a home background which she found limiting and repressive:

> I was the youngest of a large family, and at an early age my parents were so tired of children that they lent me out to an aunt and uncle, who being childless, thought it would be amusing to have me as a sort of novelty. So, at the age of four, I found myself a sort of permanent visitor, in a new household, situated in the south of England. By the time I reached the age of eight I began to think about things in general,

and I came to the conclusion that my mother evidently didn't trouble much about me, and that, in my aunt's home, I was more or less taking the place of a pet dog . . . At an early age I *definitely* decided I wanted to leave the country, go to London, and be entirely independent of all my conventional relatives. I had ideas. And I wanted to express myself through some artisitic medium.[11]

It is a sign of the buoyancy of studio portraiture that a young woman like Dorothy Wilding (1893–1976), with no connections and little or no training, was able to embark upon a career in photography with such relative ease, and that within three or four years, after working with Chandler, gaining general studio experience with the American portraitist Marian Nielson and then continuing as a retoucher at Richard Speight's New Bond Street business, she was able to open her own studio in 1914. It is significant too that the studio, which was to become one of the most important and innovative in London, and later also in New York, was entirely self-financed by the mid-thirties, dependent for its initial success on an immense determination and highly developed commercial and stylistic acumen:

> The day came, after weeks of day and night labour, when I was able to count the sum of sixty pounds. It was very little, but yet enough, I calculated, to start me off at the game – especially when I told myself reassuringly that I could manage on my stock of clothes for at least twelve months. And at the end of twelve months – well, who knows? That was in the lap of the gods. Now I set off in search of a studio. Eventually I found just what I wanted in George Street, Portman Square, within the golden area of London's West End, but not too outrageously expensive or pretentious for my pocket and my debut . . . It consisted of an exceptionally big, long room, with also a big, long window facing north, and a kind of small extended annexe on the room, about four by six feet, which was passable for developing, printing . . . and very elementary cooking! I lived in the studio and to give me some hiding space I hung up a green curtain across each end of the room, one end to hide all my clothes and belongings and the other end to hide the backgrounds and photographic equipment. My choice of lightish green was very deliberate; it was a useful background for any colour and it harmonised with the economy oak furniture I bought. I couldn't afford a carpet to cover this large room, so, instead, I made do with a very thick cigar-brown felt, the kind usually used under luxurious carpets.
>
> I scrubbed and cleaned and contrived and made everything ready for the sitters who, I hoped, would soon be queueing to be photographed by me! And, cannily, I kept my sparetime retouching for the Stereoscopic people to keep afloat meanwhile. I was ready to open my studio and I didn't owe anybody a penny. That was important to me.
>
> In my mind I had it all planned. My retouching would cover my rent and all I needed in order to eat was two sitters a week.[12]

Despite her undoubted sense of purpose, Wilding's early practice was governed by an optimism and belief in her own stylistic notions which, from the outset, were surprisingly mature. The photogra-

83 Dorothy Wilding,
Diana Wynyard, late
1920s
National Portrait Gallery

phers for whom she had already worked were solid and reputable
people who could teach her a craft rather than form her ideas, inform
her about the nature of business practice as much as they might
educate her in photographic technique.

Like the young Cecil Beaton, Dorothy Wilding's initial stylistic
impetus came from a study of picture postcards of theatrical person-
alities. Interviewed for an American broadcasting station before the
Second World War, she recalled:

> When I was about fifteen, there was a thing known as the *Post Card
> Craze*. All school girls went mad on collecting pictures of their

favourite actors and actresses. I became very keen on this, and quickly noticed that some of the photographs made a certain actress look marvellous, whereas some of them, on the contrary, made her look dreadful. And it was easy to see that this was the fault of artistry in the photographer.[13]

Although many of Dorothy Wilding's young actresses were as self-made as she was, and their populist appeal to the working class ran deep, they nevertheless had to be presented as ladies. Wilding's method of combining ideas of sexuality, class and wealth was carefully constructed to this end. In her 1929 portrait of Pola Negri, she clothes a woman in a sable and velvet coat, redolent of money and chic. While avoiding the explicit, she suggests that the woman is naked beneath the coat, that her wealth is informed by her sexuality. Above the coat appears Negri's face, fresh and youthful, an innocent rising above the trappings of wealth and glamour. It was of such exact combinations as these that Wilding's photographs were made.

Dorothy Wilding made women look as they had never looked before – beautiful, starkly elegant and uncompromisingly modern. The softness of Lallie Charles was replaced by an angularity which yet acknowledged and praised female sexuality. Wilding's women are never submissive but are a new brigade of self-made, self-sufficient characters, posed against harsh white backgrounds. Sometimes, as in Wilding's portrait of Elizabeth Allen (plate no. **81**), a vase of flowers harks back to Charles's Arcadia, but even here the arrangement is modern and spiky. Wilding's portraiture, often full-length or three-quarter's length, studies women's bodies carefully. Fay Compton's body (plate no. **82**) is delineated exactly by the flow of her dress and by the shadow appearing behind her. The photographer's attention to detail is such that the shoe which obtrudes from the hem of Fay Compton's dress follows through the diagonal line to her clasped hands which, in turn, make the line from her fingertips through to the swirling hem of her dress comprehensive and rhythmic. As if to compensate or balance this lyrical rhythm, Wilding uses the diamond cross on Compton's dress to make associations with the angularity of the background. Such a composition is complex, carrying the photograph well beyond the received notion of the glamour portrait.

While Dorothy Wilding did not exploit the limits of the photographic format as later innovators in the thirties were to do, she took the portrayal of elegant women far beyond the boundaries set by her Edwardian predecessors. Her portrait of Diana Wynyard (plate no. **83**), posed like a Greek statue, is one which exemplifies Dorothy Wilding at her best. The arrangement of the arms, prefiguring the work of later modernists, provides a link between the hardness and coldness of the block upon which Wynyard leans and the soft, pleated folds of her dress. It was such a link which Wilding provided between the romantic pictorialism of the Edwardian Lallie Charles

and the radical symmetry of the innovators who came into prominence in the decade which followed.

From the beginning of her career, Wilding was interested in surface, in decoration, in externals, and she frequently judged her sitters by their anatomy:

> I like high cheekbones and features that you can 'get hold of'. You do not want vague features, but good jaws and fine high cheekbones. The sculptured type of face, the kind of features that you can light up well . . . Skin is important. There is a lot of difference in the quality of skin people possess. Some people's skin photographs well. A very 'mat surface' does not photograph well. A silky look is good. I always advise my sitters not to use much powder when being photographed. There are people who have a naturally soft sheen to their skin and this photographs exceptionally well. A freckled face is difficult to light up.[14]

The people Wilding portrayed complied with this notion, and their complicity was essential to her method. Good jaws, fine high cheekbones and a silky skin were as much their stock-in-trade as they were Wilding's, and every component of Wilding's business, from the decoration of her studio to the mounting of her photographs, stated clearly and without ambiguity that celebrity and a highly stylised personal beauty were essentially interlinked.

Wilding's lifelong concern with the stylistic detail of her business was evident from the opening of her first studio in 1914. She worked hard to create a public persona far removed from that of the practical technician and business person she was, and early in her career even considered the adoption of a *nom de plume*:

> At the very beginning of my new life I tried every conceivable name for signing under my photographs, and one which I toyed with for quite a while was 'Glen Lorraine'. I have to laugh as I recall how I wrote it this way, that way, the other way, and any way to get the best effect. It appealed to me particularly because I had a flair for writing capital G's.[15]

Such minutiae may seem insignificant within the broad context of a photographer's career, but studio photographers were as a group intensely concerned with the detail of their presentation to their desired clientele. Many women studio photographers working between the two world wars prefixed their names (either real or invented) with 'Madame'. Lallie Charles did so, so did Edith Middleton (formerly Plummer), who became Madame Yevonde. Madame Pestel maintained a thriving studio in Eastbourne; Madame Harlip operated from premises in New Bond Street. The wide adoption of *noms de plume* and titles invested the women who used them with an ambiguous status. While 'Madame' was associated in Britain with a superior lady, it also had many connotations which high society could recognise of exclusive service, of a conscious gentrification rather than a straightforward professionalism. For women working

within portrait practice, this kind of equivocal relationship with their clientele, and most particularly with their female customers, was of the greatest importance. Dorothy Wilding's sitters were as dependent upon her skill as an image-maker as she was on their ability to fuel her business, and in some way this mutual dependency had to be acknowledged, without either person feeling in any way diminished. It is this aspect of the relationship between the possessors of physical elegance and the interpreters of it which Wilding herself describes in her account of a meeting with Tallulah Bankhead in New York just before the Second World War:

> 'Dah-h-ling! What are you doing over here?' she exclaimed, and in a voice that could be heard by the kitchen staff she turned to the diners and declared, 'This is the woman who made my name in London with her beautiful photographs of me!' As all heads in the assembly swivelled towards us, I threw out my hand with a Shakespearean gesture, faced the audience and announced, 'And this is the woman who made *my* name with her beautiful head.'[16]

If nobody knew better than Dorothy Wilding the power of the photograph to create or destroy the desired image, nobody needed this knowledge more than the theatre people and celebrities who made up her clientele.

In order for the client to feel confidence in the chosen photographer and for the photographer to create the required atmosphere of elegance and ease, the studio had to offer its own easily recognisable style, not just in its photographic product but in its overall ambience. Like most of her contemporaries, Dorothy Wilding was exceptionally conscious of the need to make her sitters feel that they were not only in the hands of an accomplished photographer but also privy to exclusivity. Wilding's own presence clearly created a compelling combination of reassurance and comfort:

> Dorothy Wilding is herself quite a 'personality', unusual and amusing. Short, dark, plump, her extreme naturalness takes any one off guard, puts them at their ease, causes them to let down the bars and 'be themselves'.[17]

And her studio decor was stylish and progressive enough to suit the most demanding arbiters of taste. An American observer viewed her first New York studio on 56th Street thus:

> . . . with its perfect lighting, [it] was a distinct surprise. Here was the perfect setting, with its fawn covered modern couches, perfectly supplemented by a fine old Italian table, credenza and chest, which had been pickled, and blended perfectly with the light feeling of the decoration of the room. A tall stone shaft in bas relief, reminiscent of the Egyptian obelisk, but topped by a large bowl, furnished the very adequate lighting of the room. Adding to the beauty of the whole, was the interesting window treatment. Over the curtains, hung a most unusual glazed chintz, with silver patterns on a white ground.

This, together with the large pale green fringed rug, completed this very delightful room.[18]

Opened at the height of Dorothy Wilding's success and prosperity, and designed in collaboration with her husband, the architect Rufus Leighton-Pearce, it was perhaps to be expected that this studio should lead the way in terms of design and furnishings.

Dorothy Wilding continued to work in photography until 1957. Although the modernist direction which had so empowered her work during the inter-war years ceased to inform her later photography, her career was sufficiently well established for her to maintain her business even when she was no longer in vogue. By the early fifties, it had fallen to other women portraitists to produce images which complied with some of the preoccupations of post-war Britain.

One of these was Betty Swaebe (b.1917), who worked as a studio photographer from 1941 after an apprenticeship with the eminent studio worker Howard Coster. She demonstrated again the essential symbiosis between client and photographer, but to a very different end from Dorothy Wilding. While a certain desire for glamour could not be disregarded, during the late 1940s and fifties, high society, perhaps taking its lead from the conservative and homely Royal Family and reassessing its position after the changes which war had brought about, desired to emphasise dignity, restraint and wholesomeness rather than the frivolity and excessiveness which had characterised its pre-war activities. Attentive to the changed demands of her prospective sitters, Betty Swaebe thus based much of her practice on an aristocratic conception of family structure which was reminiscent of Alice Hughes's work. Her photograph of Lady Melchett and her children, made in 1954, mirrors in its arrangement Hughes's earlier study of Queen Mary. Here is the same elaborately costumed family set against a luxurious interior, a mother seated with her children clustered around her. Dress and ornament play the same role as they did in the earlier Hughes picture: they are embodiments of class, status and wealth, easily identified, easily assimilated. Like other Society portraits, it provided an exceptionally accessible means of promoting the idea of family and of establishing it firmly within a structure identifiable by its use of certain symbols of wealth and power. When families were being photographed, and most particularly when the subjects were women and their children, much use was made of obvious indicators of domestic luxury and elegance. In many of Betty Swaebe's portraits from the mid-fifties, and notably in her studies of Henrietta Tiarks (1957; plate no. **84**), Lady Frances Curzon (1957), and Sally Poole Crocker (1957), the young women, although simply portrayed, wear emblems of their class and social position – a string of pearls, a brooch or bracelet – illuminating, not as Dorothy Wilding would have done, the swan neck of a beautiful celebrity or the slim wrist of a young actress, but the solid determination of a particular group within British life to

maintain and perpetuate its distinct position. More than any of the other photographers, Betty Swaebe, together with her father, the former actor A. V. Swaebe, founded her practice on the need of her clientele to bolster and enrich their collective image. From her earliest years at the Swaebes' Grosvenor Street studio, she specialised in creating photographs for use in glossy magazines designed for reading by the general public; then, interestingly, during the post-war period she began to move away from the traditional studio portrait towards what were virtually photojournalistic assignments, attending traditional society gatherings to produce photographs of group activities and celebrations. During the 1950s she went to many of the events which reinforced, in the mind of the public as well as within society itself, the tribalism and continuity of upper-class life in Britain. In summer she would travel with the nannies and their charges on annual holidays to Frinton on the Essex coast, and was present at the traditional gatherings enjoyed by debutantes at Bembridge on the Isle of Wight.[19] It is telling that Betty Swaebe continued her photographic career until her retirement in the mid-1970s, and that the business founded by her father still continues in North London. Some studio practices were sustained not so much by their ability to dictate fashion but rather by their resourcefulness in managing to avoid it. The solid, moneyed, titled families whom Betty Swaebe photographed during the fifties desired not so much to lead fashion as to seem to be impervious to it, perpetuating values unchallenged before the Second World War but under siege after it.

While women operating in studio portraiture practised with particular verve from 1900 until the mid-thirties, the force of the movement, and the demand for its product, sustained post-thirties practice in Britain. Betty Swaebe's was one of the most vital of these, as also was the studio of Florence Mellish (later Entwhistle; 1892–1982) who worked under the *nom de plume* of Vivienne. Like so many women, Vivienne came to professional studio portraiture more through expediency than through conviction. She had for a time shown promise as a musician, making her concert debut at London's Wigmore Hall; then, after marriage to the art teacher Ernest Entwhistle just prior to the First World War, became actively involved in the fine arts. Entwhistle's private art school in St John's Wood closed for the duration of the war but re-opened immediately afterwards, and throughout the 1920s Florence established herself as a working artist, particularly as a miniaturist. It was only after the closure of the school in 1934 that her attention began to turn to photographic portraiture. Coming to photography in her fifties, the thrust behind Vivienne's career was bound to be different from that of, say, Barbara Ker-Seymer, whose primary experimental work was achieved during the years 1930–1935, or from that of Dorothy Wilding, whose style had been formed during the innovative years of the 1920s and who, by the mid-thirties, was a portraitist of

84 Betty Swaebe,
Henrietta Tiarks, 1950s
*Courtesy of the
photographer*

enormous subtlety and strength. By 1934, Vivienne's notions of
portraiture were well formed, just as Alice Hughes's had been, by
principles derived from portrait painting. But where Hughes
concentrated on a certain depersonalisation of her subjects by drawing
attention to ornament and finery, Vivienne focused attention on
faces and on the positioning within the frame of head and shoulders.
Her portrait of Wendy Hiller (plate no. **85**) draws every point of the
viewer's attention towards Hiller's face, turned skyward in heroic
style, illuminated as if by some stirring light in the sky. It is a
portrait, like many others of Vivienne's, which emphasised a separate
intelligence, an individual operating on a self-defined plane.

Vivienne's work came to particular prominence after the Second
World War when she photographed many members of the new
meritocracy, emerging as an important portraitist of rising television
personalities and cultural taste-makers. Her work from this time is
typical of much fifties studio portraiture and marks the end of the
movement as an innovative force within British photography. Her
portrait of Mary Ure, made after the war, gives an impression of a

photography which lacked an overall direction. In the photograph Vivienne attempted a number of devices, including an emphasis on contrasting textures – a spangled scarf set against a smooth skin, a deep shadow cutting across a brightly lit face – but the portrait lacks conviction. By the fifties studio portraitists had a vast repertoire of visual effects to choose from, but the innovative fervour which had earlier produced the pictorial virtuosity of twenties' workers like Dorothy Wilding was no longer evident.

From Hughes through to Wilding, and in some senses to Betty Swaebe, studio portraitists had, in pursuit of one end or another, attempted to subjugate the personal by replacing it with an over-whelming notion of style. Hughes's groups established the aristocracy within the public mind and within their own consciousness as the touchstone of glamour, albeit imbued with tradition. Lallie Charles abandoned a sense of the traditional and tempered the mystique of aristocracy by beginning the process of democratising glamour, a process which Dorothy Wilding continued and perfected. Both Charles and Wilding maintained through their photographs that glamour was a matter of possession and skill rather than of right, that it was essentially manufactured by talented practitioners like them-selves, carefully nurtured in surroundings of chic and high style but backed up by a machine of well-trained operatives. Contemporary commentators have largely ignored or dismissed studio portraiture in England because it is perceived to have failed the criteria of incisive portrait photography established in the work emanating from Europe and the United States. It has not been seen for what it was – as a social and economic liberator for many women, and indeed for many men, and as a photography which consistently eschewed the notion of the personal. Studio portraiture concentrated instead on symbols, and existed in its precise understanding of class and of the presentation of worldliness. If Vivienne's subjects are seen to present a greater idealism and intelligence to the public through her photographs of them than, say, Dorothy Wilding's, then that was primarily because this was what fashion demanded. If Betty Swaebe's debutantes seem solid and without care for prevailing trends, then this was because the economic and social circumstances which prevailed during the mid-fifties demanded restraint on the part of those who were members of the aristocracy rather than of the meritocracy.

For feminist commentators, the issues which practitioners like Wilding, Swaebe and Hughes raised are of the highest significance. While Wilding can be seen to have liberated her sitters by allowing them to express themselves as sexual beings, the terms in which she delineated that sexuality must, in the end, be recognised as having limited and overdefined women as symbolic objects, epitomising freedom and self-sufficiency to a precise extent but eventually with-drawing from women their ultimate right to perceive their own sexuality and to picture it without perpetually succumbing to the

85 Vivienne (Mrs
Florence Entwhistle),
Wendy Hiller, late 1950s
National Portrait Gallery

demands of style. The takeover of fashion photography at the point at which studio photography went into serious decline served only more intensely to depersonalise women in the interests of fashion and of style. While Wilding's picturing of women during the twenties may have sprung from a reverence for beauty and elegance taken to stylistic extremes, later post-war photographers, owing nothing to Wilding's appreciation of working as a woman photographer in a woman's world, rechannelled her descriptions of sexuality and subverted them entirely to the explicit and outspoken needs of the post-fifties sexual revolution. If during that revolution women's sexuality as portrayed through photographs became so fully depersonalised that it emerged as stylish pornography, a combination of fashion and glamour, it would be wrong to suppose that this was the result of entirely new modes and social pressures. The pressure upon women to give up their bodies for the sake of society's whims

was as apparent in Alice Hughes's photograph of the swathed, child-bedecked Queen Mary as it was decades later in Wilding's pristine classical portrait of Diana Wynyard, or even in Vivienne's brave-faced Wendy Hiller. Later photographers merely took up and replaced the clues which generations of earlier studio photographers had put into position.

Feminist photographers are beginning to reinterpret the tradition of studio portraiture, to revalidate it in terms of the reassertion of women's visual identities. If studio portraiture did not recover its force within commercial photography in Britain after the fifties, its practice in the early sixties led to its usage within feminist photography. The background of one of the most interesting workers in women's photography today is worth studying in this context.

In 1951 Jo Spence (b.1934) began work as a shorthand typist at Photo Coverage, a commercial studio run by an ex-RAF reconnaissance photographer, Stephen Taffler. Taffler's photographic practice was a general one, and Jo Spence remembers that some of the studio's business revolved around photographing hotels, society group functions and weddings.[20] It was a typical post-war commercial studio. Spence eventually became its manager, administering the apprenticeship scheme run by the firm, and taking bookings. In the late fifties she took advantage of the apprenticeship scheme herself, and enrolled at the Ealing Polytechnic, but after a good deal of questioning about the structure of the course, left after only three months.

In 1962 she worked as part-time employee both for Photo Coverage and for the industrial photographer Barnet Saidman. The following year she took the job of assistant to the Canadian advertising photographer Walter Curtin. Curtin's work took Jo Spence into areas of practice which she had not encountered before: his approach was roughly a combination of documentary and advertising,[21] and his assignments, which included public relations photography for Shell Oil and some of the major banks, involved setting up real-life situations to be photographed. She remembers:

> For instance, if we wanted to photograph a block of flats, my job would be to ask all the people in the flats to come out and stand on their balconies; once we had to hire a bus and fill it with extras. I had to find models and arrange locations, iron the models' clothes. Curtin employed two people, a printer and me as assistant, a 'Girl Friday'.[22]

This use by an advertising photographer of documentary was intriguing for Jo Spence, for it posed new questions about the use of photography and the validity of the documentary 'reported' image. Issues such as these became important to feminist and socialist photographers working during the seventies, and both were reflected in the Hackney Flashers group of that decade, of which Spence was a member.

Although Jo Spence was engaged in photography continuously from the beginning of the fifties to the present day, her career as an

operating photographer (as opposed to an assistant, manager or administrator) did not begin in earnest until the mid-sixties when she took over Sydney Weaver's studio in Hampstead. It was here that she really began to consider the complexities of photographic image-making and to analyse the relationship between the photographer and the photographed. Now she sees her role as studio portraitist as having been one in which she gave her sitters 'permission to fantasise about themselves'.[23] Each photographic session was preceded by a discussion about how the sitter wished to appear: 'I knew how to treat men and women differently, and there was a big difference between photographing members of the public and actors.' Actors, Jo Spence conceived, knew how 'literally to construct themselves for the camera. Basically they use their facial expressions, their hair, their hands, much more than most people do. People know how to do that in the real world, but they don't know how to do it for the camera.'[24] Like studio portraitists before her, she quickly realised that people selected a particular studio because they could identify with its style, or because they wished to adopt the style which the photographer offered:

> When I started, I wanted to photograph actors and actresses, so in that sense I was already one step beyond the aspirations of a high street photographer. In fact, though, I'd photograph anyone who came through the door. I even borrowed a set of somebody else's photographs to put outside the studio, because I hadn't got any decent samples of my own. As I worked out better techniques so I gradually replaced these shots with my own. The pictures I borrowed from a female colleague [the photographer Lisette] were all of the pearl-and-twinset type of person, and so they were the kind of people I got in the beginning.
> I found that what you put outside the studio in some way dictates who comes through the door. A series of different people started to come in as the pictures changed, like an Indian dancer, a black body builder, and a woman who wanted herself photographed in the nude; they went beyond the images outside. When I put their new icons outside this indicated that I'd shifted my range of photography, and then it also influenced what I was asked to do at high street level because people thought 'Oh, she's an arty photographer, she will do an artistic number of our family.' Then back it rippled across mostly middle-class clients who came in and said, 'Oh we don't want a straight portrait.'[25]

The individual fantasies which each studio offered were as important to studio portraitists during the sixties as they had been since the beginning of the century.

During her seven years at the Hampstead studio, Jo Spence also began to think about the representation of women through portraiture. She realised the importance of the photographer's own taboos, as when, for instance, she found it difficult to photograph women in nude poses.

86 Jo Spence, Wedding portrait, early 1970s
Joanna Spence Associates

I had a great number of problems photographing women with no clothes on. Because of my own ideological problems of looking and fears about my own desires. You project on to the sitter to some extent as a woman.[26]

She discovered that she was 'building up a good reputation for photographing women who weren't pretty. Never having been pretty myself, I empathised with other women who weren't.'[29] Invited, as a photographer, into the private lives of the public, Jo Spence was able to observe the complexities and paradoxes of family life. As a wedding photographer, she participated as a paid outsider in that most complicated of inter-family rituals. Remembering, in 1983, this period of her career she said:

I started doing Hampstead weddings and they were fabulous, because that's just visual anthropology on the move. You are actually paid to go and watch people's lives and eat their best food and wine. I used to go and perform through a kind of split personality where I would do romantic lovey-dovey stuff and the standard groups that I'd watched other photographers doing outside registry offices, and I knew from my own experience what was expected. But I was also influenced by

Diane Arbus. I was a nasty, sneaky, little rat behind the camera who said: 'I'll show you what you are really like.' So at a wedding I would be oscillating across these two areas, and then I found that people really liked both types of pictures. Only it wasn't always the same people. So, the wedding couple might like the 'Diane Arbus' shots of their families, and the mums and dads would pick out the lovey-dovey stuff. It was extraordinary.[27]

In a photograph of a bride taken in the early seventies (plate no. **86**), Spence pictures the woman alone, smiling fixedly, surrounded by impedimenta. She is holding a bunch of lilies (as Spence herself was to do in her 1986 posings of herself as a bride), and behind her the arrangement of mirrors and a painting assumes the power of an altarpiece. Her photograph goes behind the looking-glass image of the bride, reflecting society's image of wedlock as blissful and permanent, and uncovers a bewildering array of perplexities, clashes and deceits. In one of the series in her 1986 *Photo Therapy* exploration (with Rosy Martin; plate nos. **87–88**), Jo Spence returned to the concept of the picturing of woman as bride in order to explore the 'complex set of possibilities' which the notion of portraiture offers.[28] In this series, presented with all the elegance of the studio portraitist, she conducts her viewers through received ideologies of marriage. The bride is by turn submissive, apprehensive, shocked, harassed, grieving, coy and anticipatory, at all times a reflection of attitudes rather than a determiner of them.

As a studio photographer during the sixties, Jo Spence was invited into private lives, asked to reconstruct, through photography, the pattern of a stranger's existence. In no area of her work is this more significant than in that undertaken with family groups. To stress the power of portraiture over the family's perception of its own image, she quotes this apocryphal exchange: 'Two mothers meet, and one mother says to the other: "Isn't your child beautiful," and the other says, "Yes, but wait till you see the photographs!"'[29] During the course of her work with family groups in Hampstead, Spence developed what she now calls 'the split eye – being able to watch the studio group, and then watching what was going on behind it'.[30] In two studies of family groups taken during this time, she explores and exploits the fragile structure of domesticity. In one photograph made in the early seventies (plate no. **89**) two parents, the mother and father of new twins, isolate themselves from their older children, pushing them out from the centre of the photograph, excluding them from the family group. Marooned on either side of the sofa, displaced from the family cluster and replaced by the new children, these two are uneasy, resentful and unexpectedly lonely. The picture is resonant with a sense of domestic catastrophe. The mother is enclosed in a capsule of maternity, and only she is smiling; even the father of the twins is not included fully – he stretches out a tentative finger to caress one of his children, but his gesture is uncertain. In another group photograph, Spence states clearly that the photographer

87 and 88 Rosy Martin/
Jo Spence, 'An ex-
wedding photographer
has a photo therapy
session in which she
explores the concept of
powerlessness'
Rosy Martin/Jo Spence

was present by revealing the boundaries of her studio backdrop roll. The family members whom she photographs are unaware of the intrusion and present themselves as insular, perfect in appearance, united by gesture. By introducing the machinery of portraiture into the photograph, Spence reminds us of her presence, of her participation in the photograph, challenging the family's perceived notion of its own self-sufficiency and perfection.

Spence's earlier observations about family groups made during her time as a studio portraitist are highly significant when brought into discussion about her work as member of the Polysnappers group (whose other members were Mary Anne Kennedy, Jane Munro and Charlotte Pembrey). Writing about their work on *Family, Fantasy and Photography* (which formed part of an exhibition which was produced when the members of the group were final-year students

89 Jo Spence, Family
group, 1970s
Joanna Spence Associates

at the Polytechnic of Central London in 1981), the Polysnappers
suggested that:

> In western society particular ways of discussing the family have come
> to be seen as dominant and correct, and it is seen as the most 'natural'
> way to live – particularly the nuclear family. It is believed to constitute
> the realm of 'the private' whereas in fact it is highly public through
> forms of legislation and taxation, and through institutions of education,
> welfare and surveillance. A lynch pin in our class society, it is seen as a
> universal state, outside of history, outside of power relationships – 'an
> ideological haven in the heartless world of capitalism'. Visual
> representation privileges this dominant grouping of people, naturalising,
> romanticising and idealising family relationships above all others. In
> this exhibition we have tried to indicate that we could perhaps look at
> the family as an ideological sign system.[31]

In the 1880s, Alice Hughes used family groupings to reinforce the
public's perception of the confidence, security and prosperity of the
Royal Family and the aristocracy. Continuing into the 1980s, Jo
Spence and many other feminist photographers have been actively
deconstructing such an ideology. In its maturity, studio portraiture,
which for so long thought of itself as essentially a passive form,
reflecting society's preoccupations, has begun to consider its powerful
and manipulative relationship with society's most sacred structures.

■ CHAPTER EIGHT

CELEBRATION AND SATIRE: FEMINIST PHOTOGRAPHY 1970-1986

The women's photography of the last twenty years presents a complex range of highly significant developments. To attempt to detail all of these would be unsatisfactory insofar as such a discussion could be only a superficial one. The analysis which follows therefore attempts to trace some of the developments which signalled the beginnings of a feminist practice in Britain, with particular emphasis on the progression of documentary photography since the early seventies. It also pinpoints some of the vital moves within the organisation of women's photography which have created a particular place for feminist work within the medium.

During the 1960s, an emerging consumerist culture, founded on a combination of received ideas of glamour and new sexual and social mores, saw photography as its main vehicle for propaganda. Whereas before the Second World War women in photography had featured strongly as interpreters of female elegance and sexuality through the medium of studio portraiture, by the 1960s the emphasis had switched to fashion photography. For the first time in photography's history, ideas of female glamour began to be interpreted almost wholly by men. Even the newly established magazines like *Nova* were the result of a raising of a *male* consciousness about women's roles rather than of feminist thinking. For women, the sixties were confusing years; film, television and mass-market publishing presented them with an image of themselves as progressive, intelligent, dynamic and sexually potent, yet for most British women life had changed little from the way it had been during the post-war austerity years. Women saw themselves being presented as capable and versatile organisers, able to control jobs, family and relationships effortlessly. If the writers contributing to the new magazines did address new issues, they did so from the viewpoint of the educated, moneyed middle classes: for working-class women, no platform existed. During the Wilson years, the political left took on an increasingly chauvinistic stance and had little sensitivity towards those ways of picturing women which had been so effective before the war. Turning away from traditional left politics, women photographers had, by the mid-sixties, begun to direct their work towards a women's audience which establishment channels overlooked.

90 Val Wilmer, 'Sadie Saddlers, Member of the Church of God in Christ, Mississippi, 1972'. From the one-person exhibition *Jazz Seen: The Face of Black Music*, held at the Victoria and Albert Museum, London, 1973 *Courtesy of the photographer*

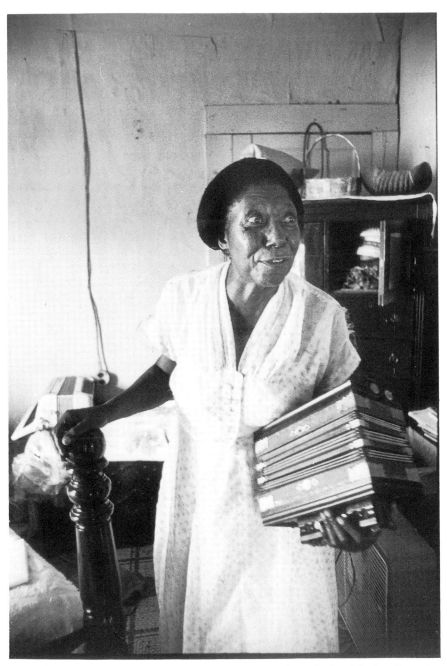

Many of the photographers who are now identified with the feminist movement of the early and mid-seventies began developing their photographic thinking during the sixties. The photodocumentarist Maggie Murray entered the Regent Street Polytechnic in London in 1963, as many of her predecessors had done. Other students in that year's intake included the future documentary photographers Val

Wilmer and Sally Greenhill. The Regent Street Polytechnic was one of the few colleges administering a photographic course which included women as senior members of staff. The photographer and theorist Margaret Harker was head of the photography school, and was an important reminder to the young women on the course that women's engagement in photography was not new. Guest lecturers, too, provided important impetus: Maggie Murray remembers particularly visits by the fashion photographer Mrs Challoner Woods and the photojournalist Peggy Delius.[1] The example of such distinguished teachers meant that women starting out in photography during the early sixties were certainly conscious of both earlier and contemporary workers – Maggie Murray remembers being aware of the work of Ida Kar, Sandra Lousada and the theatre photographer Zoë Dominic – but this did not generally extend to a consciousness of an alternative, specifically women's photography concerned with women's issues. At such an early stage in their careers, they saw themselves within a mainstream tradition, and when they wanted examples of good photography they turned to *Vogue* and to the *British Journal of Photography*. Neither the language nor the visual awareness had yet developed by which women could view photography in feminist terms. When Maggie Murray, for example, visited the Whitechapel Gallery's Ida Kar exhibition in 1966 she saw it as 'photography rather than women's photography'.[2] And on completion of her training she moved directly into social documentary, but, she says, continued to look at women in a traditional way. She visited Ghana during the very early seventies but photographed African women as a photojournalist rather than as a feminist.[3]

That politically aware women like Murray were participating during the sixties in the upsurge of mass public protest around such controversial issues as American involvement in Vietnam did not necessarily mean that these events were specifically linked with their own photography. Photojournalism was still élitist, and photographers continued to rely upon the patronage of influential picture editors on major newspapers to sell their work. When the photojournalist Sally Soames visited the picture editor of the *Sunday Times* in the early sixties, 'he told me that "a woman would be employed over his dead body". He took me to Ernestine Carter, the Woman's Page editor, for whom I worked a lot.'[4] As in the days of *Picture Post*, editors saw women photojournalists as being suited to cover 'women's interest' stories. It was not until the beginning of the seventies that women began to turn away from issues which mass publishing had decided were of interest and to explore those which reflected women's real lives and preoccupations, be they social, political or economic.

But the raising of women's consciousness about the presentation of their own image relied not only on a personal/political reawakening, but also on the emergence of distribution and viewing networks. The growth of feminist photography in Britain coincided with the

91 Susan Hiller, detail from 'Midnight, Baker Street', 1983. The complete work is a set of three C-type photographs, enlarged from hand-coloured photobooth originals, each 30" × 20"
Photo courtesy of S. Coxhead; illustration courtesy of the artist

resurgence of interest in photography as an art form and as a communicator. The publication of *The Concerned Photographer: 2* by Thames and Hudson in 1972 brought the high-quality photoreportage of workers like Bruce Davidson, Gordon Parks, Don McCullin and Eugene Smith into libraries, colleges and bookshops. The availability of these kinds of books established a debate among British photo-documentarists which centred around the stance of the photographer in relation to her or his subjects. Many feminist photographers, although undoubtedly impressed by the calibre of this powerful documentary work, also saw its political limitations and observed the consistent lack of interaction between the photographer and the people being photographed. Photojournalism had judged itself, erroneously, as being without class or sex consciousness, and it was the new feminist photographers who drew attention to the need for a reassessment of current practice. Up until then, white middle-class photojournalists had provided society with its visual interpretation of events at home and abroad by thinking and titling themselves 'concerned'; the public was sold a humanitarian view of world politics, presented with drama and enormous skill.

Some women in the 1970s and eighties produced work which stood as a marker to the ways in which women photographers and artists were beginning to consider their own positions as women within the creative and political context. Where the Hackney Flashers,

Who's holding the baby...
and where?

92 The Hackney Flashers, Exhibition panel from *Who's Holding the Baby?*, 1977–78 *Courtesy of The Hackney Flashers*

Jo Spence, and satirists like Jill Posener and Cath Tate have their roots within mainstream photographic traditions, the works of the artist Susan Hiller, one of a group of women working within a primarily fine-art context, signalled a significant departure: it represents a counter-balance to a more direct and accessible feminist photography (plate no. **91**). Talking with Rozsika Parker in 1983, she reflected on her work on dreams:

> I think it was James Hillman who said something about the fact that we worry all day about what our dream self gets up to – people talk about it in analysis and so on – but what if our dream self is deeply, deeply disturbed at what we get up to during the day? (*Laughter*) So much of the truth about the situation of women that has been discovered through the hard intellectual work of the women's movement is about retrieving repressed, suppressed, unknown, rendered invisible, erased, negative meanings – so it makes sense to locate this work from the other side looking back.[5]

Considering her work on automatic writing (continuous since the

early seventies) in the same interview, Hiller said:

> Women who are struggling with their own incoherence tell me they
> identify with this work. They feel they recognise these signs . . . what
> can I say? . . . these ineffable signs, because don't forget that on one
> level the world is constantly presenting us with signs that we as
> women have to deny or translate. My scripts are signs with a slightly
> exotic, hieratic feel to them. They don't accuse us the way signs in the
> world do.[6]

Working within a fairly classical documentary tradition, in 1972
the Half Moon Gallery in Whitechapel initiated a photography
project which was to result in an exhibition called *Women On Women*.
A group of women photographers was formed to construct this
project, and among its members were Maggie Murray, Sally Green-
hill, Val Wilmer and Angela Phillips. Maggie Murray recalls that
'through these meetings we met Jo Spence, and this led to the
formation of the Hackney Flashers'.[7] Given the present sophistication
and refinement of feminist photography, *Women On Women* does not
startle, but in 1972 it was the first project to be presented to a British
audience which not only showed women attempting to take photo-
journalism away from established stereotyping but also established
women's right to picture themselves. *Women On Women* was one of
the first exhibitions to propose that photojournalism need be neither
mysterious nor élitist. Unsophisticated as it now appears, it intro-
duced the concept of collectivism into exhibition-making, removed
the established relationship between curator and artist and introduced
the idea that the woman photographer was a vital part of a reforming
feminist movement.

The popularity of feminist journals (the earliest and most prominent
of these being the highly illustrated *Spare Rib*), and their enthusiastic
use of photographs by women, created one important outlet for
feminist photographic work in Britain. Undoubtedly many young
women photographers were encouraged to continue in the medium
because of these opportunities to publish. The *Format* photographer
Brenda Prince remembers well the impetus given to her when her
first *Spare Rib* photograph was published, and looking through the
magazine's back copies the direction and precision of the picture-
editing can be quickly discerned.

With the formation of the Hackney Flashers in 1974, women
refined even further the idea of the group dynamic:

> All of us work within education or the media and between us share a
> variety of skills – design, illustration, photography. Our practice is
> also rooted in on-going discussion and criticism around feminist issues
> and the prepresentation of women. We all define ourselves as socialists
> and feminists.[8]

Even more importantly, the group's nine women members began to
study the use of photography within the capitalist system and to

present alternatives. They played a decisive part in establishing a context within which women workers from different cultural fields could work together in pursuit of a collective political aim.

In its two exhibitions, *Women at Work* produced in 1975, and *Who's Holding the Baby?* (plate no. **92**), first shown at Centerprise in London's Dalston in 1978, the Hackney Flashers collective set out to show that the presentation of photography was as important as the image itself. Graphic designers and photographers worked together to deconstruct the process of photographic image-making and its use within our society, contrasting the fantasies of capitalist publicity with the feminist perception of real life for women and children. In one panel from *Who's Holding the Baby?*, titled 'Who's holding the baby . . . and where?', an estate agent's advertisement for a luxurious dwelling in South Kensington is set against a photograph of a rotting house in the inner city, the two photographs making points about social inequality and the uses of photography central to the socialist and feminist debate. On the same panel, two children eat and a woman works in a kitchen. All the iconography of poverty is in the picture – the furniture, the washing draped across the ceiling – and across the

93 Jill Posener, London, 1982. Sexist advertising which denigrates women and pictures them as submissive consumers formed an important part of feminist photography in the late 1970s and early eighties. This photograph, which contrasts strong, humorous graffiti with the ad-man's appeals to women's traditional insecurities, was one which appealed to women across class and consciousness barriers *Courtesy of the photographer*

173

panel appears a photograph of the advertising agency's construction of the ideal kitchen – a smiling woman bends to speak reassuringly to her well-dressed daughter, who in turn is opening a well-stocked fridge. The set of photographs works well, not just because it presents effectively a social contrast, but also because it poses questions about usage; the prosperous woman is as much a part of the consumerist confidence trick as the inner-city woman is on the receiving end of political ineptitude, and the marketing of the dream house is as carefully contrived as fiction. These photographs sought to identify and to explore the visual coda which direct women's lives.

The eclectic use of graphics, of cartooning and of advertisements began a process which took photography out of its traditional limits and re-established it as a medium of cohesive political propaganda. The two Hackney Flashers exhibitions established that photography could be used by women to explore women's issues (primarily, in these two projects, employment and childcare) and to present these

94 Cath Tate,
'Prevent Street Crime',
photomontage 1980s
*Courtesy of the
photographer*

interpretations without intervention from outside sources. Another important acceptance within the projects was that the photograph was not sacrosanct and self-sufficient, and that the notion of photographic truth was one which should be continually challenged. As the women themselves commented:

> The limitations of documentary photography became apparent with the completion of the *Women and Work* exhibition. The photographs assumed a 'window on the world' through the camera and failed to question the notion of reality rooted in appearances. The photographs were positive and promoted self-recognition but could not expose the complex social and economic relationships within which women's subordination is maintained. We began to juxtapose our naturalistic photographs with media images to point to the contradictions between women's experience and how it is represented in the media. We wanted to raise the question of class, so much obscured in the representation of women's experience as universal.[9]

Despite the innovation of its methods, the Hackney Flashers depended to a substantial extent on traditional picturing of women in need. Setting working-class women against a background of deprivation and domestic disintegration in order to campaign against the burden which society imposed upon them was a device which both Norah Smyth and Edith Tudor Hart had used with some success. The concentration on women as uncared-for carers was also familiar within women's photographic iconography. However, much feminist work sought to present women as a positive force, protesting and powerful.

This orientation is particularly evident in much of the work which has emerged from the frontline of the protest movements of the eighties, photographs in which feminist women are pictured by feminist photographers as celebratory and satirical in their challenging of the political and social establishment. A Sally Greenhill photograph of 1980 shows women marching by torchlight against proposed anti-abortionist legislation: the photograph uses the graphics of the banners to weld the image into a cohesive whole. Countless feminist photographs of this period feature the graphics of agitprop. Dianne Ceresa's photograph 'Graffiti on graffiti', *c.* 1980, shows the reorganisation of a piece of feminist street graffiti so that the slogan 'Women Reclaim the Night' has been altered in the photograph to 'Bat Women Reclaim the Night', introducing filmic fantasies into this feminist context. Found graffiti was often replaced by graffiti constructed as an integral part of the photograph's composition, leading to images which are direct and unequivocal satires. In a feature titled 'Knit Yourself a Woman's Woolly' in a 1982 issue of *Spare Rib* magazine, a woman sits in front of a wall on which a written slogan asks: 'If I gave her the wool would she make me one too?' The photograph, by Jill Posener, is a caricature of traditional attitudes to knitting and the equally traditional emphasis on domestic

95 Brenda Prince, 'Jill and Laura with baby Rowan, aged three months'. From *The Politics of Lesbian Motherhood*, June 1982 *Courtesy of Brenda Prince/ Format*

crafts in mainstream women's magazines – as well as a playful send-up of a piece of lesbian self-mockery, 'My mother made me a homosexual'. Posener's photographs were to become representative of a particularly accessible women's photographic satire upon women's relationship to men, as seen through graffitied sexist advertising. These photographs, which were popularised as post-cards, were direct and witty in their appeal. Thus on a photograph for the well-known 'A Diamond is For Ever' campaign, the advertiser's question, 'Isn't it time you changed the sweet nothings into some-things?' is answered by the graffiti 'Give *her* your pay packet' (plate no. **93**). Again, in an advertisement for Fiat cars, the traditional posing of an elegant model on top of a car is juxtaposed by the slogan 'When I'm not lying on cars I'm a brain surgeon'.

Throughout the first half of the eighties women's pictures of protest have relied on the presence of graphics, both found and positioned. Raissa Page's 1982 photograph taken at Greenham Common shows two women laughing as they stand against the perimeter fence. One of the women wears as a hat a bag marked 'Official Citizens Survival Bag'. The juxtaposition of the wire fence, the laughing women and the ludicrous graphics makes for an image which celebrates the strength and humour of the women and satirises the ill-informed pompousness of the state. Another photograph taken at Greenham by Nina Prescod, 'The Fence, Greenham, 1984',

96 Raissa Page,
Greenham Women,
January 1983
*Courtesy of Raissa Page/
Format*

shows two women masked and inanimate holding a banner inscribed with the words 'Blodwen and Ethel say "We Won't be Puppets for the US Government"'. In the background patterns appear behind the wire which suggest the artefacts of a circus – huge hoops and garlands – and the two women stand like masked performers, holding their message out to their audience, presenting protest as theatre.

Satire is an integral and traditional part of political propagandist photography, and one of its most satisfying vehicles has been photomontage. By creating differences of scale and distorting the physical, while at the same time maintaining recognisable subjects, photomontage invites social criticism through visual effects. The photomontagist Cath Tate created a series in the early 1980s of situations in which Margaret Thatcher was positioned variously as a terrified Scrooge being confronted with the Ghost of Christmas Present (who menaces her with 'Cuts in Health, Unemployment, Poor Housing, Poverty and Cruise Missiles'), as a pickpocket stealing from a mother and her small child (plate no. **94**), and replicating a strident Warrior Queen as she poses with a copy of the *Sun* newspaper. Tate lampoons other establishment figures in her montages: a beautifully dressed Princess Diana converses graciously with a hunched famine victim, and with Prince Charles she appears as a vastly distorted two-headed monster in a montage entitled 'Our Suburban Dream'.

The stylisation in Tate's work is often quite rudimentary, yet seeks to carry into contemporary photography the methods and motivations of agitprop photography, and as such its place within the scheme of a radical women's photography is an imporant one. Demystifying the oppressive forces of world capitalism – and in the case of Greenham, of the militant state – photographers have sought to render them as objects of mockery; ludicrous, mismanaged, bizarre.

Significant events in women's history have always sparked off a mass of photographic activity. Just as during the Suffrage campaigns and the First World War women adapted their photographic methods and styles to events, so contemporary women's photography has taken a multitude of directions to represent women's lives throughout the 1970s and eighties.

Brenda Prince's *Lesbian Mothers* series, made during her last year at the Polytechnic of Central London in 1982, marked an important move in radical documentary portraiture (plate no. **95**). Prince, who had worked on the Lesbian Line telephone advice service for seven years, wished to document aspects of the experience of lesbian women who risked losing their children in custody cases. She had perceived that lesbianism was a frightening taboo to many people, and so adopted a method of presenting the women through the means of large-format coloured family photographs juxtaposed with a text which outlined the women's fears and anxieties of losing their children. Thus, while emphasising through the photographs the solidity and positiveness of lesbian families, she also 'shattered the image' through a textual device. Brenda Prince's photography since the mid-seventies is one which has emerged directly through her growing awareness of the position of women within a male-dominated establishment.

Other vital significant events have been the on-going protest at Greenham Common, begun in 1981, and the miners' strike of 1984–5. On 28 August 1981, Women for Life on Earth marched from Cardiff to Greenham Common in Berkshire, the proposed site for a large concentration of US Cruise missiles. Later that year, the first women's peace camp was established outside the base, and from that time women have maintained a continuous presence, attracting support and solidarity from peace groups throughout the world. From the beginning, women's action at Greenham was direct, invasive and inventive, often using highly emotive symbolism to promote the cause. In 1981, some of the Greenham women chained themselves to the perimeter fence of the base to demand a public debate with the Ministry of Defence. In 1982, the City of London witnessed Greenham women 'dying' outside the Stock Exchange (earlier that year, they had 'keened' outside the Houses of Parliament). In August of that same year, eight women had entered the base to present the Commander with an origami crane, 'symbol of hope and peace'. In October, protesting women wove themselves over with

97 Brenda Prince,
Nottingham Miners'
Wives Support Group
picketing Bevercotes
Colliery, 10 p.m. night
shift, January 1985
*Courtesy of Brenda Prince/
Format*

webs of wool and lay in front of machinery and in ditches to prevent
sewers being laid. Shortly before Christmas, 30,000 women held
hands and embraced the nine-mile fence surrounding USAF Greenham
Common, and the next day women entered the base and planted
snowdrops. Such protests were high theatre, celebratory in style and
strong in conviction, but in their sheer visibility they ensured that as
the activities of the Greenham women attracted more and more
publicity and support, the forces of the establishment would also
gather against them. Women were abused, verbally and physically,
their cars and possessions were taken away, and they were conscious
always of a police presence. In the popular press, they were labelled
freaks, and by many local residents they were perceived as unwashed
deviants, as a subversive element disturbing the status quo.

From the clash between celebratory protest and antagonism from
police, press and public, a remarkable iconography grew. In its
structure and picturing devices, it developed a documentary method
precisely suited to the tenor of the confrontation which it recorded. It
took its stance from the development of the ritualistic, symbolic
theatre of protest which so typifies the movement, giving rise to a
pattern of images which does not occur within other documentary
themes in feminist photography. The Greenham protest has been
essentially one which depended on unity and on numbers for its
effectiveness; it is a protest, unlike many others, which relies upon a
body of people being *continuously* present at one place for an indefinite
time. In this way it is different from traditional demonstrations at
which protesters gather and then disperse. Even more unusually, the

women's presence is a very domestic one; they (and at some points their children) live at the camp, establish temporary homes there, display their commitment to the movement by adopting communality. This massing together of women has formed a crucial part of the documentary theme which photographers have developed. In a photograph by Lesley McIntyre, two kinds of group dynamic are explored. In the foreground of the photograph a group of women is perceived as fluid, energetic, even ecstatic – in stark constrast to the stolidity of a line of servicemen standing behind the women. The men frown and the women laugh, and the opposition of culture, sex and politics is visualised. Another, more common group effect depends on the picturing of the unbroken circle. In a photograph made in January 1983 after fifty-two women had climbed the perimeter fence to dance on the missile silos, Raissa Page pictured the women holding hands in a huge circle, foregrounded by the fence, with its own circular patterning of barbed wire and a clutter of buildings, ladders and police cars (plate no. **96**). In all the Greenham photographs taken by women during the early eighties there is the conviction that this essentially powerless minority of women protesters is possessed of a symbolic power quite incomprehensible to the forces which oppose it.

When feminist photographers looked at the participation of women in the miners' strike of 1984–5, they again adapted their picturing methods to suit the tenor of the events which they photographed. Greenham Common was a protest in which women had used high theatre and ritualistic celebration to mark the global significance of their campaign. The women who formed the campaign against pit closures adopted much more traditional postures. Reacting to their subjects' point of view and to the structure of activities and demonstrations which they saw, the satire which so characterises the Greenham photographs is completely displaced. Here, feminist photographers encountered women who did not necessarily share either their sexual politics or their cultural mores; even more importantly, they worked with women who were made deeply suspicious of photography and its usage by the way in which the popular press had manipulated the portrayal of the miners' activities throughout the strike. The mining women of 1984–5 needed both to be seen and to perceive themselves as strong working-class women, caring for their families and for their community, protesting against the actions of the state and at the same time retaining an identification with their class. For these women, mass public protest and involvement in picketing was a new departure. As one miner's wife wrote of her life before the strike:

> I've never been out of the house before. Not before strike. House, kids, that's all I were. I thought there were only me who ever existed in this world.[10]

The women who documented the strike were observing women

who catapulted themselves into a political arena which had formerly been the property of men and the male political hierarchy, and this process of emergence is necessarily the one which appears most spectacularly through the photographic representations.

One of the most perceptive observers of the women's campaign during the miners' strike was the *Format* photographer Brenda Prince, who pictured women as dynamic and forceful organisers, entering completely new spheres of activity. Her photographs form a detailed chronicle of these first-time participants in organised politics. In a photograph of Hucknall Women's Action Group, Prince explores the structure of a women's meeting. She is careful to establish visually that the meeting is taking place in a committee room rather than in one of the women's homes (for miners' wives felt very strongly that the action groups had taken them out of their homes and liberated them from domesticity), and illustrates the procedural structure of the meeting, which has speakers, a chairperson and an audience. The photograph demonstrates with precision the tension of the meeting, the division of responsibility, the assumption of roles by the women within the structure. Some of the women in the photograph seem unsure of their presence, some are assertive and questioning, some are quizzical; the photograph demonstrates these

98 Roshini Kempadoo, The 'Seven Steppers', Black women's netball team at a tournament in Coventry, 1985
Courtesy Roshini Kempadoo/Format

differences with care. Prince's documentary is important, for it chronicles the progression of the striking women from the platforms of discussion, and takes the documentary through to observe the women creating their own militancy. Thus, in a photograph which shows the Nottingham Miners' Wives Support Group picketing the night shift at Bevercotes Colliery (plate no. **97**) she presents quite clearly the strength and force of the women's anger and determination. A complicated picture, which concentrates on the physical postures of the women (all of whom react differently to a non-striking miner), it tells much about the ways in which women altered their perceptions of their own physical presence during the strike.

Women photographers documented the miners' strike in a way which was very different from that of male photographers. Throughout their work, feminists pictured the women as strong and joyous, sometimes uncertain, but always powerful, and the collusion and understanding between the photographers and the wives can usually be felt quite palpably.

Just as it did at Greenham Common, an iconography emerged from feminist photographic documentary of women's actions during the miners' strike. In some ways, the documentary went back to a much more traditional picturing method than that which had emerged in feminist photography from the mid-seventies. In others, it established an important new progression, for it marked the beginning of a photography which felt able to step outside the by-now traditional methodology of feminist visuals – the found and created graffiti, the symbolism, the manipulation of the image – to create a weighty and complex documentary which depended on the sympathy and empathy between photographer and photographed. Documentary photography has always been one of the main tools of socialism; it has traditionally pictured working-class men and women engaged in a struggle against social injustice. Here, the socialism of the mining women came together with the methodology of feminist picturing to become a united and dynamic force.

From the base established by the early feminist photographers and groups of the early seventies, important movements grew. The founding in 1982 of *Format*, the first women-only photographic agency in Britain, was immensely important. Not only did it give established women documentarists like Sheila Gray, Pam Isherwood, Jenny Mathews, Maggie Murray, Raissa Page, Brenda Prince and Valerie Wilmer a collective base and a sound administrative structure, it also allowed them to reflect carefully about the ways in which photographs are used when released to the mass media. Discussing the work of the agency with its members in 1984, Janette Webster summarised the group's practice:

The agency's approach to responsible picture usage is much more complex than simply not supplying nudes to the *Sun*. Knowing the client's orientation is very much an essential and it is an area in which

they have necessarily become expert. On very controversial issues like the present miners' strike they know precisely who is likely to be for and who against, and all material relating to that would be handled very carefully. Material going out, however small the amount, is discussed within the group.[11]

The emergence of Black women into British photography is also a significant development when considering new areas opened by feminist practice. While much of their impetus is undoubtedly derived from the powerful Black movement within the arts during the 1980s, the women's movement within photography has also influenced the practice of Black women photographers like Lesley Mitchell and Brenda Agard, and Roshini Kempadoo (plate no. **98**) and Suzanne Roden, now both members of *Format*.

The establishment of girls' groups, of women-only darkroom sessions and workshops (strongly evident in the London collective *Camerawork*'s programme) reflect a conviction by women working within photography that women are establishing their own photographic practice.

In addition to these moves, concerted attempts have been made to bring women's photography and the issues which it explores into the mainstream critical arena. The Arts Council's *Three Perspectives* exhibition, shown at the Hayward Gallery in 1979, included a section organised by Angela Kelly, and in her curator's statement in the catalogue she wrote:

> I set out to discover what feminist photographic practice existed and put together the aspects which I see as important developing strands. All the work I have chosen deals essentially with women's lives and can be seen as representing a spectrum between two poles of a feminist photographic practice. I have called these the 'documentary' and the 'analytical' poles. Within these bounds the photographers employ a number of styles, approaches and contents which raise various issues through and about the medium of photography.

In her selection, Kelly included a series of portraits by Aileen Ferriday, social documentary work by Christine Leah Hobbeheydar, sequential pieces by Yve Lomax and Sarah McCarthy, works by Jo Spence from *Beyond the Family Album*, and photographs by Valerie Wilmer from *Mississippi Women*.

More recently, Maureen Paley's directorship of Interim Art in East London has involved showings of photographic works by women like Hannah Collins and Susan Hiller, and Susan Butler's editorship of *Creative Camera* magazine has brought to critical attention the work of many exciting and innovative photographers including Anita Corbin, Sue Packer and Mitra Tabrizian. *The Selectors Show*, exhibited at *Camerawork* in 1984, invited six women (Deborah Baker, Susan Butler, Maggie Murray, Leslie Mitchell, Karen Knorr and Maureen Paley) to select from a wide range of contemporary work by, among others, Roberta M. Graham (plate no. **99**), Sarita

99 Roberta M. Graham, 'From Short Cuts to Sharp Looks'. The photographer writes of her exploration of cosmetic surgery: 'The issues raised are not specifically concerned with the female image.' Yet her work is significant within women's photographic iconography as it explores 'a desire to cut up and restructure the face to disguise the ageing process so that it conforms with the socially prescribed aesthetic of "youthful beauty". It is a close and intimate look at motivation, techniques and results of this type of essentially violent self-mutilation in the pursuit of beauty.' *Courtesy of the photographer*

Sharma and Belinda Whiting.

Feminist photography, in its different forms, is important within the context of a women's photography not only because it has challenged traditional photographic usage and radicalised classic methods of picture-making, but also because it has allowed women greater access to the medium. Although women had operated successfully within photography from its very beginnings, they had not before been able to create a methodology and a market which was shaped and determined by feminist principles.

Now almost twenty years of this new women's photography demonstrates a diversity of concerns and techniques – a sign itself of the confidence and richness of feminist practice. This emergence of a new, directly political women's photography – be it documentary, portrait, satire or sequential work – has created an opportunity for women photographers not only to contribute to the course of photographic history, but also to determine it.

■ NOTES

All books published in London, except where stated otherwise.

CHAPTER ONE
Photography in Transition: An Overview 1840–1939

1 Cyanotype: 'The cyanotype, or blueprint process was invented by the astronomer and scientist Sir John Herschel, whose many contributions to the early development of photography included the discovery in 1819 that sodium thiosulphate (or hyposulphite as it was then known) was a solvent for silver salts – a fact which was later to make possible the "fixing" of photographs to make them permanent – and to this day thiosulphates are still used for this purpose. In 1842 Sir John found that paper impregnated with iron salts was light sensitive, prussian blue being formed in the paper. At the time, the cyanotype process was little used, except for printing "photograms". From the 1880s, it was used for copying engineering and architectural drawings, for which it was well suited, since it gave best results from an original of high contrast. For some years, especially in the 1890s and 1900s, it was used by amateurs for proofing snapshot negatives, but the low contrast of the process often gave rather muddled results, and the strong blue colour was not suitable for many subjects.' (From Brian Coe, *A Guide to Early Photographic Processes*, Hurtwood Press and Victoria and Albert Museum, 1983.)

2 Calotype: 'In September 1840 William Henry Fox Talbot discovered that by briefly exposing photogenic drawing paper to light he produced a latent image which could be developed with gallic acid. Positives were made from the negatives by contact printing in daylight (about 30 to 90 minutes) without development. Virtually the only negative/positive process in use before 1851.' (From Cecil Beaton and Gail Buckland, *The Magic Image*, Weidenfeld & Nicolson, 1975.)

3 Daguerreotype: 'The name given to the process introduced in 1839 by L. J. M. Daguerre by which an image was formed upon the silvered surface of a coppered plate after sensitising with iodine vapour. The image was developed with mercury vapour. The process comprised five operations: cleaning and polishing the silvered plate, sensitising, exposing in the camera, developing, fixing and finishing. Went out of general use after the mid-1850s.' (From Cecil Beaton and Gail Buckland, *The Magic Image*.)

4 *The Times*, 17 May 1852.

5 Advertisement from *Norfolk Chronicle and Norwich Gazette*, 9 July 1853.

6 For a full description of this and other processes, see the Glossary in Cecil Beaton and Gail Buckland, *The Magic Image*.

7 From Royal Photographic Society, *Masterpieces of Photography*, 1926.

8 Autochrome process: A process of screen-plate colour photography based on the use of equal amounts of microscopic starch grains dyed red, green and blue violet, mixed and sifted on to glass coated with a tacky surface. The screen-plate was then coated with a panchromatic emulsion and was exposed in the camera with the mosaic towards the lens and then reversed through processing. Patented in England, 1904; marketed on glass plates, 1907; on sheet film, 1933.

9 Royal Photographic Society, *Masterpieces of Photography*, 1926.

10 *Ibid.*

11 Helmut Gernsheim, *The Man Behind the Camera*, Fountain Press, 1948.

12 *Ibid.*

13 *Ibid.*

14 *Ibid.*

CHAPTER TWO
No Cockneys in the East End: Women Documentary Photographers 1900–1918

1 Information from Hilary Spurling, *Ivy When Young*, Hodder & Stoughton, 1974.

2 Gertrude Jekyll, *Old West Surrey*, 1904.

3 Bill Jay, *Victorian Candid Camera*, David & Charles, 1973, p.6. Introduction by Cecil Beaton.

4 Olive Edis's albums are in the collection of the Imperial War Museum, London.

5 Information from Imperial War Museum records.

6 *Ibid.*

7 Photograph in the collection of the Imperial War Museum, London.

8 *Ibid.*

9 *Ibid.*

10 *Ibid.*

11 Elsie Corbett, *Red Cross in Serbia, 1915–19*, Cheney & Sons Ltd, 1964.

12 *Ibid.*

13 Sylvia Pankhurst, *The Home Front: 1914–1916*, Hutchinson, 1932, p.144.

14 *Ibid.*, p.542.

15 David Mitchell, *The Fighting Pankhursts*, Jonathan Cape, 1967.

16 *Ibid.*

17 Information about Norah Smyth's later life in Florence comes from correspondence between the author and Eve Leckley, British Institute of Florence, May 1985.

18 George Eliot, *Adam Bede* (1857), Harmondsworth, Penguin, 1980.

CHAPTER THREE
Reconstructing the Imagination: Documentary Photographers in the 1930s

1 Storm Jameson, *Journey from the North*, Vol. 1, Virago Press, 1984.

2 Stephen Spender, *The Thirties and After*, Fontana, 1978, p.25.

3 *Ibid.*

4 Published by the Communist Party of Great Britain (CPGB Library).

5 *Ibid.*

6 Margaret Monck in conversation

with the author, 1984.

7 For more information about Edith Kaye's work with *Picture Post*, see Bert Hardy, *My Life*, Gordon Fraser, 1985.

8 Information about the initial meetings of Edith and Wolf Suschitzky and the Tudor Hart family comes from the author in conversation with Jennifer Jones, September 1984.

9 *Ibid.*

10 Quoted from *Women Architects*, an exhibition organised by the RIBA in 1983.

11 Sir Tom Hopkinson remembers Alex Tudor Hart as a prominent protester at the Mosleyite meetings of the thirties. (Sir Tom Hopkinson in conversation with Amanda Hopkinson, 1984.)

12 First published by Pelican Books, 1939.

13 Robert Radford and Lynda Morris, *op.cit.*, Oxford: Museum of Modern Art, 1981.

14 Information about Tommy Tudor Hart's illness comes from conversations between the author and Wolf Suschitzky in 1983 and Jennifer Jones in 1984.

15 Letter to the author from Marjorie Abbatt, 1984.

16 *Picture Post*, 30 April 1949.

17 Quoted in *The World's Best Photographs*, Odhams Press, 1939.

18 Kurt Hutton, *Speaking Likeness*, Focal Press, 1947.

19 Quoted from Robert Radford and Lynda Morris, *AIA: The Story of the Artists International Association*.

20 See *Ibid.*

21 *Ibid.*

22 *Ibid.*

23 From evidence obtained during author's study of the AIA papers at the Tate Gallery Archive, 1985.

24 AIA papers, Tate Gallery Archive.

25 *Ibid.*

26 Quoted by Stephen Spender in *The Thirties and After*.

27 See *Journey from the North*.

28 Quoted in William Stott, *Documentary Expression and Thirties America*, New York: Oxford University Press, 1973.

29 Margaret Monck in conversation with the author, 1985.

30 *Ibid.*

31 *Ibid.*

CHAPTER FOUR
Carefully Creating an Idyll: Vanessa Bell and Snapshot Photography 1917–1950

1 Amanda Hopkinson in conversation with the author, 1985.

2 Lisa Sheridan, *From Cabbages to Kings*, Odhams Press, 1955.

3 *Ibid.*

4 Barbara Nash (ed), *The Complete Book of Babycare*, St Michael, 1980.

5 Quentin Bell and Angelica Garnett, *Vanessa Bell's Family Album*, Jill Norman and Hobhouse Ltd, 1981.

6 Angelica Garnett, *Deceived With Kindness*, Chatto & Windus/The Hogarth Press, 1984.

7 Letter to the author, 1985.

8 Nigel Nicolson (ed), *A Change of Perspective: The Letters of Virginia Woolf Vol. II 1923–1928*, The Hogarth Press, 1977. July 1926.

9 *Ibid.*

10 Anne Olivier Bell (ed), *The Diary of Virginia Woolf, Vol. I 1915–1919*, The Hogarth Press, 1977. 30 January 1919.

11 See *A Change of Perspective*, 7 October 1923.

12 See *The Diary of Virginia Woolf*, Vol. 1.

13 See *A Change of Perspective*, 12 May 1923.

14 As described by Frances Spalding in *Vanessa Bell*, Weidenfeld & Nicolson, 1983.

15 See Angelica Garnett, *Deceived With Kindness*.

16 See Introduction, *Vanessa Bell's Family Album*.

17 Charleston Trust papers, Tate Gallery Archive, September 1910.

18 From Frances Spalding, *Vanessa Bell*.

CHAPTER FIVE
Innovators: Women's Experimental Photography 1920–1940

1 *Op. cit.*, edited by T. Korda, published by *Photography* magazine.

2 For descriptions of the kinds of publications which became available to the British public in the late twenties, see David Mellor, *Germany, The New Photography 1927–33*, Arts Council of Great Britain, 1978, and *A Salute to British Surrealism*, The Minories, 1985 (exhibition catalogue).

3 *The Times*, 16 June 1925.

4 *Daily Chronicle*, 11 April 1926.

5 Madame Yevonde, *In Camera*, The Woman's Book Club, 1940.

6 *Ibid.*

7 *Ibid.*

8 *Ibid.*

9 *Ibid.*

10 *Ibid.*

11 *Ibid.*

12 *Ibid.*

13 Tessa Codrington in conversation with the author, 1984.

14 Biographical information supplied to the author by Barbara Ker-Seymer, 1986.

15 Cecil Beaton and Gail Buckland, *The Magic Image*, Weidenfeld & Nicolson, 1975.

16 Biographical information supplied to the author by Barbara Ker-Seymer, 1986.

17 Evelyn Waugh, *Brideshead Revisited* (1945) Harmondsworth, Penguin, 1981.

18 *Harper's Bazaar*, February 1932.

19 *Ibid.*, December 1931.

20 Barbara Ker-Seymer in conversation with the author, 1984.

21 *Ibid.*

22 See David Mellor, *Germany, The New Photography 1927–33* for more

information about Brian Howard and Humphrey Spender.

23 *Ibid.*

24 Barbara Ker-Seymer in conversation with the author, 1984.

25 *Ibid.*

26 *Ibid.*

27 *Ibid.*

28 *Professional Photographer* magazine, December 1930.

29 Helen Muspratt's recollections of her career were made in an interview with the author, 1985, and in letters written during 1984 and 1985.

30 Ursula Powys-Lybbe in conversation with the author, 1983.

31 *Ibid.*

32 *Ibid.*

33 Letter to the author from John Somerset Murray, 1984.

34 *Ibid.*

CHAPTER SIX
Women Reporters and *Picture Post*

1 Merlyn Severn, *Double Exposure*, Faber & Faber, 1958.

2 Tom Hopkinson in Foreword to *Double Exposure*.

3 John Lane, *op. cit.*, The Bodley Head, 1936.

4 Merlyn Severn, *Double Exposure*.

5 Bert Hardy, *My Life*, Gordon Fraser, 1985.

6 Merlyn Severn, *op.cit.*

7 *Picture Post*, 9 June 1945.

8 Described to the author in letters written during 1984.

9 *Ibid.*

10 *Ibid.*

11 *Ibid.*

12 *Ibid.*

13 *Ibid.*

14 In 'The Photographer of "And"', *Photoguide* magazine, n.d.

15 From a letter to the author, 1985.

16 *Ibid.*

17 *Ibid.*

18 *Ibid.*

CHAPTER SEVEN
Through the Looking Glass: Portraiture in the Studio 1900–1955

1 Madame Yevonde, *In Camera*, The Woman's Book Club, 1940, p.45.

2 Molly Durelle, *Women's Employment*, 1924 (Fawcett Collection).

3 *Professional Photographer* magazine, June 1915 (National Portrait Gallery Collection).

4 *The Times*, 4 April 1933 (Fawcett Collection).

5 *Ibid.*

6 Cecil Beaton and Gail Buckland, *The Magic Image*, Weidenfeld & Nicolson, 1975, p.270.

7 Madame Yevonde, *In Camera*, p.46.

8 *Ibid.*, p 68.

9 *Professional Photographer* magazine, October 1917 (National Portrait Gallery Collection).

10 *Ibid.*

11 Interview with Dorothy Wilding for N.B.C., n.d. (National Portrait Gallery Collection).

12 Dorothy Wilding, *In Pursuit of Perfection*, Robert Hale, 1958, pp.24–5.

13 Interview with Dorothy Wilding for N.B.C.

14 'Look Pleasant Please', cutting from American newspaper, *c.* 1939 (National Portrait Gallery Collection).

15 *In Pursuit of Perfection*, p.28.

16 *Ibid.*, p.130.

17 'Look Pleasant Please', *c.* 1939 (National Portrait Gallery Collection).

18 Betty Mohr, *Unity in Britain*, New York, n.d. (Unpublished typescript).

19 Betty Swaebe in conversation with the author, 1985.

20 Jo Spence in conversation with the author, 1986.

21 *Ibid.*

22 *Ibid.*

23 *Ibid.*

24 *Ibid.*

25 Quoted from 'Public Images Private Functions', Jo Spence in conversation with Ed Barber, *Ten. 8* magazine.

26 *Ibid.*

27 *Ibid.*

28 Jo Spence, *Working Photography*, Cambridge Darkroom, 1985.

29 Jo Spence in conversation with the author, 1986.

30 *Ibid.*

31 Jo Spence, *Working Photography*, Cambridge Darkroom, 1985.

CHAPTER EIGHT
Celebration and Satire: Women's Documentary Photography 1972–1986

1 Maggie Murray in conversation with the author, March 1986.

2 *Ibid.*

3 *Ibid.*

4 *Creative Camera*, November 1984.

5 Interview in *Susan Hiller 1973–83: The Muse My Sister*, Londonderry, Orchard Gallery, 1984.

6 *Ibid.*

7 Interview with the author, 1986.

8 *Three Perspectives on Photography*, Arts Council of Great Britain, 1979.

9 *Ibid.*

10 Chrys Salt and Jim Layzell (eds), *Here We Go: Women's Memories of the 1984–85 Miners' Strike*, London Political Committee, Co-operative Retail Services Ltd, 1985, p.21.

11 *Creative Camera*, November 1984.

■ SELECT BIBLIOGRAPHY

All books published in London, except where stated otherwise.

Architectural Association, *Miss Gertrude Jekyll 1943–1932*, Architectural Association, 1981 (exhibition catalogue).

Arts Council of Great Britain, *Three Perspectives on Photography*, Arts Council of Great Britain, 1979 (exhibition catalogue).

Bell, Anne Olivier (ed), *The Diary of Virginia Woolf, Vol. I: 1915–1919*, The Hogarth Press, 1978.

—— *The Diary of Virginia Woolf, Vol. II: 1920–1924*, The Hogarth Press, 1978.

—— *The Diary of Virginia Woolf, Vol. III: 1925–1930*, The Hogarth Press, 1980.

—— *The Diary of Virginia Woolf, Vol. IV: 1931–1938*, The Hogarth Press, 1982.

Beaton, Cecil, *British Photographers*, William Collins, 1944.

—— *The Wandering Years, 1922–39*, Weidenfeld & Nicolson, 1964.

—— *The Years Between, 1939–44*, Weidenfeld & Nicolson, 1965.

Beaton, Cecil and Buckland, Gail, *The Magic Image*, Weidenfeld & Nicolson, 1975.

Bell, Quentin, *Bloomsbury*, Weidenfeld & Nicolson, 1968.

Bell, Quentin and Garnett, Angelica (eds), *Vanessa Bell's Family Album*, Jill Norman and Hobhouse Ltd, 1981.

Bloch, Olaf (ed), *The Photographer Speaks*, Allen & Unwin, 1940.

Bourke-White, Margaret, *Portrait of Myself*, William Collins, 1964.

Brandt, Bill, *The English at Home*, Batsford, 1936.

—— *London in the Thirties*, Gordon Fraser, 1983.

Bryher, *The Days of Mars*, Calder & Boyars, 1972.

Clark, J., Heinemann, M., Margolies, D. and Snee, C. (eds), *Culture and Crisis in Britain in the 30s*, Lawrence & Wishart, 1979.

Coe, Brian, *A Guide to Early Photographic Processes*, Hurtwood Press and the Victoria and Albert Museum, 1983.

Cole, G. D. H. and M., *The Condition of Britain*, Left Book Club, 1937.

Corbett, Elsie, *Red Cross in Serbia, 1915–19*, Cheney & Sons Ltd, 1964.

Cunard, Nancy, *Black Man and White Ladyship*, Utopia Press, 1931.

De Salvo, Louise and Leaska, Mitchell A. (eds), *The Letters of Vita Sackville-West to Virginia Woolf*, Hutchinson, 1984.

Dahl Wolfe, Louise, *A Photographer's Scrapbook*, Quartet, 1984.

Fitzgibbon, Theodora, *With Love: An Autobiography 1938–1946*, Pan Books, 1983.

Ford, Hugh (ed), *Nancy Cunard: Brave Poet, Indomitable Rebel 1896–1965*, New York: Chiltern Books, 1981.

—— *Published in Paris: American and British Writers, Printers and Publishers in Paris, 1920–1939*, Garnstone Press, 1975.

Garnett, Angelica, *Deceived with Kindness*, Chatto & Windus/The Hogarth Press, 1984.

Garnett, David, *Carrington: Letters and Extracts from her Diaries*, Jonathan Cape, 1970.

Garland, Madge, *The Changing Face of Beauty*, Readers Union, 1960.

Gernsheim, Helmut, *Julia Margaret Cameron*, Fountain Press, 1948.

—— *The Man Behind the Camera*, Fountain Press, 1948.

—— *The Origins of Photography*, Thames & Hudson, 1982.

Hamblin, Jane, *That Was The Life*, Andre Deutsch, 1977.

Hamnett, Nina, *Laughing Torso*, Constable, 1938; Virago Press, 1984.

Hannington, Wal, *The Problem of the Distressed Areas*, Left Book Club, 1937.

Hardy, Bert, *My Life*, Gordon Fraser, 1985.

Holme, C. G. (ed), *Modern Photography*, The Studio Ltd, 1942.

Hopkinson, Amanda, *Julia Margaret Cameron*, Virago Press, 1986.

Hopkinson, Tom, *Of This Our Time*, Hutchinson, 1982.

—— (ed), *Picture Post 1938–1950*, Chatto & Windus/The Hogarth Press, 1984.

Hughes, Alice, *My Father and I*, Butterworth, 1923.

Hutton, Kurt, *Speaking Likeness*, Focal Press, 1947.

Jameson, Storm, *Journey from the North*, Virago Press, 1984.

Jay, Bill, *Victorian Candid Camera: Paul Martin 1864–1944*, David & Charles, 1973.

Jeffrey, Ian and Mellor, David, *The Real Thing: An Anthology of British Photographs 1840–1950*, Arts Council of Great Britain, 1975 (exhibition catalogue).

Keenan, Brigid, *The Women We Wanted to Look Like*, Macmillan, 1977.

Korda, T. (ed), *Photography Yearbook*, Cosmopolitan Press, 1935 and 1936–7.

Kraszna Krauss, A. (ed), *Photography as a Career*, Focal Press, 1944.

Lancaster, Marie Jacqueline (ed), *Brian Howard: Portrait of a Failure*, Anthony Blond, 1968.

Lane, John, *Ballet in Action*, The Bodley Head, 1936.

Lloyd, Valerie, *Photography: The First Eighty Years*, Colagni, 1976 (exhibition catalogue).

London Borough of Tower Hamlets, *Tower Hamlets in Photographs 1914–1939*, London Borough of Tower Hamlets, 1980.

Marwick, Arthur, *Women at War 1914–1918*, Fontana Paperbacks, in association with the Imperial War Museum, 1977.

Mellor, David (ed), *Germany, The New Photography 1927–33*, Arts Council of Great Britain, 1978.

—— *Modern British Photography*

1919–39, Arts Council of Great Britain, 1980 (exhibition catalogue).

Minories, The, *A Salute to British Surrealism 1930–1950*, Colchester: The Minories, 1985 (exhibition catalogue).

Mitchell, David, *The Fighting Pankhursts*, Jonathan Cape, 1967.

Nicolson, Nigel (ed), *The Flight of the Mind: The Letters of Virginia Woolf Vol. I 1888–1912*, The Hogarth Press, 1975.

—— *The Question of Things Happening: The Letters of Virginia Woolf Vol. II 1912–1922*, The Hogarth Press, 1976.

—— *A Change of Perspective: The Letters of Virginia Woolf Vol. III 1923–1928*, The Hogarth Press, 1977.

—— *A Reflection of the Other Person: The Letters of Virginia Woolf Vol. IV 1928–1932*, The Hogarth Press, 1978.

—— *The Sickle Side of the Moon: The Letters of Virginia Woolf Vol. V 1932–1935*, The Hogarth Press, 1979.

Odhams Press, *The World's Best Photographs*, Odhams Press Ltd, 1939.

Pankhurst, Sylvia, *The Home Front: 1914–1916*, Hutchinson, 1932.

Partridge, Frances, *Julia*, Gollancz, 1983.

—— *Memories*, Robin Clark, 1981.

Pepper, Terence, *Monday's Children: Portrait Photography in the 1920s and 1930s*, York: Impressions Gallery of Photography, 1977 (exhibition catalogue).

—— *Howard Coster's Celebrity Portraits*, New York: National Portrait Gallery and Dover Publications Inc., 1985 (exhibition catalogue).

Professional Photographers' Association, *Photography in Commerce and Industry*, Professional Photographers' Association, 1936 (exhibition catalogue).

Radford, Robert and Morris, Lynda, *AIA: The Story of the Artists International Association*, Oxford: Museum of Modern Art, 1983 (exhibition catalogue).

Rice, Leland D. and Steadman, David W., *Photographs of Moholy Nagy*, Claremont USA: Galleries of the Claremont Colleges, 1975.

Rotzler, W., *Photography as Artistic Experiment*, New York: Amphoto, 1976.

Royal Photographic Society, *Masterpieces of Photography*, Royal Photographic Society, 1936.

Salt, Chrys and Layzell, Jim (eds), *Here We Go: Women's Memories of the 1984–85 Miners' Strike*, London Political Committee, Co-operative Retail Services Ltd, 1985.

Serclaes de T', Baroness, *Flanders and Other Fields*, Harrap, 1964.

Severn, Merlyn, *Double Exposure*, Faber & Faber, 1956.

Sheridan, Lisa, *From Cabbages to Kings*, Odhams Press Ltd, 1955.

Shone, Richard, *Bloomsbury Portraits*, Oxford: Phaidon Press, 1976.

—— *The Century of Change: British Painting Since 1900*, Oxford: Phaidon Press, 1977.

Sheffield City Art Galleries, *Vanessa Bell 1879–1961*, Sheffield: Sheffield City Art Galleries, 1979 (exhibition catalogue).

Spalding, Frances, *Vanessa Bell*, Weidenfeld & Nicolson, 1983.

Spender, Stephen, *The Thirties and After*, Fontana, 1978.

Spring Rice, Margery, *Working Class Wives*, Pelican Books, 1939.

Spurling, Hilary, *Ivy When Young*, Hodder & Stoughton, 1974.

Stoppard, Tom, *Night and Day*, Faber & Faber, 1978 (playscript).

Stott, William, *Documentary Expression and Thirties America*, New York: Oxford University Press, 1973.

Swaebe, A. V., *Photographer Royal*, Leslie Frewin, 1967.

Taylor, John, *Pictorial Photography in Britain 1900-1926*, Arts Council of Great Britain, 1978 (exhibition catalogue).

Walker, Lynne (ed), *Women Architects: Their Work*, Sorella Press, 1984.

Wilding, Dorothy, *In Pursuit of Perfection*, Robert Hale, 1958.

Williams, Val (ed), *Too Short a Summer: The Photographs of Peter Rose Pulham*, York: Impressions Gallery of Photography, 1979 (exhibition catalogue).

Woodhouse, Adrian, *Angus McBean*, Quartet, 1982.

Yevonde, Madame, *In Camera*, The Woman's Book Club, 1958.

■ INDEX

Page numbers in *italics* refer to the illustrations.